PICASSO CHALLENGING THE PAST

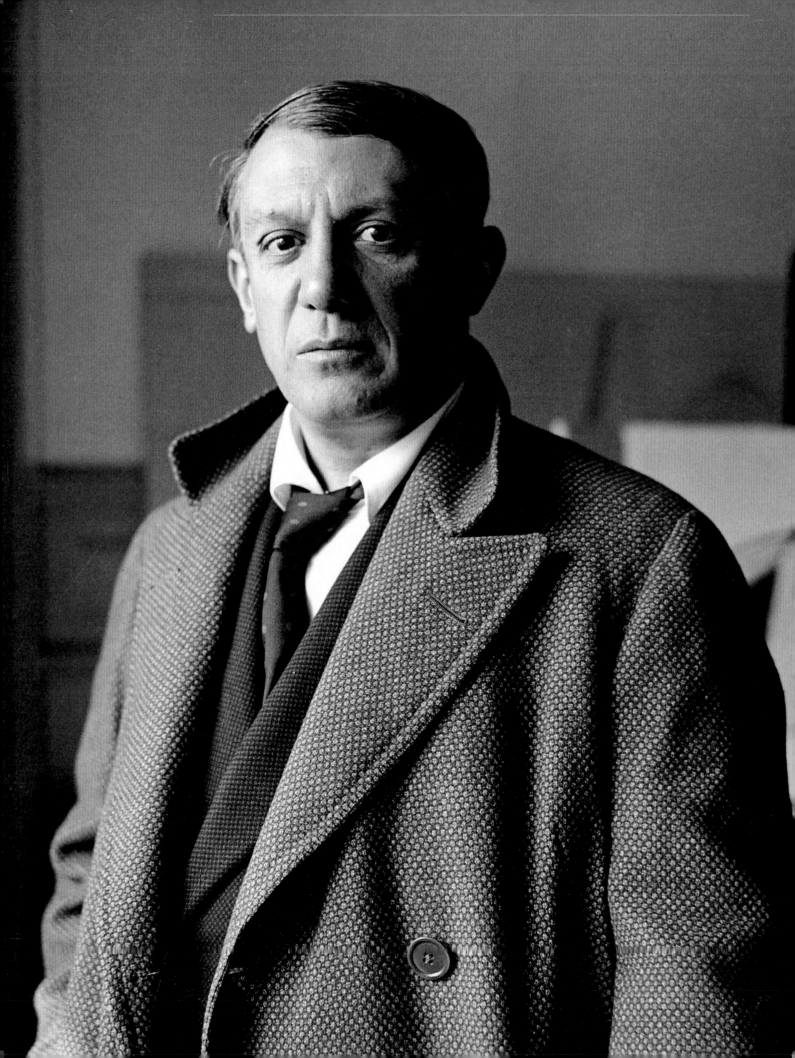

ELIZABETH COWLING, NEIL COX,

SIMONETTA FRAQUELLI, SUSAN GRACE GALASSI,

CHRISTOPHER RIOPELLE AND ANNE ROBBINS

PICASSO CHALLENGING THE PAST

National Gallery Company, London

DISTRIBUTED BY YALE UNIVERSITY PRESS

Published to accompany the exhibition

Picasso: Challenging the Past

at the National Gallery, London: 25 February to 7 June 2009

Curated by Christopher Riopelle and Anne Robbins
Sponsored by Credit Suisse

This exhibition has been organised jointly by
the National Gallery, London and the Réunion des musées
nationaux, Paris; with special support from the musée
national Picasso, Paris; in conjunction with the *Picasso et
les maîtres* exhibition in Paris, organised by the Réunion des
musées nationaux, the musée national Picasso, the musée
du Louvre and the musée d'Orsay.

First published in Great Britain in 2009 by
National Gallery Company Limited
St Vincent House, 30 Orange Street, London WC2H 7HH
www.nationalgallery.co.uk

Hardback 525565
ISBN 9781857094527

Softback 525564
ISBN 9781857094510

British Library Cataloguing-in-Publication Data.
A catalogue record is available from the British Library.
Library of Congress Control Number: 2009920545

Publisher Louise Rice
Project editor Claire Young
Editor Johanna Stephenson
Picture researcher Suzanne Bosman
Production Jane Hyne and Penny Le Tissier
Designed by LewisHallam
Reproduction by Altaimage, London
Printed and bound in Great Britain by
Westerham Press Ltd. St Ives plc

**National Gallery publications generate valuable revenue
for the Gallery, to ensure that future generations are able
to enjoy the paintings as we do today.**

All works are by Pablo Picasso (1881–1973) unless
otherwise stated.

Frontispiece Pablo Picasso in 1928
p. 8 *Girl in a Chemise*, about 1905 (cat. 8, detail)
p. 10 *Women of Algiers (O) (after Delacroix)*, 1955 (cat. 41, detail)
pp. 24–5 *Luncheon on the Grass (after Manet)*, 1960
 (cat. 47, detail)
p. 26 *Self Portrait with a Wig*, 1897 (cat. 1, detail)
p. 54 *Seated Nude*, 1909–10 (cat. 13, detail)
p. 68 *The Lovers*, 1923 (cat. 19, detail)
p. 86 *The Artist in Front of his Canvas*, 1938 (cat. 28, detail)
p. 108 *Las Meninas (after Velázquez)*, 1957 (cat. 44, detail)
p. 140 *Rape of the Sabine Women (after Poussin)*, 1962
 (cat. 74, detail)

Contents

Picasso was an exceptionally competitive artist, keenly attentive to major rivals among contemporaries – most notably Henri Matisse (a relationship explored in 2002–3 in a major exhibition in London, Paris and New York) – who, once he was virtually identified with modernity, began to raid the 'art of the museums', taking technical ideas and motifs from artists as diverse as Lucas Cranach and Edgar Degas. His modernity was not of a kind that revealed much interest in the novelties of his own world and, apart from the use of newsprint in his earliest paintings, not much more than a bathing hut and a light bulb comes to mind in this connection. His chief subjects – still life, the female nude, the self portrait – had long been established in the academy and the official exhibition.

Museums of modern art were relatively little developed during the first half of his working life, and Picasso must have believed that he would eventually be considered in the company and hung in the same buildings as the old masters. Increasingly, and especially in prints and drawings, he included some of the latter among the cast of characters in his personal mythology: Rembrandt, the wrinkled and unkempt old man; Velázquez, the stiff, courtly knight of the brush; Degas, frequenter of brothels. But Picasso was not especially noted as a museum visitor (although he did come to the National Gallery when he was in London in 1919), and much of his knowledge of the art of the past came from reproductions. This should not surprise us, since compositional motifs have always been transmitted by prints, but in Picasso's case the influence of certain artists may actually have depended upon a partial and second-hand acquaintance. Indeed, some of the 'variations' on famous paintings he executed in his later years were based on slides projected on his studio wall. For that reason, he appears to have paid little attention to the way Ingres painted but took a great interest in the quality of his line, in his distortions of form and in his technique as a draughtsman. What influence we detect in Picasso's work of Poussin, Velázquez, Delacroix and Manet is evident in his adoption of their compositions, and owes far less, if anything, to their handling or even colour.

Director's Foreword

This exhibition's precursor, *Picasso et les maîtres*, was shown in Paris at three separate venues: the Grand Palais, musée du Louvre and musée d'Orsay. Viewing Picasso's work here, in the more intimate space of the National Gallery, offers the visitor a new but, we hope, equally stimulating appreciation of his relationship with the old master paintings in our collection. We fervently hope that visitors to the exhibition will take the opportunity at the same time to re-acquaint themselves with the Gallery's permanent collection displayed only a few floors away.

We acknowledge the contribution of Anne Baldassari, director of the musée national Picasso and Marie-Laure Bernadac of the musée du Louvre, who conceived and curated the Paris exhibition, and that of all four Paris institutions, together with Thomas Grenon, Administrateur général de la Réunion des musées nationaux, Guy Cogeval, Président de l'établissement public du musée d'Orsay, and Henri Loyrette, Président-Directeur du musée du Louvre. At the Réunion des musées nationaux, we also owe thanks to Marion Mangon, Marion Tenbusch and Isabelle Mancarella. We are greatly indebted to all our lenders who have allowed their treasured artworks to travel to London, particularly Josep Serra, director of the Museu Picasso in Barcelona, Alfred Pacquement, Centre Pompidou, Paris, and Helly Nahmad in London. Members of the Picasso family, in addition to their generous loans, have been unfailingly helpful with their advice and encouragement for our project.

For the *Picasso: Challenging the Past* exhibition it is a pleasure to acknowledge the curators, Christopher Riopelle and Anne Robbins, as well as the important input of all National Gallery staff. For the book, we are grateful for the contribution of our authors, all fine writers, scholars and curators. We thank Credit Suisse for their support of this exhibition.

NICHOLAS PENNY
Director
The National Gallery, London

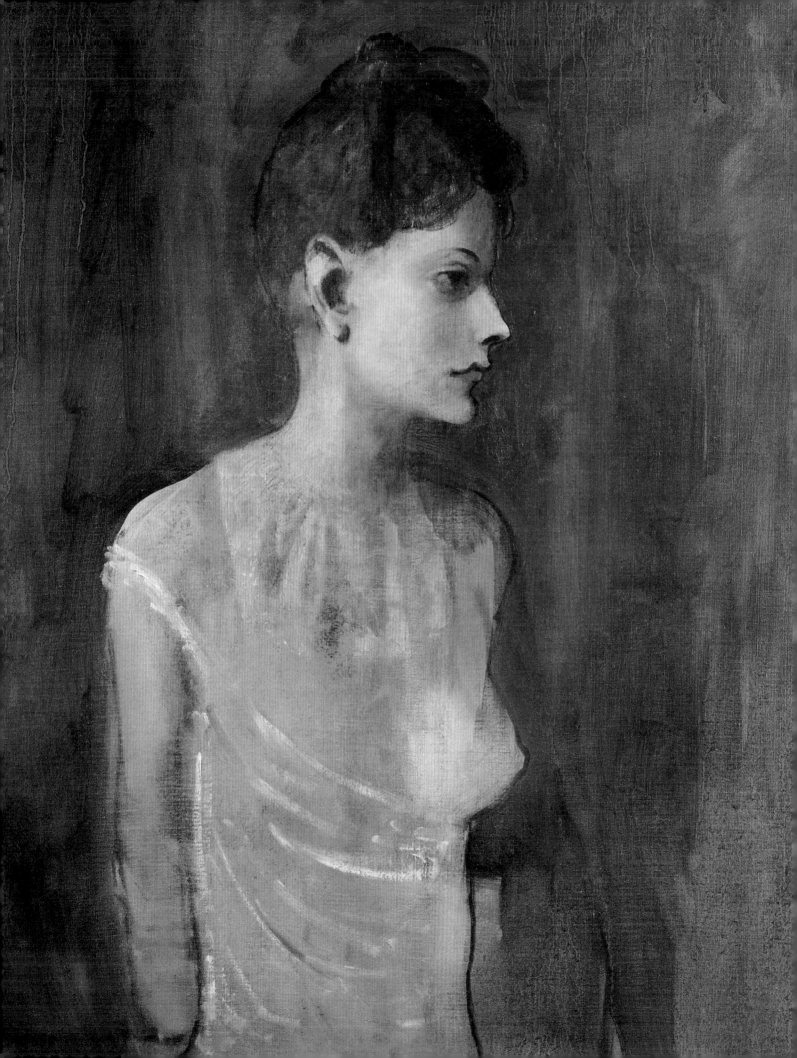

Partner of the National Gallery

As Partner of the National Gallery, Credit Suisse is delighted to support *Picasso: Challenging the Past.*

A passionate student of the grand European painting tradition, Pablo Picasso (1881–1973) became one of its most daring agents of change when he burst onto the art scene in the early twentieth century. Using as a starting point the enduring images that had captivated his predecessors over hundreds of years – the still life, the seated female figure, the self portrait – Picasso indelibly stamped his own identity on this tradition. In the process he established a dialogue with the old masters that was often direct and occasionally irreverent, but always informed by his conviction that the twentieth century deserved a central place in the canon of Western art.

The balance between tradition and innovation also plays an important role at Credit Suisse as we respond to the challenges of today's markets while seeking new solutions for the benefit of our clients. With this in mind, it's particularly fitting for us to sponsor this exhibition of some seventy major works by Picasso, which remain fresh and vibrant, while standing the test of time. We hope you enjoy your visit.

ERIC VARVEL
CEO Europe, Middle East and Africa
Credit Suisse

Sponsor's Foreword

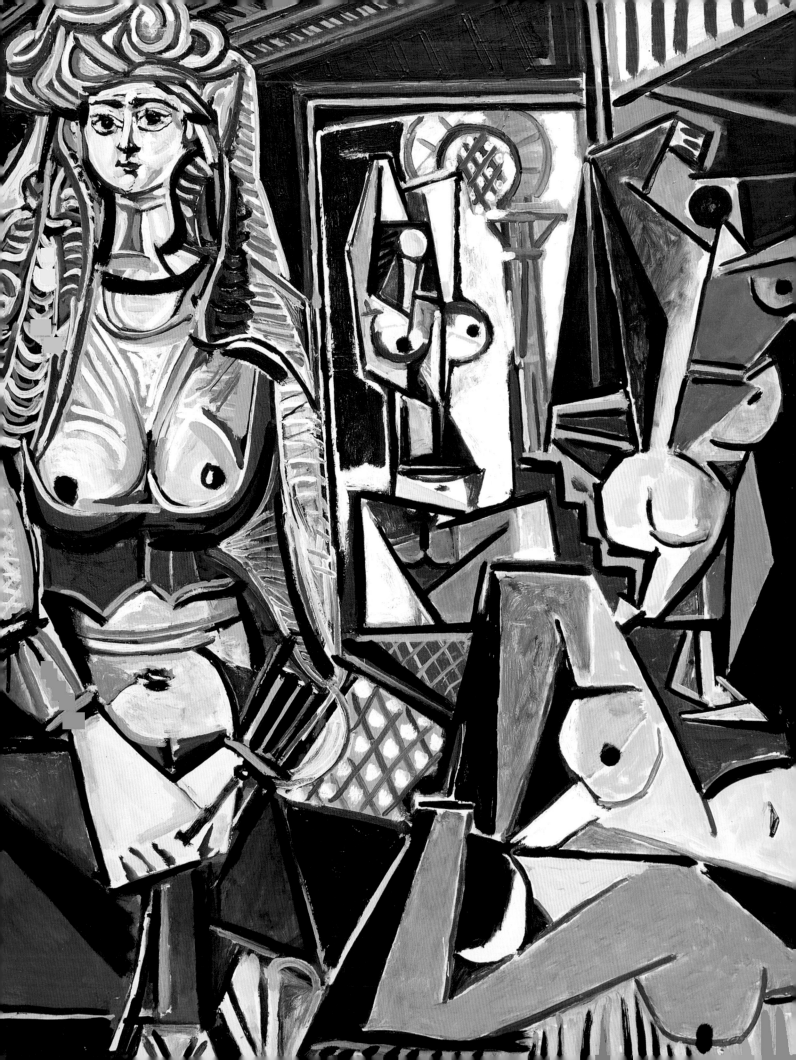

Nearly fifty years ago London hosted a famously successful Picasso exhibition.[1] Breaking all records, almost half a million people flocked to see it and journalists regaled their readers with stories of the country gripped by 'Picassomania', of Hollywood celebrities jostling with the crowds and the Royal Family's secret late-night visit. But the lengthening queues snaked down Millbank outside the Tate Gallery, not around Trafalgar Square, for in 1960 few people would have dreamed of introducing Picasso, the arch-modernist – arch-iconoclast, some said – into the sanctum of the old masters.[2] Now, by contrast, as the extent of his debt to the art of the past is better understood his occupation of the Sainsbury Wing galleries seems both proper and inevitable.

The well-known story of the 'Louvre test' suggests that Picasso himself would have been proud and gratified, but also very nervous, at the prospect of exhibiting in the National Gallery. The 'test' took place in 1947 when the paintings he had donated to the new Musée national d'art moderne in Paris were stored temporarily in the Louvre. Georges Salles, the director of the French museums, offered to have them taken into the main galleries and placed alongside whichever works Picasso chose. It was an irresistible proposal but on the appointed day he was tense and apprehensive: would his work hold up beside the great Spanish and French masters he thought of as his ancestors? Initially silent, he gradually gained in confidence, finally exclaiming excitedly, 'You see it's the same thing! It's the same thing!'[3] This reaction is telling: what Picasso must have wanted most was confirmation that his sense of affinity and equality was justified, confirmation moreover that he had not, as his detractors claimed, violated and endangered the great tradition but reinvigorated it through his resolute commitment to doing things his way. That affirmation experienced in the Louvre seems to have prompted the outburst of (very) free adaptations of old master paintings succeeding the 'test'.[4] Lucas Cranach (1472–1553), whose piquant images of women and intricate draughtsmanship fascinated Picasso, had the dignity of being his first choice in this evolving strategy (cats. 35–6, fig. 57).[5]

Unlike his friend and rival Matisse (1869–1954), Picasso never wrote about art or his intentions as an artist. Contemptuous of intellectualism, whenever young artists started outlining their theories he would interrupt impatiently, 'But say it with brushes and paint'.[6] Nevertheless, he sometimes agreed to be interviewed and permitted people he trusted, such as his dealer Daniel-Henri Kahnweiler and the journalist and fellow Communist Hélène Parmelin, to quote snatches of his conversation in their texts about him. Numerous remarks he made about the old masters have been reported and what emerges from reading them en masse is that – like all of us – Picasso

Competition and Collaboration: Picasso and the Old Masters

ELIZABETH COWLING

was prone to change his mind, but also that such was his sense of rivalry that he could not be cool or objective. His typical style was pungently partisan and blunt: 'That bastard' – he was speaking of Delacroix – 'he's really good'.[7] 'With the Italians the slickness is revolting.'[8] 'People are always talking about the Renaissance – but it's really pathetic. I've been seeing some Tintorettos recently. It's nothing but cinema, cheap cinema.'[9] 'I'd give the whole of Italian painting for Vermeer of Delft.'[10] Unlike the Futurists and Dadaists, however, Picasso never entertained brutal iconoclastic fantasies and when in the right mood he could be enraptured by Italian Renaissance art: 'Michelangelo … I love to get lost in his work as in a rich and powerful mountain … but Raphael is sheer heaven: what serenity these lines possess, what power!'[11] He was indeed very susceptible to ideal beauty in art, although he usually fought this impulse and extolled the power of the coarsely truthful and ugly instead: 'With the Greeks there's always an aesthetic element. I prefer the virile realism of Rome.'[12] 'It's magnificent to invent new subjects. Take van Gogh: Potatoes, those shapeless things! To have painted that, or a pair of old shoes! That's really something!'[13]

The amount of time Picasso actually spent in museums that were on his doorstep and the amount of travelling he undertook in order to see those that were not remain unanswered questions. Probably, he did more of both than he cared to admit: he later pretended, for instance, not to have visited the Vatican on his first trip to Italy in 1917, but his companions at the time tell a very different story.[14] Museum-lover or not, Picasso possessed a phenomenal visual memory and voracious visual appetite, and the combination provided him with endless stimulus because, as he blithely put it, 'I have a horror of copying myself. But when I am shown a portfolio of old drawings, for instance, I have no qualms about taking anything I want from them'.[15] Teetering stacks of books and catalogues accumulated in his various homes, supplemented by a mass of photographs and postcards, some bought, some sent by friends, none ever thrown away.[16] In old age, when he no longer went to Paris and left his country house outside Mougins with the greatest reluctance, Picasso immersed himself in masterpieces like Poussin's *Massacre of the Innocents* (1630–1), Rembrandt's *Night Watch* (1642) and a van Gogh *Self Portrait* (1889) by projecting slides blown up to a gigantic scale onto his studio wall.[17] And he had his own original old master pictures to draw upon. They are, admittedly, of mixed quality because most were obtained opportunistically through exchange with a dealer, not as the result of a determined effort to form a top-notch collection. But they provide further evidence of Picasso's allegiance to the art of the past and he was very proud of major paintings like his two large Cézanne landscapes and

The Procession of the Fatted Ox (The Wine Feast), which he acquired in 1957 as a Le Nain.[18]

Picasso's *musée imaginaire* was, in short, richly stocked and as he grew older he often spoke of being accompanied by other artists whenever he entered his studio: 'I have a feeling that Delacroix, Giotto, Tintoretto, El Greco, and the rest, as well as all the modern painters, the good and the bad, the abstract and the non-abstract, are all standing behind me watching me at work.'[19] When he was occupied with a suite of variations inspired by a particular picture this sensation was acute: the artist in question never left his side, he claimed, and he imagined debates and arguments breaking out with the other painters who dropped by unbidden to check out the latest developments.[20] After discussing the part played by Matisse's odalisque paintings of the 1920s in the cycle inspired by Delacroix's *Women of Algiers* (1954–5) (cats. 38–41, fig. 58), Roland Penrose noted: 'P[icasso] is thinking of other collaborations: talking of certain similarities in composition with these studies and the "Bain turc" of Ingres, he said he wanted some day to do a version of the Odalisque of Ingres à la van Gogh' (fig. 46).[21]

That highly eccentric 'collaboration' between two of Picasso's favourite artists, Ingres (1780–1867) and van Gogh (1853–1890), never came off. But the notion of collaboration is revealing because it implies not only a sense of comradeship and equality, but also that history and chronology are irrelevant: for Picasso, all these 'dead' artists from different eras or generations were alive, and indeed would never die, and what is more were driven by funda-mentally the same imperatives as himself. He had said as much in 1923 in an interview with the artist and dealer Marius de Zayas, when defending his controversial practice of working simultaneously in Cubist and naturalist styles:

> Repeatedly I am asked to explain how my painting evolved. To me there is no past or future in art. If a work of art cannot live always in the present it must not be considered at all. The art of the Greeks, of the Egyptians, of the great painters who lived in other times, is not an art of the past; perhaps it is more alive today than it ever was.[22]

Picasso's strategy while embroiled in one of these 'collaborations' varied. Sometimes he would make a single response, such as his florid, *cloisonné*-like rendition of Courbet's *Young Ladies on the Banks of the Seine* (1950; Kunstmuseum, Basle). Sometimes he would make an extended series of variations, like the vast, sprawling series in different media derived from Manet's *Luncheon on the Grass* (fig. 60, cat. 47–53). Sometimes the homage would be concealed by the change in iconography, as in the series of *Studios*

(1955–6) ostensibly depicting his own vast studio In Cannes which were, he said, inspired by the naturalism of *Las Meninas* (1656; fig. 59) by Velázquez (1599–1660).[23] Sometimes a theme common to several old master paintings would fire him and no single source was dominant, as when Poussin's *Massacre of the Innocents* and *Rape of the Sabine Women* (1637–8; fig. 73) fused with memories of David's *Intervention of the Sabine Women* (1799; fig. 74) in the series devoted to the *Rape of the Sabine Women* in 1962–3 (cats. 73–4).[24] Sometimes, especially in Picasso's most elaborate late prints, it is as if the colony of artists who occupied his thoughts were speaking simultaneously. So although Rembrandt's famous drypoint *Christ presented to the People* (1655; cat. 75) was Picasso's starting point for a print that went through seven states (1970; cat. 76), echoes of El Greco, Ingres and Goya as well as his own earlier paintings intermingle in the densely populated border surrounding the light central stage.[25] But whichever form the 'collaboration' took, it never involved the respectful, self-effacing submission normally associated with copying. On the contrary, as Picasso explained to André Malraux during a long discussion of the latter's concept of the 'Museum Without Walls', although he lived 'with' the painters who mattered to him – lived 'as much with' them as with the people with whom he shared his life,

> I paint against the canvases that are important to me, but I paint in accord with *everything that's still missing* from that Museum of yours.... You've got to make what doesn't exist, what has never been made before. That's painting: for a painter it means wrestling with painting.[26]

The homage was highly competitive in spirit, never conservative.

One gains some idea of the dynamics of the dialogue by comparing Picasso's first explicit variant of *Las Meninas* with the original, which he had not seen for over twenty years (cat. 44, fig. 59). In that it includes all the elements in Velázquez's composition, this is by far the most faithful of the set. On the other hand, so much is wilfully altered – starting with the horizontal instead of vertical orientation of the huge canvas and the decision to paint exclusively in monochrome – that the spectator is initially more conscious of contradiction than affirmation. Nevertheless, the apparently capricious changes bear witness to Picasso's inhabitation of *Las Meninas* and sense of companionship with his great predecessor. He has imagined, for instance, what the huge, murky, cavernous room in the Alcázar where Velázquez is at work would be like if all the shutters were opened and more light allowed to flood in; intently scrutinising the setting, he has become enthralled by the rather sinister lamp hooks fixed on the ceiling – a detail

Fig. 1
The Bathers, 1956
Six sculptures assembled from
pieces of wood
Staatsgalerie Stuttgart

many people miss altogether – and has highlighted them dramatically. A more personal change, revealing the depth of his identification with Velázquez, is the substitution of Lump, the playful dachshund to which Picasso was so devoted, for the great guard dog in the foreground of *Las Meninas*: Lump has joined Velázquez/Picasso in the Alcázar and chased off the mastiff.[27]

In interpreting *Las Meninas* Picasso also recast it in terms of his work, as if liberating Velázquez from his own era and imagining how he might have painted had he been familiar with his, Picasso's, oeuvre. Thus the female dwarf and the male and female chaperones in the middle distance at the right closely resemble the stiff, rudimentary figures roughly assembled from flat pieces of wood in Picasso's recently completed *Bathers* group (fig. 1). The style used for the giant figure of Velázquez, his easel and canvas, and the maid of honour immediately in front of him, is entirely different, but equally Picasso-esque – the ornate version of 'Analytical' Cubism he had used in many paintings since the war, including *Goat's Skull, Bottle and Candle* (1952; fig. 63). This blatant inconsistency of style and also finish – the right half of the picture is far sketchier and more simplified than the left – is at odds with the unity and harmony of *Las Meninas* itself, but typical of Picasso's own experimental approach to execution and obsession with the unpredictable fluidity of the creative process, and his aversion to definitively 'completing' anything because, 'To finish, to achieve – don't those words actually have a double meaning? To terminate, to execute, but also to put to death, to give the *coup de grâce*?'[28]

But while the transformational overhaul bears out Picasso's claim that he battled with his source in order to say something new, he was also at pains to draw our attention to essential aspects of *Las Meninas*. Thus the play of light and shade, which is so important to its mesmerising illusionism and beauty, is one of Picasso's chief preoccupations in this first variant, and his decision to work in grisaille was conditioned not so much by his dependence on a black-and-white reproduction as by his desire to isolate and explore this element in Velázquez's masterpiece. (In a later canvas in the series he investigated its atmospheric qualities, using blues and greens and dilute paint roughly brushed over the white ground to do so.)[29] Velázquez's sensitivity to the *comédie humaine* of court life evidently appealed to Picasso and he used parodic exaggeration to bring out the anxious fussing of the curtseying maids of honour as they attempt to instil perfect deportment in the little princess, while broadening the humour of the episode of the male dwarf kicking the dozing mastiff to alert it to the presence of the royal couple by introducing the absurdly anachronistic sausage dog and using a startlingly

childish style. Picasso also understood that Velázquez's intense pride in his privileged status at Philip IV's court underpinned the unique conception of *Las Meninas* and enlarged him to the full height of the canvas so that, god-like, he towers above the pygmy figures of the Infanta and her attendants and the mirror-image of the king and queen. In effect, Picasso was offering his shrewd but sympathetic commentary on Velázquez and his masterpiece.

In the string of variations which followed Picasso allowed himself greater latitude, dismantling the composition, focusing on parts rather than the whole (cats. 45–6), pushing to extremes the neo-Cubist and neo-kinder-garten styles he had juxtaposed in this first painting.[30] But to conclude that his frequently grotesque distortions of *Las Meninas* or any of the other masterpieces he 'wrestled with' indicate contempt would be a gross mis-conception. A useful analogy is with Picasso's attitude to the women in his life who inspired innumerable works of art in a great variety of styles. Except during the romantic early stage of an infatuation – the tender, smoky portrait of Fernande Olivier (1881–1966; cat. 9) was painted at such a time – few of those works were straightforwardly naturalistic, and the liberties he took with his lovers' faces and bodies when the affair was at its most intense were rarely flattering in a conventional sense and sometimes shockingly monstrous. Like his relationship with the old masters, Picasso's relationship with these models-cum-muses was competitive and became truly creative only when he felt sufficiently liberated to impose his own vision. Speaking of one of his earliest portraits of Jacqueline Roque (1926–1986), his constant companion from 1954 onwards and eventually his second wife, Picasso told Penrose: 'That one's a failure because she dominated me.'[31] By contrast, in the monumental late nudes inspired by Jacqueline he did not scruple to evoke the pathos and melancholy of the model or the voluptuous pressure of dense flesh on a thickset frame (cat. 69).

Picasso's searching dialogue with the old masters is sometimes described as the defining feature of the so-called 'Jacqueline period' – the sign of increased anxiety about his place within the history of art and, as he entered his final decade, of the retrospection and nostalgia typical of an old man anticipating death and haunted by a vivid kaleidoscope of memories. Censorious critics at the time accused him of completely running out of ideas of his own and living parasitically on the old masters out of sheer desperation.[32] In fact, however, the dialogue was a constant throughout Picasso's entire career and his attitude to his sources in his youth set the pattern for his attitude in maturity and old age.

Picasso's apprenticeship had involved making copies of canonical sculp-tures and paintings and planning multi-figure compositions in which he

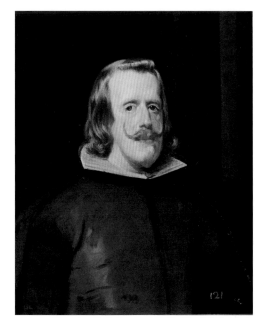

Fig. 2
Diego Velázquez (1599–1660)
Portrait of Philip IV, about 1653
Oil on canvas, 69 × 56 cm
Museo Nacional del Prado, Madrid

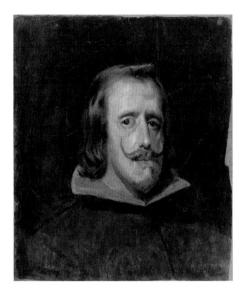

Fig. 3
Copy of Velázquez's Portrait of Philip IV, 1897
Oil on canvas, 54.2 × 46.7 cm
Museu Picasso de Barcelona

deployed what he had learned through copying. He could be very dutiful in executing both these tasks: many polished drawings of antique sculptures mimicking the impersonal style of the pattern books recommended by his teachers and many adroit compositional sketches in the neoclassical idiom survive from his boyhood. While enrolled at the Academia Real de San Fernando in Madrid in 1897–8 he produced an unexceptionable copy in oils of Velázquez's sober, bust-length *Portrait of Philip IV* (about 1653) in the Prado (figs. 2, 3). The most intimate, least regal of Velázquez's portraits of the king, it probably attracted Picasso both because of its timeless candour and because of the inviting simplicity of the composition. But even in this early art-school exercise he did not unreservedly submit. Compressing the background, he closed in on the head, narrowing it slightly, deepening the shadows cast by the brows and generally giving Philip a more haggard, nervous look, so that he reminds one of El Greco's pious noblemen in black (fig. 4). In a contemporary letter to a friend in Barcelona listing the artists in the Prado who had struck him most, Picasso began with Velázquez – 'first rate' – and then continued: 'El Greco has some magnificent heads'.[33] In his copy Picasso effectively fused elements of both these favourite portraitists – a prophetic move because contrived elisions with a point to make quite soon became a hallmark of his work. A couple of much later instances have already been mentioned: Matisse and Ingres as Orientalists cooperating with Delacroix (1798–1863) in the *Women of Algiers* variations, David (1748–1825) with Poussin (1594–1665) in the *Sabines* series.

Precociously self-confident, a teenage Picasso also experimented with 'copies' that were far from faithful. In 1896 he was commissioned by nuns in a convent in Barcelona to copy two altarpieces by Murillo (1617–1682) but, he recalled, 'the idea bored me, so I copied them up to a point, then rearranged things according to my own ideas'.[34] This was an act of bravado because Murillo was the darling of all pious Spaniards of his father's generation, but he got away with it. Artists Picasso venerated were treated with similar apparent nonchalance, however. Although he spent hours in Toledo marvelling at *The Burial of the Count of Orgaz* (1586–8; fig. 5) by El Greco (1541–1614), his instant response took the form of a cheeky spoof caricaturing his teachers in Madrid. (Unfortunately it has not survived.)[35] In 1901 he subverted the painting once again in a mock altarpiece dedicated to the memory of his friend Carles Casagemas (1880–1901), who had committed suicide following a disastrous love affair. In Picasso's sacrilegious version the heavens are populated by naked whores, one of whom thrusts herself at the rigid form of Casagemas who, garbed in monkish black, is being borne aloft on a white horse. *The Burial of Casagemas (Evocation)* (Musée d'Art

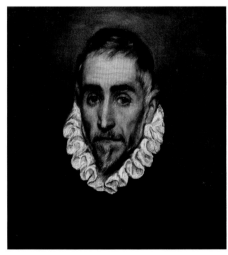

Fig. 4
El Greco (1541–1614)
Aged Nobleman, about 1594
Oil on canvas, 46 × 43 cm
Museo Nacional del Prado, Madrid

18

Moderne de la Ville de Paris) is another painting to involve deliberate elision, for the lower half, depicting the burial, draws not only on El Greco's master-piece but also on the thematically similar, but stylistically entirely different *Saint Bonaventure on his Bier* (about 1629) by Zurbarán (1598–1664), which Picasso had discovered during visits to the Louvre. This too was a picture he admired enormously, but admiration did not preclude travesty.[36] Nor did mourning for one of his closest friends preclude black humour. Between these early works and the variations of the 1950s and 1960s there were many instances of this impious plundering of the great tradition: the ever popular motif of the Three Graces travestied as a lewd bacchanal-cum-Dance of Death in *The Three Dancers* (1925; Tate), to give just one example.

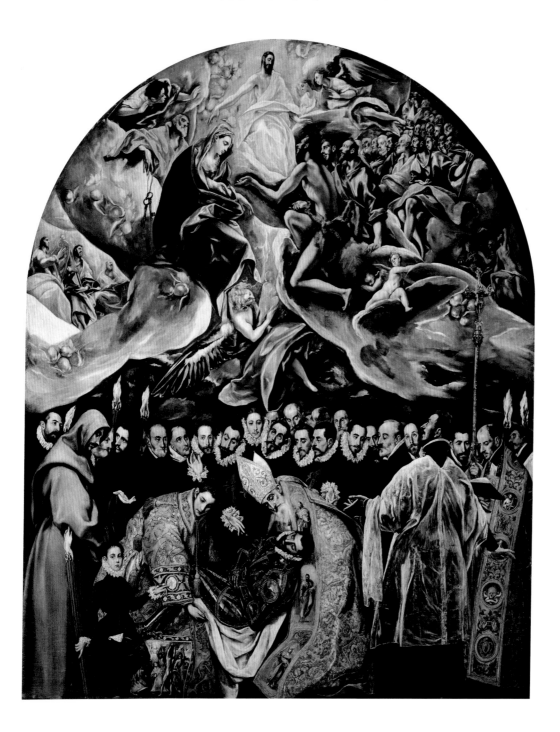

The elderly Picasso loved posturing in trashy joke-shop disguises in front of photographers. Self-dramatisation was another trait he developed in boyhood, masquerading in one early self portrait as a Mozartian Don Juan in jabot and powdered wig (cat. 1). Now and then his absorptive relationship with the old masters also took the form of explicit identification. At the height of his youthful obsession with El Greco, when his doodles frequently included gaunt, soulful, bearded men in ruffs and he painted a thorough-going pastiche (cat. 2), a sheet of rapid sketches scattered with heads of this type is inscribed, alongside a self-portrait, 'Yo El Greco, yo Greco, Greco' ('I am El Greco, I am Greco, Greco'; Museu Picasso, Barcelona). Another sketch of Spanish types done in the winter of 1899–1900, when he was making thumbnail copies of the bullfight imagery of Goya (1746–1828), is signed 'Goya' (Museu Picasso, Barcelona). An intriguing late instance of this phenomenon is the roughly executed painting of a bearded man in seventeenth-century costume inscribed on the reverse 'Domenico Theotocopoulos van Rijn da Silva' (fig. 66). We can take this to mean that the picture represents El Greco, Rembrandt and Velázquez rolled into one, and/or that it is a homage to all three, and/or that it is by all three. However one interprets the inscription, it tells us who was in the studio with Picasso at the time and on the front he added the date of execution in giant numbers, '28.3.67', to indicate that all three artist-heroes were alive at that moment as far as he was concerned. Later he added his own signature in much smaller letters beneath the date, only at that point publicly claiming the picture as his own work.[37]

For the spectator, all this cannibalising of 'high' art can be bewildering if not outrageous, especially when the effect is absurd or crude. Picasso had a real gift for caricature, which blossomed when he was still a child, and it facilitated the development of his assertive relationship with the art of the past: the caricaturist does not submit tamely to higher authority.[38] Just as he could pinpoint the defining look of an individual or convincingly evoke a recognisable type, so he could catch the essence of a master's characteristic idiom, using simplification and exaggeration to do so. But although caricature involves ironic or satirical humour, it need not be, and frequently isn't, driven by hostility, and in practice the targets of the majority of Picasso's caricatures were people to whom he was attached by ties of love or friendship; and he did not exempt himself. It is worth remembering this when contemplating the caricatural aspect of the old master variations of his maturity – the inflated size of Velázquez in the first version of *Las Meninas* or the jokey hands and feet of the picnickers in *Luncheon on the Grass* paintings, for instance. Imitation, adaptation, impersonation, elision, travesty, caricature: inasmuch as the commonly used expression 'influenced by'

implies passive acceptance of the source in question it seems inappropriate for Picasso. His own exhortation, 'Greco, Velázquez, INSPIRE ME!' scrawled on an early sheet of drawings sums up much better his position vis-à-vis the art of the past.[39]

Picasso grew up at a time when naturalism was the most popular style in painting and anecdotal genre scenes the most popular subjects. His father saw to it that he learned the rudiments of this potentially lucrative mode at the same time as he acquired all the necessary academic skills in composing history paintings in the grand, classicising manner. When Picasso dropped out of the Academy in Madrid and joined the avant-garde circle centred on Els Quatre Gats (The Four Cats) tavern in Barcelona, he immediately adopted the Catalan version of Art Nouveau known as Modernisme. Although the Modernistes dismissed 'literary' subjects, contemporary or historical, as crassly inartistic, their focus remained primarily on human figures expressing some powerful mood or feeling through body language. Picasso's experience of contemporary French art between the time of his first visit to Paris in October 1900 and April 1904 when he settled in Montmartre reinforced this lesson, while greatly increasing the range of avant-garde styles to which he was exposed. The Lautrecian *Absinthe Drinker* (cat. 7) – expressionistic in style and emotionally involving, but not anecdotal – belongs to this period.

Picasso's formation, in alliance with his voracious visual appetite and obstinate hostility to theorising (already a fixed standpoint in his student days), helps to explain why he was later so stubbornly resistant to pure abstraction when other major artists of his generation were renouncing figuration:

Abstract art is only painting. What about drama?
There is no abstract art. You must always start with something. Afterward you can remove all traces of reality. There's no danger then, anyway, because the idea of the object will have left an indelible mark. It is what started the artist off, excited his ideas, and stirred up his emotions. Ideas and emotions will in the end be prisoners in his work. Whatever they do, they can't escape from the picture.[40]

During the Cubist period Picasso's work occasionally verged on the indecipherable, but even in the more extreme cases there were always minimal indicators of the 'object' which had served as catalyst – strategically placed scraps of descriptive information such as the segments of the half lemon towards the centre of the Cincinnati still life (cat. 17), variations in tone to suggest a light source and the presence of three-dimensional forms (the table leg at bottom right), diagonal lines to suggest spatial depth (the

receding table top on the left), and so on. By such means a link with the still-life tradition was maintained.

The great challenge for Picasso lay in creating 'drama' without resorting to the 'cheap cinema' or – to quote him again – the 'stupid' subjects of old master painting,[41] in compositions involving perhaps only a single figure in a standardised, inactive pose or a few mundane objects arranged on a table. This is where his *musée imaginaire* came to his aid, supplying by proxy what was missing in the banal motif. Take, for instance, *Large Bather* of 1921 (cat. 22): on the face of it the subject is intrinsically inexpressive. As if this were a conventional art-school exercise, the nude model sits on a chair covered in drapery, does nothing and doesn't engage with the spectator. However, her looming monumentality and the chiselled folds of the drapery immediately conjure up memories of ancient Classical sculpture (such as the massive figures from the east pediment of the Parthenon which Picasso had seen in the British Museum during his first visit to London in 1919; fig. 6), and by extension thoughts of the Classical world, of a vanished but great civilisation, of the ruinous effects of time. Thanks to the reference to Antiquity the bather's torpor and apparent introspection seem charged with nostalgia and regret: we sense that the past has overwhelmed her, inducing inertia and disengagement. Given the post-war context, when memorials to the dead were being erected all over Europe, it is tempting to connect the melancholy of *Large Bather* with the trauma of bereavement and the human need to mourn. The allusion to Antiquity and Picasso's 'outdated' neoclassical style function like metaphors, triggering associations that help establish the mood. At the same time they protect the painting from the taint of circumstantial illustration: one can respond empathetically to the emotional tone of *Large Bather* without making that temporal connection to the First World War; it is effectively 'timeless'.

This was almost always Picasso's tactic when reacting to contemporary political events in his work: his response was oblique, not realist in the

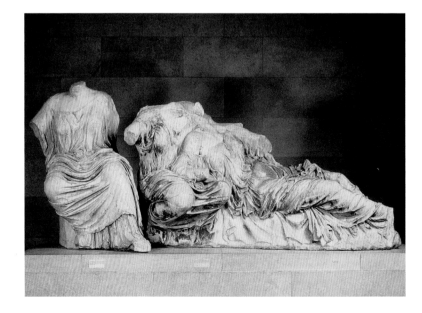

documentary sense, and he relied on imagery rooted In the art of the past. At one level, *Goat's Skull, Bottle and Candle* (Tate, London) is simply a still life in the long tradition of the memento mori, with Zurbarán and Goya among its distinguished antecedents. True, Picasso has given the familiar symbols his own twist: in place of the usual human skull is the skull of a once lusty goat; his candle gutters in the poor man's empty wine bottle, not in the rich man's gleaming candlestick; his ashen palette and cobweb of lines evoke the blanket of dust and the decay of a long-abandoned attic. The picture was painted at the height of Picasso's involvement with the French Communist Party and at another level it is an oblique political statement.[42] The Korean War, which had provoked his major allegorical composition *Massacre in Korea* in January 1951 (fig. 64), also inspired several still lifes with death's heads which precede *Goat's Skull, Bottle and Candle*. The Korean War was surely therefore on Picasso's mind. But the immediate catalyst for the Tate painting was almost certainly the execution of the Greek Communist partisan Nikos Beloyannis on 30 March 1952, only a fortnight or so before the picture was completed. (Picasso had taken a high-profile part in the crusade to save Beloyannis and on the day of his death painted a smaller canvas [*Goat's Skull, Bottle and Candle*, private collection] with exactly the same iconography as the Tate painting.[43]) And for those familiar with his work his use of the grisaille palette and Cubist fragmentation of *Guernica* (fig. 43) hinted strongly that his theme was not death and sacrifice in general, but some specific atrocity. However, by using a long-established pictorial genre and familiar symbolism, and by omitting any obvious reference to these real-life events, Picasso kept his picture in a timeless, universal realm.

In *Nude Woman in a Red Armchair* (cat. 26) he wanted to celebrate youth, natural beauty and sexual passion and he used an entirely different metaphoric language, likening the girl's arms to sprouting seeds and the scrolled arms of the chair to her lover's embrace. The brilliant, flatly applied colours and the sweeping, curvilinear style of drawing intentionally invoke the odalisque paintings of Ingres, enhancing the ambience of languorous sensuality and erotic fantasy and insinuating thoughts of the harem (fig. 46). The picture is invariably discussed in relation to Picasso's passionate extra-marital affair with a young, blond-haired woman called Marie-Thérèse Walter (1909–1977), but it is worth pointing out that, just as *Goat's Skull, Bottle and Candle* does not document the tragic events of spring 1952, so *Nude Woman* is not literally a portrait of her at that moment, July 1932. 'If I do a nude', he told Malraux, 'people ought to think, That's a nude. Not: That's Mrs So-and-So'.[44] The aura of Ingres and of the whole European tradition of voluptuous paintings of naked women serves to raise the painting above the strictly anecdotal

circumstances of Picasso's life, encouraging the spectator to project onto it the cultural associations of that tradition and to respond to the organic metaphors that enrich the banal imagery and establish the lyrically ecstatic mood. A form of dramatisation takes place without recourse to a 'stupid' subject.

Compare *Nude Woman in a Red Armchair* with *Large Bather*, which has the same routine iconography, and Picasso's command of emotional drama through style is immediately apparent. Compare both of them with the sources on which Picasso drew and his independence and inventiveness are exhilarating. It was thanks to his probing wit and competitive spirit that his career-long collaboration with the artists of the past proved so creative.

Notes

1 'Picasso', Arts Council of Great Britain, in association with the Tate Gallery, 6 July to 18 September 1960. Picasso's friend and biographer Roland Penrose curated the show.

2 To mark the occasion of Picasso's 90th birthday on 25 October 1971 a number of his paintings from French public collections were exhibited in the Grande Galerie of the Louvre – an unprecedented honour for a living artist.

3 Penrose 1958, p. 350. Penrose heard the story from Salles. For a slightly different account, see Gilot and Lake 1966, pp. 199–201.

4 For an excellent survey, see Galassi 1996.

5 See Susan G. Galassi's essay in the present catalogue, p. 109.

6 Picasso reported by Michel Georges-Michel. Cited in Ashton 1972, p. 122.

7 Gilot and Lake 1966, p. 201.

8 Picasso reported by Kahnweiler. Ashton 1972, p. 167.

9 Picasso reported by Kahnweiler. Ashton 1972, p. 167.

10 Picasso reported by Kahnweiler. Ashton 1972, p. 167.

11 Picasso reported by Georges-Michel. Ashton 1972, p. 168.

12 Picasso reported by Kahnweiler. Ashton 1972, p. 170.

13 Picasso reported by Kahnweiler. Ashton 1972, p. 36.

14 When speaking to Kahnweiler on 17 November 1949 about his recent trip to Italy, Picasso said that he had 'at last seen the Sistine Chapel' (cited in Madrid 2006, p. 357). But Ernest Ansermet, Enrico Prampolini and Michel Georges-Michel all remembered Picasso's enthusiastic reaction to the frescoes of Michelangelo and Raphael in the Vatican (e.g. Georges-Michel 1923, pp. 63–4).

15 Picasso in conversation with Christian Zervos in 1935. Ashton 1972, p. 10.

16 Many of these reproductions have been deposited in the Archives Picasso, Paris. No complete inventory of Picasso's books was drawn up at the time of his death and they have unfortunately been dispersed.

17 Parmelin 1969, pp. 48–50.

18 See Paris 1998 for all the works donated to the French state, not those that went to Picasso's heirs. *The Procession of the Fatted Ox* is now attributed to an unidentified follower of the Le Nain brothers.

19 Parmelin 1963, p. 77.

20 Parmelin 1969, p. 40.

21 Cowling 2006, p. 105.

22 Ashton 1972, p. 4.

23 Picasso reported by Kahnweiler. Madrid 2006, p. 363.

24 Picasso's *Sabines* series originated in a proposal that he paint a picture inspired by Delacroix's *The Entry of the Crusaders into Constantinople* (1840; Louvre, Paris) for exhibition in the Salon de Mai. But Delacroix's warriors led to thoughts of Poussin and David. (See Parmelin 1969, pp. 49–61.)

25 See B. Baer, 'Seven Years of printmaking: The Theatre and its Limits', in London 1988, pp. 114–16.

26 Malraux 1976, p. 135.

27 The Picasso-Lump relationship is the subject of a charming book by the dog's original owner, the photographer David Douglas Duncan (2006).

28 Picasso reported by Brassaï (1966, p. 182).

29 See the version dated 15 September 1957 (Museu Picasso, Barcelona, inv. MPB 70.460).

30 For a riveting evocation of Picasso's state of mind while he 'wrestled' with Velázquez throughout the summer of 1957, see Parmelin 1963, pp. 227–43.

31 Cowling 2006, p. 172.

32 Notably John Berger (1965, pp. 180 ff.).

33 Letter to Joaquín Bas Gisch dated 3 November 1897. Madrid 2006, p. 350.

34 Richardson 1991, pp. 72–4. The paintings were destroyed in the riots in Barcelona in 1909.

35 See Palau i Fabre 1981 (English edn), p. 137. The visit to Toledo is described by Picasso's friend Francisco Bernareggi Calderón, who remembered that their enthusiasm for El Greco deeply shocked their elders (Madrid 2006, p. 350).

36 During the 'Louvre test' Picasso specifically asked to have his pictures put beside the Zurbarán (see note 3 above.)

37 For a detailed commentary, see José Álvarez Lopera's catalogue entry in Madrid 2006, pp. 336–41. The signature was doubtless added when Picasso sold the painting to the Swiss dealer Siegfried Rosengart.

38 Childhood caricatures include those decorating the handwritten newspapers *La Coruña* and *Azul y Blanco* which Picasso produced in 1894. For a broadly based discussion, see Barcelona 2003.

39 '¡Greco, Velázquez, INSPIRARME!' The drawing was done in 1898 or 1899 (Museu Picasso, Barcelona, inv. MPB 110.747R).

40 Picasso in conversation with Christian Zervos in 1935. Ashton 1972, p. 9.

41 For Picasso's reference to 'cheap cinema', see note 9 above. Speaking of subject matter to Kahnweiler on 18 July 1957, he remarked: 'Besides, all those museum paintings are stupid' (Madrid 2006, pp. 353–4).

42 For a full account of Picasso's political activities at this moment, see Utley 2000, chaps 9, 10.

43 Jean Sutherland Boggs makes the connection with Beloyannis's execution in her entry on *Goat's Skull, Bottle and Candle*, Cleveland 1992, p. 315.

44 Malraux 1976, p. 118.

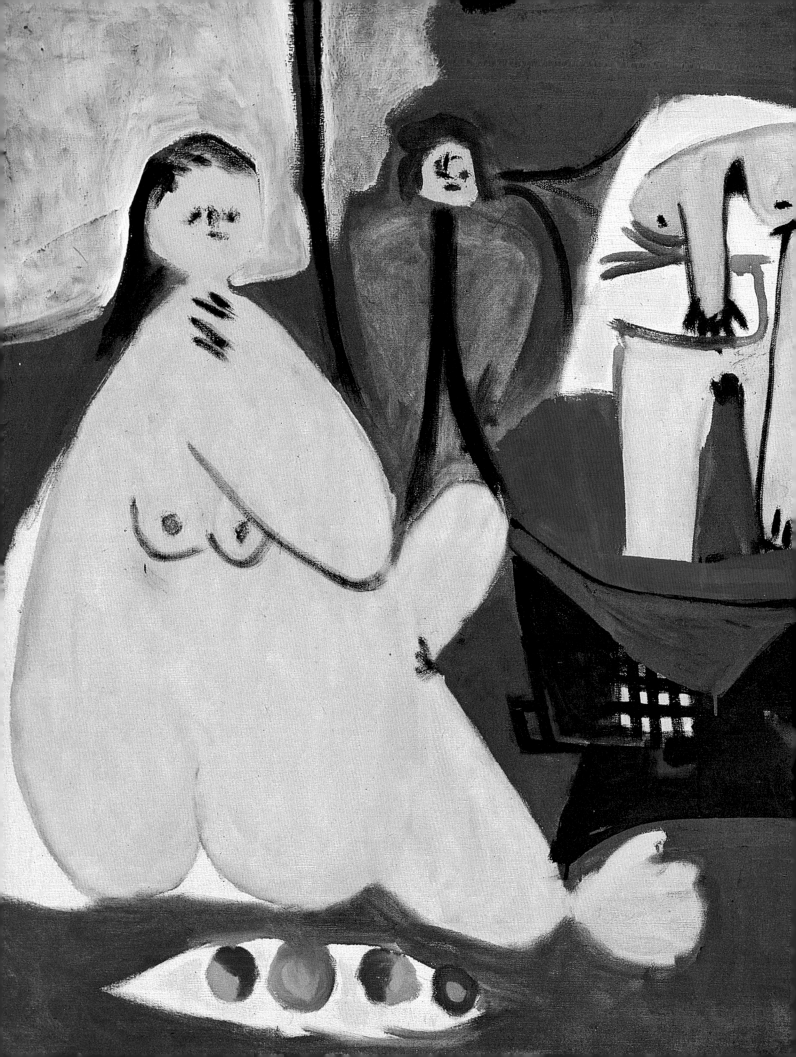

Picasso 1895–1906: 'Each influence transitory, taking flight as soon as caught'

ANNE ROBBINS

Picasso's childhood: 'Je dessinais comme Raphaël'[1]

Born in Malaga in 1881, the eldest of three children, Picasso was a prodigiously talented child who owed his early artistic development to his parents, and particularly his father. Don José Ruíz y Blasco (1841–1913) was a fairly successful animal and flower painter who worked both as drawing professor at the local Escuela Provincial de Bellas Artes and as curator of the municipal museum. Despite the dominant presence in the household of Picasso's mother, Doña María, his father's influence was crucial: he identified his son's extraordinary artistic gifts at a very early age, and nurtured them assiduously. He encouraged the young Picasso to draw the pigeons he himself used as models; doves were to remain a recurrent motif in Picasso's personal imagery for the rest of his life (cat. 5).

Pierre Daix recorded that late in life Picasso would confess his liking for televised images, perhaps noting how far removed these were from the first, static pictures to which he was exposed to as a child. Through his father he would have had easy access to a wide range of images: engraved or photographic reproductions of old master paintings, his father's own copies after them, and Don José's own original – if conventional – works. This tension between tradition and innovation, an awareness of the art of the past and the elaboration of new formulas, was to shape Picasso's approach to art for the rest of his life.

Picasso's eight years of formal art instruction, at three different art schools, began in 1892 with his enrolment in his father's drawing classes at La Coruña's Escuela de Bellas Artes. Having just been appointed professor there – which prompted the whole family to move to Spain's Atlantic coast – Don José kept a close eye on his young son's artistic education, teaching him the well-established practice of drawing from plastercasts after the Antique as well as figure drawing. Impressed by his prodigious ability, Don José had handed over his paint and brushes to his son, and with them his own challenge with painting. Picasso's first-known oil painting, executed before his tenth birthday, was of a bullfight, a favourite subject throughout his life. Under Don José's supervision he later produced conventional yet highly skilled paintings of family, friends and others, dating them after 1894. In that year, as a Christmas present to his son, Don José arranged for a model (a poor girl from the neighbourhood) to sit for him. The resulting painting, *Girl with Bare Feet* (Musée Picasso, Paris),[2] is a striking example of the young Picasso's amazing artistic maturity and emerging personality.

Following the death of Picasso's 7-year-old sister from diphtheria in 1895

the family moved to Barcelona. Here Don José took up a post at the Escuela de Bellas Artes, known as La Lonja (La Llotja in Catalan), again determining the next step in his son's artistic career: in September 1895 Picasso sat the entrance examinations to La Lonja's senior course in classical art and still life, passing them with flying colours. However, the young artist, who had already started exhibiting his work, found the school's teaching uninspiring and felt that he had outgrown what academies had to offer. A visit to Madrid earlier that summer, where for the first time the 13-year-old Picasso visited the Prado, had opened new horizons to him, introducing him to the Spanish masters whose work he had only known hitherto through reproductions. Rigorously trained in the art of looking and copying, here he produced some studies of a jester and dwarf after Velázquez's *Jester Calabacillas* and *Child of Vallecas*.[3]

In Barcelona, where he remained until September 1897, Picasso received his first official recognition: his large, dark, academic painting of 1897, *Science and Charity* (fig. 7),[4] was awarded prizes in both Malaga and Madrid. Still only 16, he was now an acknowledged artist, on course to become a master himself and ready to present himself to the world. He produced relatively few self portraits: one of his first was *Self Portrait with a Wig* of 1897 (cat. 1), in which he wears a Goya-like powdered wig, recalling portraits or self portraits by some of the artists he most revered. Yet the extraordinary poise of the sitter belies the playful masquerade, the masked-ball joke; his imperious glance tells of his confidence and maturity as he experiments with his own image (romantic bohemian, decadent dandy) while playing with others.

Disliking the straitjacket imposed by his teachers, Picasso the student was not afraid to confront them: this desire for destruction and subversion would in due course lead to the most radical innovations in the history of modern art. He later told his friend and collector Gertrude Stein (1874–1946): 'They say that I can draw better than Raphael, and they're probably right; perhaps I even draw better. But if I draw as well as Raphael, I believe that at the very least I have the right to choose my own path, and they should recognise that right'.[5]

From Madrid to Paris, 1897–1901: 'Taking the wrong path'

Encouraged by his recent successes, and on the insistence of his family, in September 1897 Picasso settled in Madrid to study at the prestigious Academia Real de San Fernando. But before long the teaching offered there, of which he was deeply critical, demotivated him and he left a few months later.

Fig. 7
Science and Charity, 1897
Oil on canvas, 197 × 249.5 cm
Museu Picasso, Barcelona

Increasingly aware of the limitations of his own, traditional artistic background and training, he discovered in magazines other styles of painting that were far removed from his own dark and conventionally realistic work, at that time restricted to genre scenes and sacred subjects. Street life in Madrid offered him the opportunity to renew and enlarge his repertoire, while the museum provided him with countless new ways of rethinking his art.

Back in Barcelona from February 1899, but not inclined to resume his art classes, he frequented Els Quatre Gats tavern, a popular bohemian meeting place, particularly of the Modernistes – avant-garde Catalan artists and writers, influenced by foreign *fin-de-siècle* intellectual movements, many of whose ideas developed from Symbolism and Arts and Crafts. The friends Picasso made here would nurture the development of his art, among them painter Carles Casagemas (1880–1901) and the poet Jaime Sabartés (1881–1968). Fêted among this circle for his youthful talent and attracted by its intellectual effervescence, the academically trained prodigy rapidly established himself as a provocateur, enjoying his new status of avant-garde artist. Adopting their style as well as their ideas, Picasso took on the linear and tenebrist manner then in vogue, and looked for inspiration to the work of El Greco recently reappraised and celebrated by Modernistes Ramón Casas (1866–1932) and Santiago Rusiñol (1861–1931). With his predilection for the avant-garde, Picasso had been familiar with El Greco's recently rediscovered work since his period in Madrid; his Madrid friend Pancho later recalled:

> Because Picasso and I copied El Greco in the Prado, people were scandalised and called us Modernistes. We sent our copies to our professor in Barcelona [Picasso's father]. All was well so long as we worked on Velázquez, Goya and the Venetians – but the day we decided to do a copy of El Greco and sent it to him, his reaction was: 'You're taking the wrong path'. That was in 1897, when El Greco was considered a menace.[6]

Don José's reaction exemplifies El Greco's status among the masters of the Spanish school at the time: distinctive and threatening. But his intense, vibrant and highly spiritualised images stimulated Picasso in an unprecedented manner, his fascination sometimes verging on identification, as indicated by the inscription on one of his drawings (see p. 19).[7] His *Face in the Style of El Greco* (autumn or winter 1899; cat. 2), in which a long, pointed and emaciated face emerges from the darkness, alludes to the Cretan's late distorted style (fig. 18) while also reflecting Picasso's own emerging personality in these anonymous features.

He spent the next few months working in Barcelona, mostly as a graphic artist, earning a living by producing ephemera such as posters and menus in the flat, decorative, *fin-de-siècle* style praised by the modernists. An exhibition at Els Quatre Gats in February 1900, comprising some of these drawings and other works on paper, was considered a great success; but for Picasso endorsement only came later that spring, when his large, ambitious painting *Last Moments*[8] was selected for the Spanish Pavilion at the Paris Exposition Universelle, which opened on 14 April 1900. Determined to see his work on display, Picasso travelled to Paris in late September. Here he visited the paintings section of the Exposition, the 'rétrospective centennale', during its last week, and saw a selection of the French painting he had been so eager to view at first hand: David, Ingres and Delacroix, Courbet, Puvis de Chavannes, Manet, Monet, Renoir, Pissarro, Sisley, Cézanne and Degas (fig. 8).

Picasso was to spend the next four years travelling back and forth between the French capital and his native Spain. He and Carles Casagemas explored the Louvre, the Musée du Luxembourg and the renowned galleries of rue Laffitte, as well as experiencing life in the *ville-lumière*, strolling along its boulevards, haunting its cabarets, dance halls and brothels, producing immediate sketches of this exciting new scenery. Catalan art dealer Pere Mañach soon offered Picasso a two-year contract, providing him with a regular income and organising his first exhibition in Paris. Shared with fellow Catalan artist Francisco Iturrino (1864–1924), the show included 64 of Picasso's paintings, and a number of drawings, and opened at Ambroise Vollard's gallery on 24 June 1901 during the artist's second sojourn in Paris.

Picasso's own assessment of the exhibition was that it had had 'some success. Almost all the papers have treated it favourably, which is something'.[9] Poet Max Jacob (1876–1944), introduced to Picasso by Mañach and with whom he was to form an important friendship, later confirmed: 'As soon as he arrived in Paris, [Picasso] had an exhibition at Vollard's, which was a veritable success'; the poet recalled that Picasso 'was accused of imitating Steinlen, Lautrec, Vuillard, van Gogh'.[10] With their subject matter of dissolute demi-mondaines, *The Absinthe Drinker* (cat. 7) and *At the Moulin Rouge (Le divan Japonais)* (cat. 6), both included in Vollard's show,[11] do seem to fuse such French influences.

Picasso had been familiar with the work of Toulouse-Lautrec (1864–1901) long before he arrived in Paris, through reproductions and exhibitions. He had exhibited at Barcelona's Sala Parés gallery in 1896, alongside major contemporary artists and designers such as Théophile Steinlen (1859–1923), Jules Chéret (1836–1932), Jan Toorop (1858–1928), Alphonse Mucha (1860–

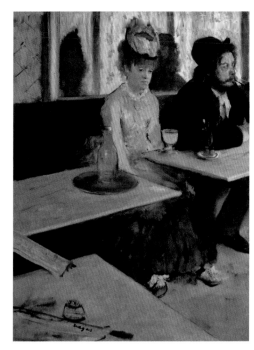

Fig. 8
Hilaire-Germain-Edgar Degas
(1834–1917)
The Absinthe Drinker,
about 1875–6
Oil on canvas, 92 × 68 cm
Musée d'Orsay, Paris

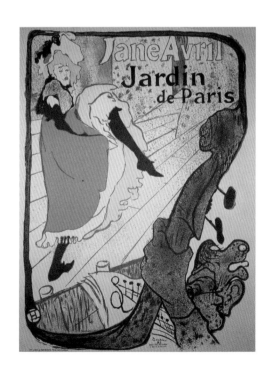

Fig. 9
The Tub, 1901
Oil on canvas, 50.4 × 61.5 cm
The Phillips Collection,
Washington, DC

Fig. 10
Henri de Toulouse-Lautrec
(1864–1901)
Jane Avril, 1893
Colour lithograph,
54 × 40 cm
Private collection

Fig. 11
Henri de Toulouse-Lautrec
(1864–1901)
May Milton, 1895
Colour lithograph,
79.5 × 61 cm
Private collection

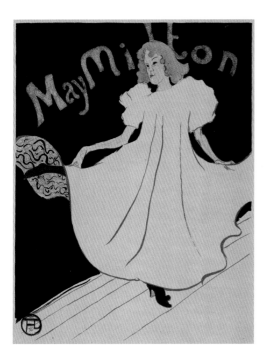

1939) and Edvard Munch (1863–1944). The show attracted particular interest among the 'decadent' circles, impressed by Toulouse-Lautrec's draughtsmanship and handling of vibrant colour, as well as his signature themes of cafés, cabarets and music halls (fig. 19). Picasso's Moulin Rouge dancers, their legs raised in a cancan, are a direct response to Toulouse-Lautrec's famous poster of Jane Avril dancing (1893; fig. 10); Picasso is known to have hung on the walls of his studio on Boulevard de Clichy the Albi painter's poster of May Milton (1895; fig. 11), which appears in the background of *The Tub* (fig. 9).[12] With its spatial construction, Picasso's *Moulin Rouge* perhaps brought van Gogh's *Dance Hall in Arles* (about 1888; Musée d'Orsay) to Max Jacob's mind, its progressive, energetic brushwork also recalling van Gogh's broad and broken strokes, while its bright hues, 'violent tonalities and colours' reminded Picasso's friend Jaime Sabartés 'of the shades of playing cards'.[13]

Vollard's exhibition established Picasso as a promising talent on the Parisian scene; Jacob admitted that 'everyone recognised that he had a fire, a real brilliance, a painter's eye'.[14] Contemporary critic Félicien Fagus perceptively suspected that for Picasso, appropriation of various aesthetic sources had become a style in itself:

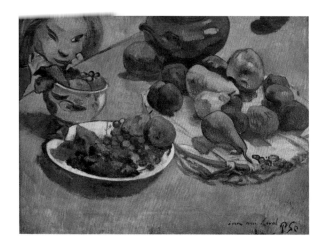

Fig. 12
Paul Gauguin (1848–1903)
Still Life with Fruit, 1888
Oil on canvas, 43 × 58 cm
Pushkin State Museum, Moscow

Fig. 13
Francisco de Goya (1746–1828)
Manuel Osorio Manrique de Zuñiga,
about 1780
Oil on canvas, 127 × 101.6 cm
The Metropolitan Museum of Art,
New York
The Jules Bache Collection, 1949

Besides the great ancestral masters, many likely influences can be distinguished – Delacroix, Manet (everything points to him, whose painting is a little Spanish), Monet, van Gogh, Pissarro, Toulouse-Lautrec, Forain, Rops … Each one a passing phase, taking flight as soon as caught … Picasso's passionate surge forwards has not yet left him the leisure to forge a personal style; his personality is embodied in this hastiness, this youthful impetuous spontaneity…[15]

Dating from Picasso's second stay in Paris (May 1901 to January 1902) are his *Child with a Dove* (cat. 5) and *Still Life (La Desserte)* (fig. 14). The former harks back to the tradition of children's portraits epitomised by 'great ancestral masters' such as Velázquez and Goya (fig. 13), while stylistically and thematically evocative of the work of the Nabis; the latter, his first ambitious still life, displays the same youthful spontaneity adapted to a traditional genre. The remains of a lavish dinner glow seductively from the table. With its abundance of objects and sumptuous colour the picture exudes confidence and vitality. Rather than referring to the Spanish *bodegón* still-life tradition, it recalls the Dutch convention of demonstrating artistic virtuosity by describing objects and textures – in this case the blue glaze of earthenware and the waxy surface of fruit. The still-life paintings of Paul Gauguin (1848–1903), luminous and archaic, were also a powerful source of inspiration, the Breton motifs of the earthenware here alluding to Gauguin's Pont-Aven pictures (fig. 12). The reference to Cézanne (1839–1906) is equally obvious in the vigorous modelling of the fruit and the elaborate arrangement of food and crockery on the table: like him, Picasso focuses here on the definition of volumes and relationships between objects and space.

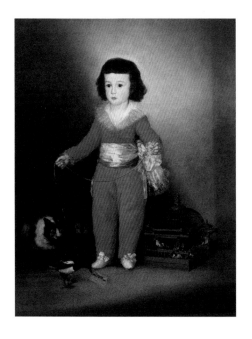

Fig. 14
Still Life (La Desserte), 1901
Oil on canvas, 59 × 78 cm
Museu Picasso de Barcelona

During this period Picasso also tried his hand at self portraiture, depicting himself frontally, staring at himself with particular authority in the *Self Portrait – Yo* (cat. 3). His wild-eyed look evokes Edvard Munch's tense and anxious self images, while the exaggerated staring expression, combined with the provocative, self-assertive title, hint at the work of Gustave Courbet (1819–1877), whose *Rencontre ou Bonjour Monsieur Courbet* (1854; Musée Fabre, Montpellier) Picasso would have seen at the 1900 Paris Exposition Centennale.

No less provocative, the self-assured *Yo Picasso* (1901; private collection) shows the artist depicting himself for the first time in the act of painting, in what looks like a lurid, gas-lit room. Here again he glances back at the masters of the genre, notably Nicolas Poussin, whose remarkable self portrait he had admired at the Louvre.[16] His veneration for Poussin was

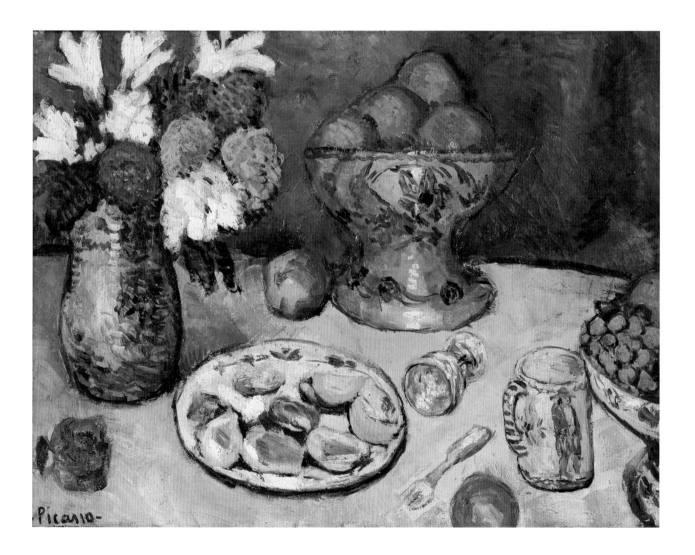

far-reaching: he later joked that what had prompted him to adopt his mother's name (Picasso) rather than his father's (Ruíz) was the former's resemblance to Poussin, also spelt with a double 's'.[17]

The portrait of *Gustave Coquiot* (cat. 4) is another fine psychological study expressing its sitter's inner dilemmas. Critic Coquiot had met Picasso on the occasion of Ambroise Vollard's 1901 show, for which he had written a catalogue preface. The picture's background seems to show the reflection of the cabaret show being watched by Coquiot. The frieze-like composition recalls again the self portraits of Munch or Gauguin;[18] the influence of the latter is also palpable in the primitive, convulsive exotic dancers, their elbows raised and their hips swaying suggestively.

1901–1904: 'La bleue misère'

In the autumn of 1901 Picasso's bright, colour-saturated pictures gave way to new, sober images with a predominantly blue palette. Coquiot acknowledged at least two sources for this new development: 'As he was suddenly enamoured of El Greco, as he placed photographs of this master all around his room, he began his "blue period".'[19] Whether an extension of his ongoing dialogue with the art of El Greco, a derivation from the monochrome reproductive images of the time (films or photographs, often blue)[20] or an expression of his emotional state at that moment (his friend Carles Casagemas had committed suicide just a few months earlier), Picasso's Blue Period was to last until the end of 1904. Depicted in shades of blue, the society outcasts in his paintings – street beggars, prostitutes, the sick – are conferred majesty and grandeur under his brush. Having returned to Barcelona for most of the year 1902, where he saw an exhibition of ancient and medieval Catalan art at the Palau de Bellas Artes, Picasso returned to Paris in October, sharing spartan lodgings with Max Jacob. Despite two exhibitions at the Berthe Weill Gallery in April and November that year, he experienced a brief period of extreme poverty, later described by poet André Salmon (1881–1969) as 'la bleue misère'. Picasso said: 'It was only later when I set about doing blue paintings that things went really badly. This lasted for years.'[21]

More than just a reflection on these days of misery, *La Vie (La Vida)* (Cleveland Museum of Art), painted back in Barcelona in 1903, reflects his existential preoccupations of the time in a complex assemblage of images within images, anticipating his Cubist collages. In the light of Paul Gauguin's recent death, this meditation on the meaning of life takes a particular resonance, recalling Gauguin's masterpiece *Where Do We Come From? What Are We? Where Are We Going?* (1897–8; Museum of Fine Arts, Boston). In

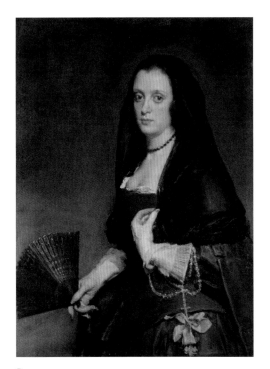

Fig. 15
Diego Velázquez (1599–1660)
Lady with a Fan, about 1640
Oil on canvas, 95 × 70 cm
The Wallace Collection, London

December 1903 he produced a drawing of a standing, Tahitian-like woman (private collection, Germany), which he signed 'Paul Picasso' in tribute to Gauguin.[22]

Returning to Paris in April 1904, Picasso rented lodgings and a studio in the Bateau-Lavoir, on the hill of Montmartre; from now France became his permanent home. In October, an exhibition at the Berthe Weill Gallery of twelve of his works from the three previous years marked the culmination as well as the conclusion of his Blue Period. By the end of the year both his palette and his themes had brightened. Dominated by a new, less monochromatic colour scheme of pink, beige and flesh tones, his new style was described as the Rose Period, a term coined by Gustave Coquiot. Surrounded by his new poet friends Guillaume Apollinaire (1880–1918) and André Salmon, Picasso paid regular visits to the Cirque Médrano, populating his pictures with acrobats, harlequins and clowns, regarding these struggling actors as his own alter-egos. His Rose Period pictures owe no less to the traditions of the past, bearing the footprints of the greatest masters: after seeing the Spanish-themed *Old Musician* (1862; National Gallery of Art, Washington, DC) by Edouard Manet (1832–1883) at the 1905 Salon d'automne, Picasso returned to his large *Family of Saltimbanques* (National Gallery of Art, Washington, DC), begun a year earlier, placing his motionless figures in a flat space, where they appear hieratic and alienated, trapped in silence.

A comparable Spanish flavour, the same stillness and stylisation, can be observed in the 1905–6 *Fernande with a Black Mantilla* (cat. 9). Picasso shrouds his model and mistress Fernande Olivier, who was to lend her features to most of his female figures over subsequent years, in a traditional scarf, hinting at the painting's Spanish sources – Velázquez (fig. 15) and Goya. The portrait's daring treatment, with its expressionistic brushstrokes and subdued palette, and tears of paint trickling down the surface, contributes to its haunting appearance, evocative of El Greco's highly spiritualised visions of an emaciated *mater dolorosa*. Furthermore, as an image of material poverty the picture conveys with extraordinary dignity a sense of Picasso and Fernande's hardship, when in 1905, still 'poor as church mice'[23] despite a recent exhibition of *Saltimbanques* at the Galeries Serrurier, they were 'scrounging the last peseta to pay for the studio or a restaurant'.[24]

1905–6: New Sources, New Directions

In the summer of 1906 Picasso spent a few weeks in the town of Schoorl in the Netherlands at the invitation of his writer friend Tom Schilperoort. Here he was struck by the statuesque beauty of Dutch women, far removed

from the sickly girls and waif-like destitutes haunting his blue and rose canvases. This, together with a visit to the Salon d'automne back in Paris a few months later, prompted a crucial and radical shift in the development of his art.

The large *Combing the Hair* of 1906 (cat. 10) firmly encloses within its frame the imposing figures of two women and a child engaged in a silent exchange. Two large retrospectives held at the Salon d'automne had great impact on Picasso: one of these was devoted to Manet and the other to Ingres, showing for the first time his sulphurous *Turkish Bath* (1852, Louvre), where in the torpid atmosphere of a harem a woman languorously attends to a courtesan's hair. The theme of women at their toilette harks back to a well-established European pictorial tradition with origins in Eastern prints of courtesans and geishas, of which Picasso was well aware. But the discovery of Ingres's masterpiece probably prompted the subject matter of Picasso's painting, which also bears the legacy of Pierre Puvis de Chavannes (1824–1898) in its timeless simplicity. Picasso had seen Puvis's *La Toilette* (1883; Musée d'Orsay) at the 1900 Paris Exposition Universelle, and had copied the left side of his Sainte Geneviève fresco at the Panthéon in Paris.[25]

Room VII of the same 1905 Salon d'automne featured the work of artists soon to be named the Fauves, who created a sensation with their revolutionary use of strident colours – the 'pot of paint thrown at the face of the public'.[26] Picasso was well informed of Matisse's bold experiments through his patrons Leo and Gertrude Stein, who in their weekly salons promoted both of their protégés while encouraging rivalry between them. Although he admired the innovations of Matisse and his companions and was impressed by their liberated, expressive use of colour, Picasso did not use their controversial new techniques, and the subdued palette in *Combing the Hair* is a far cry from the Fauves' unmodulated colours. Pathos and gloom have been erased in favour of greater analysis and simplification of form. The painting's archaic stylisation reflects the ground-breaking impact of African and Iberian sculpture on Picasso's art and makes it a landmark in the understanding of his primitivism. Treating them with planes and angles, Picasso turns the models' faces in *Combing the Hair*, and his own in the *Self Portrait with Palette* (cat. 11), into masks. This process of stylisation and generalisation was initiated by Cézanne, who gave his sitters a mask-like appearance, favouring attention to form over psychological treatment. No longer aiming at producing a likeness, Picasso goes further in the depersonalisation of his models, and fuses Cézanne's influence with that of Romanesque sculpture he had discovered while on holiday at Gósol with Fernande in the summer of 1906.[27]

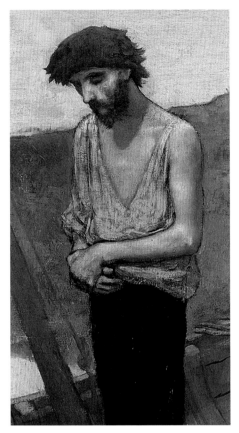

Fig. 16
Pierre Puvis de Chavannes (1824–1898)
The Poor Fisherman, 1881 (detail)
Oil on canvas, 155.5 × 192.5 cm
Musée d'Orsay, Paris

The paintings made at Gósol are characterised by a warm, ochre or clay-coloured palette echoing the colours of the surrounding landscape. A stunning example of this style, the 1906 *Nude with Joined Hands* (cat. 12), encompasses the same rich references as *Combing the Hair*: the figure's distinctly remote and meditative attitude and tightly interlocked hands bring to mind Puvis's *The Poor Fisherman* of 1881 (fig. 16). As the model shyly steps forward her attitude also recalls Antique sources such as the Medici Venus, while her neat contours and mask-like face, with fine but fixed features, bear the influence of Gauguin's own archaic paintings and sculptures. Glowing incandescently, perhaps reflecting the light of summer on the room's red tiles, Fernande's terracotta-coloured body exudes the mystery and gravity of an idol.

Picasso's early work reveals his remarkable ability to fuse his own ideas with elements from the most diverse artists and cultures, a skill he developed further as a mature artist. He later asserted: 'We are heirs to Rembrandt, Velázquez, Cézanne, Matisse. A painter still has a father and a mother, he doesn't come out of nothingness.'[28] Astonishingly complex and uniquely fertile, Picasso's early filiations certainly engendered a multifaceted yet fiercely individual oeuvre, containing the seeds of the very foundations of modern art.

Notes

1 Penrose 1958, p. 361.
2 *La Fillette aux Pieds Nus*, 1895, Musée Picasso, Paris, inv. MP2.
3 Both studies are in the Museu Picasso, Barcelona (inv. MPB 111.170 and MPB 111.172R respectively).
4 Museu Picasso, Barcelona, inv. MPB 110.046.
5 'Ils disent que je peux dessiner mieux que Raphaël et probablement ils ont raison ; peut-être que je dessine mieux. Mais si je dessine aussi bien que Raphaël, je crois que j'ai au moins le droit de choisir mon chemin et ils doivent me reconnaître ce droit.' Stein 1938, p. 61.
6 Diego Pro, *Conversaciones con Bernareggi*, Tucumán 1949, p. 21, quoted in Richardson 1991, pp. 94–5. Picasso had befriended Francisco Bernareggi or 'Pancho', from Argentina, at La Lonja.
7 Museu Picasso, Barcelona, inv. MPB 110.678.
8 The painting, thought to be lost, was discovered through x-rays underneath another work by Picasso, *La Vie*, 1903, Cleveland Museum of Art, Ohio.
9 McCully 1981, p. 35.

10 McCully 1981, p. 37.
11 Nos 10 and 11 respectively at the 1901 Vollard show. Cf. Palau i Fabre 1981, p. 248.
12 With *Le Tub* Picasso pays tribute to Toulouse-Lautrec, who had died in September 1901.
13 Daix 1993, p. 154.
14 McCully 1981, p. 37.
15 Félicien Fagus, '*Gazette d'Art*: "L'Invasion Espagnole: Picasso"', in *La Revue Blanche*, 15 July 1901, pp. 464–5, quoted in Richardson 1991, p. 199.
16 Pierre Daix recalls that Picasso once told him in front of a reproduction of *Yo Picasso*, 'In Paris I immediately went to the Louvre. I saw the Poussins' ('A Paris, je suis tout de suite allé au Louvre. J'ai vu les Poussin'). Pierre Daix, 'Picasso et la tradition française, un historique', in Paris 2008.
17 Washington, DC, and Boston 1997, p. 21.
18 Edvard Munch, *Self Portrait Beneath Woman's Mask* (1891–2; Munch Museum, Oslo); Paul Gauguin, *Autoportrait au Christ Jaune* (1889–90; Musée d'Orsay, Paris).
19 'Comme il s'est épris soudainement du Greco, qu'il a placé les photographies de ce maître

tout autour de sa chambre, il innove la "période bleue"'. Gustave Coquiot on the 1901 Vollard show, in 'Cubistes, futuristes, passéistes: Essai sur la jeune peinture et la jeune sculpture', Paris 1914, p. 135. 'La bleue misère' is taken from A. Salmon, *Souvenirs sans Fin: Première Epoque (1903–1908)*, Paris 1955, p. 170.
20 See A. Baldassari, Paris 2008, p. 26.
21 Daix 1993, p. 154.
22 See C. Zervos, *Pablo Picasso* (catalogue raisonné), 33 vols., Paris 1932–78, vol. VI, p. 564.
23 Otto van Rees (a Dutch artist living at the Bateau-Lavoir), quoted in Richardson 1991, p. 376.
24 McCully 1981, p. 51.
25 Drawing in Museu Picasso, Barcelona, inv. MPB 110.468.
26 Camille Mauclair quoted in R.T. Clement, *Les Fauves: A Sourcebook*, Westport, CT, 1994, p. XII
27 Daix and Boudaille 1966.
28 Madrid 1973, p. 154.

Fig. 17
Francisco de Goya (1746–1828)
King Charles IV of Spain, 1800
Oil on canvas, 74 × 60 cm
Museo del Prado, Madrid

Cat. 1
Self Portrait with a Wig, 1897
Oil on canvas, 55.8 × 46 cm
Museu Picasso, Barcelona
(MPB 110.053)

39

Fig. 18
El Greco (1541–1614)
Portrait of a Man, about 1590–1600
Oil on canvas, 52.7 × 46.7 cm
The Metropolitan Museum of Art,
New York
Purchase, Joseph Pulitzer Bequest, 1924

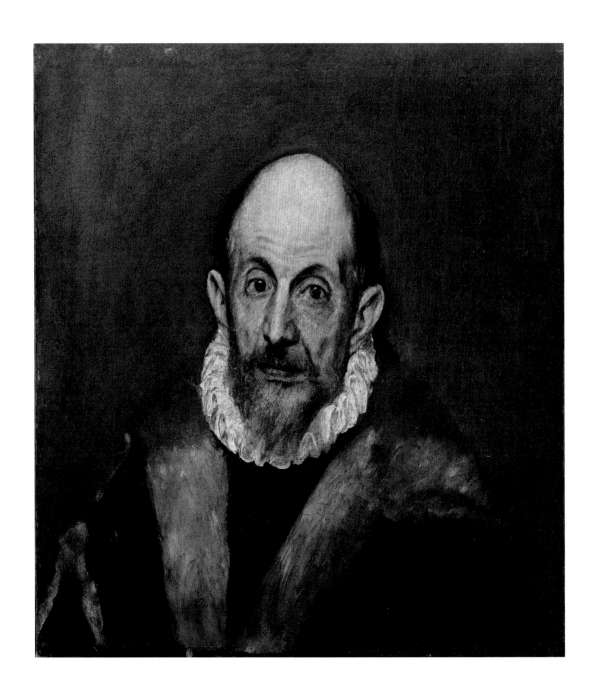

Cat. 2
Face in the Style of El Greco,
1899
Oil on canvas, 34.7 × 31.2 cm
Museu Picasso, Barcelona
(MPB 110.034)

41

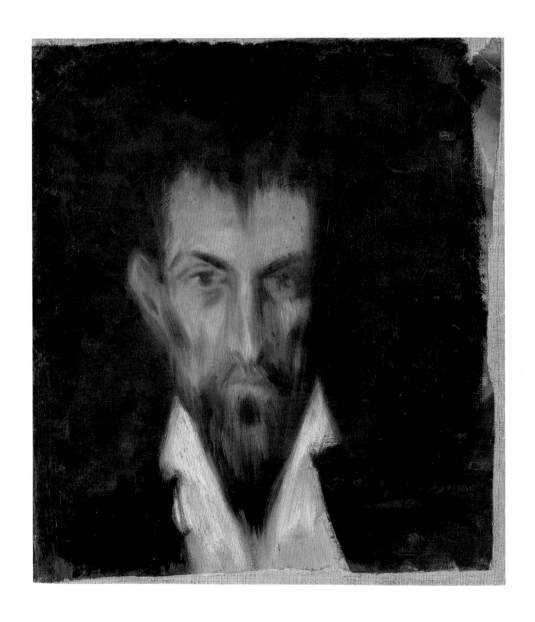

Cat. 3
Self Portrait – Yo, 1901
Oil on cardboard, 54 × 31.8 cm
The Museum of Modern Art (MoMA),
New York
Mrs John Hay Whitney Bequest
(587.1998)

Cat. 4
Gustave Coquiot, 1901
Oil on canvas, 100 × 81 cm
Centre Georges Pompidou, Paris,
Musée national d'art moderne /
Centre de création industrielle
Gift of Mme Gustave Coquiot 1933
(JP652P)

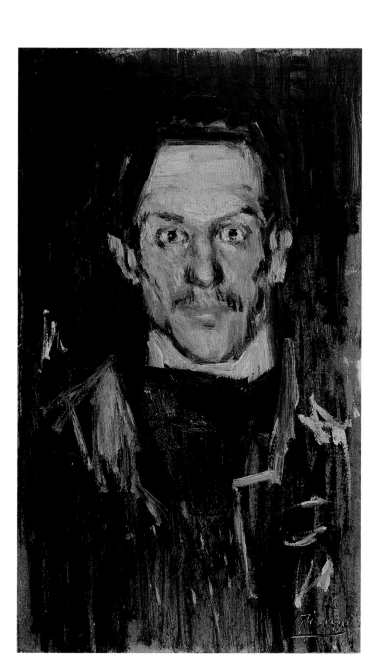

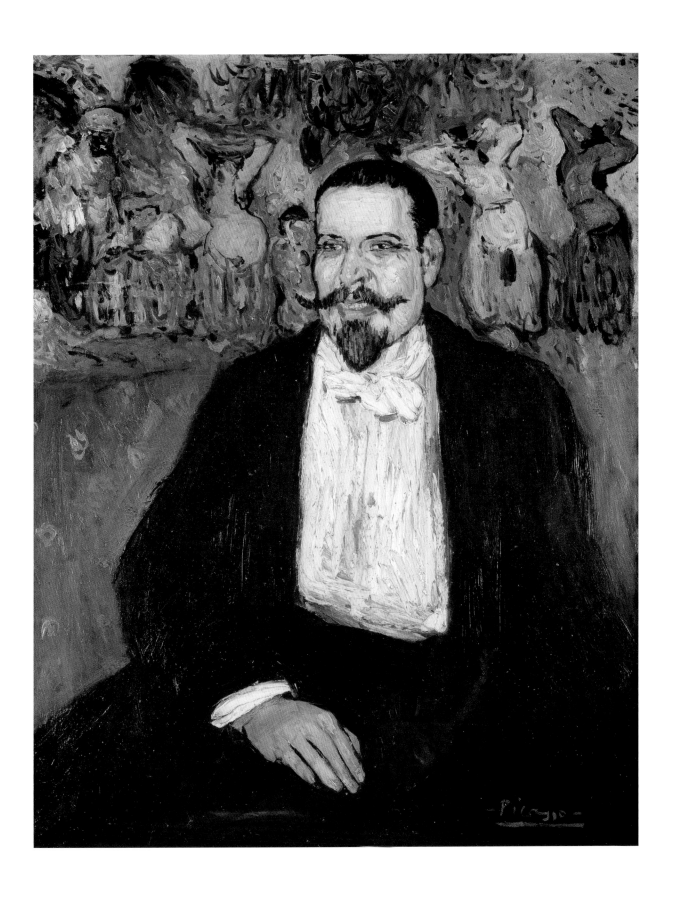

Cat. 5
Child with a Dove, 1901
Oil on canvas, 73 × 54 cm
The National Gallery, London,
on loan from a private collection

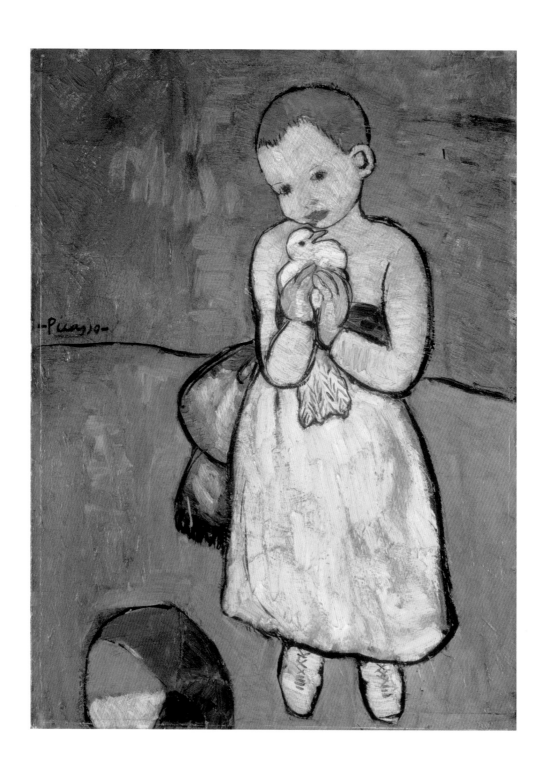

Cat. 6
**At the Moulin Rouge
(Le Divan Japonais)**, 1901
Oil on board laid down on
cradled panel, 69.5 × 53.7 cm
Private collection

45

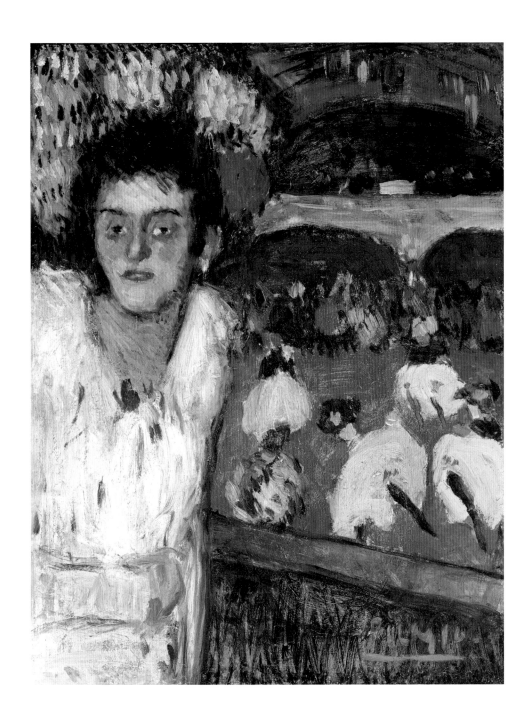

Fig. 19
Henri de Toulouse-Lautrec (1864–1901)
Messalina, 1900
Oil on canvas, 92.5 × 68 cm
Stiftung Sammlung E.G.Bührle, Zurich

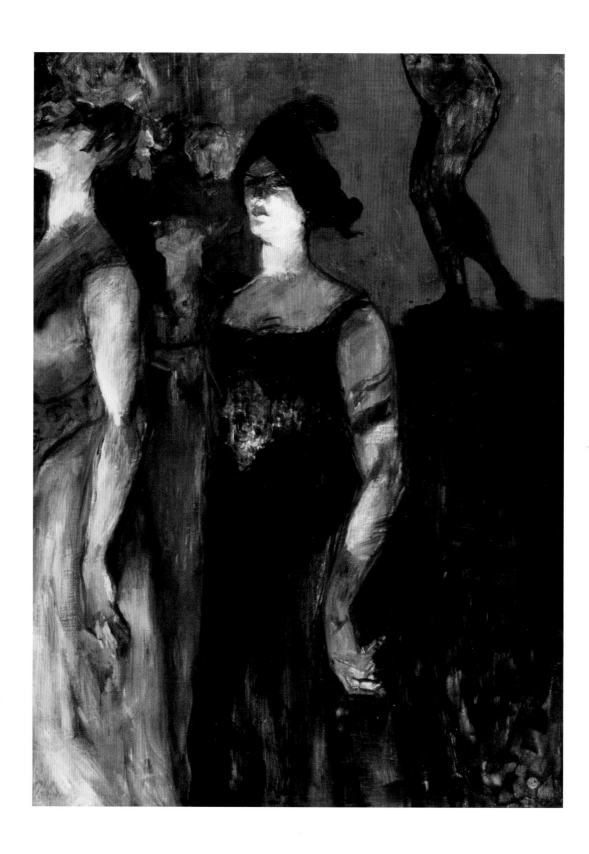

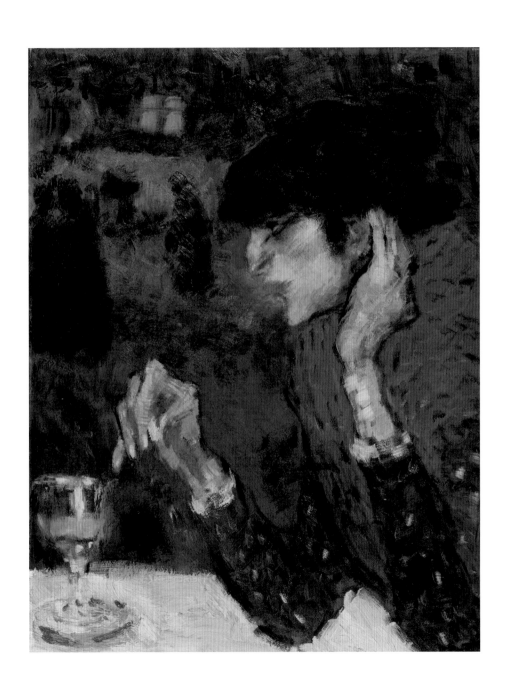

Cat. 8
Girl in a Chemise, about 1905
Oil on canvas, 72.7 × 60 cm
Tate, London (N04720)

Cat. 9
Fernande with a Black Mantilla, 1905–6
Oil on canvas, 100 × 81 cm
Solomon R. Guggenheim Museum, New York.
Thannhauser Collection, Bequest Hilde Thannhauser, 1991 (91. 3914)

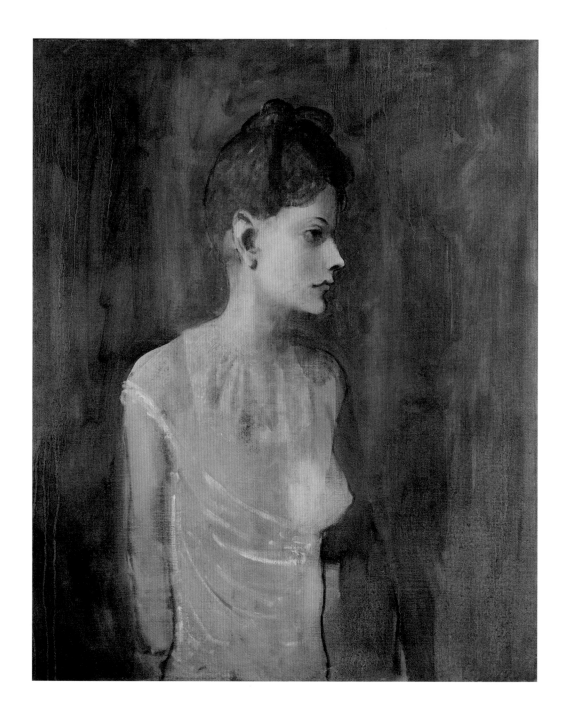

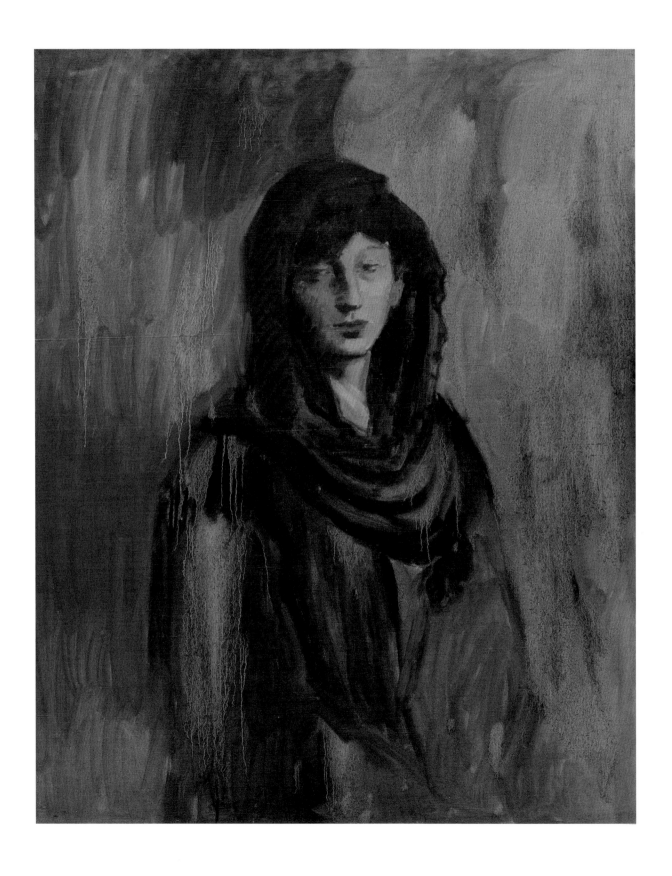

Cat. 10
Combing the Hair, 1906
Oil on canvas, 174.9 × 99.7 cm
The Metropolitan Museum of Art,
New York
Catherine Lorillard Wolfe Collection,
Wolfe Fund, 1951; acquired from
The Museum of Modern Art,
Anonymous Gift (53.140.3)

Fig. 20
Titian (active about 1506–1576)
Venus Anadyomene, 1520–5
Oil on canvas, 74 × 56.2 cm
The National Gallery of
Scotland, Edinburgh

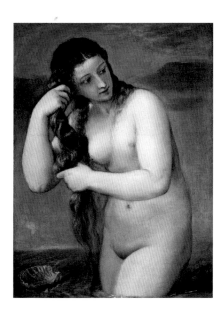

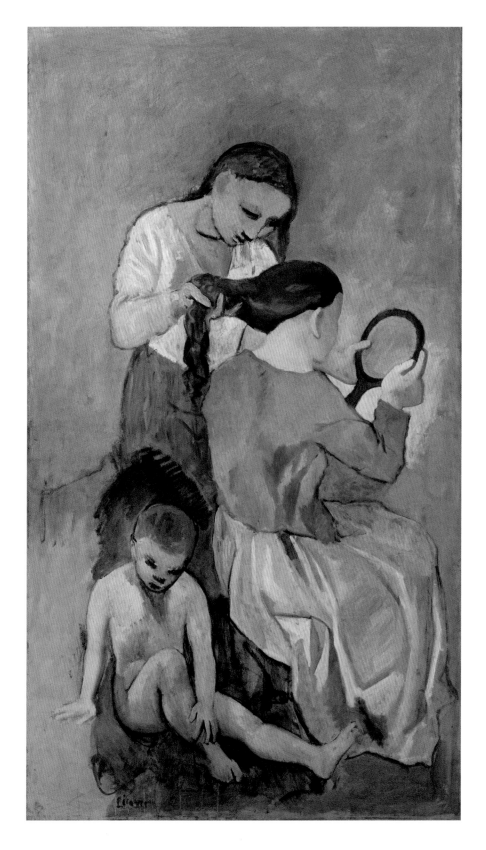

Cat. 11
Self Portrait with Palette, 1906
Oil on canvas, 92 × 73 cm
Philadelphia Museum of Art,
Pennsylvania
A.E. Gallatin Collection 1950
(1950-1-1)

51

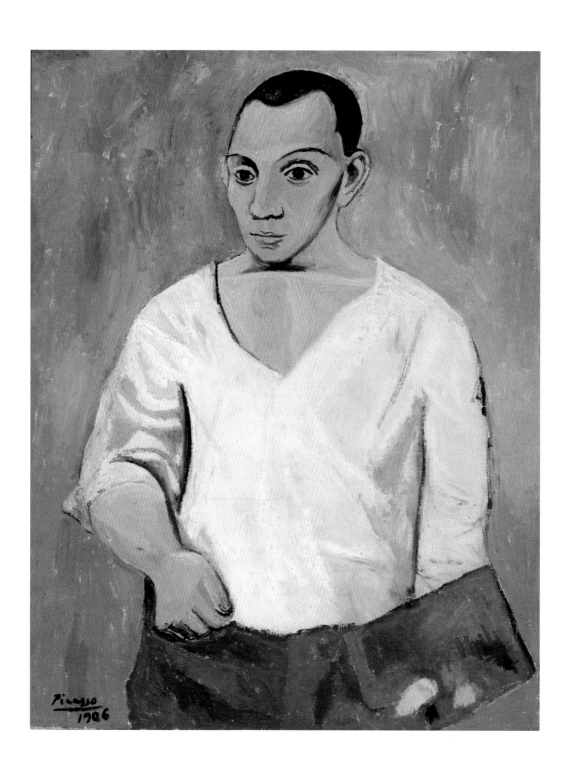

Fig. 21
Paul Cézanne
(1839–1906)
**Madame Cézanne in
a Yellow Chair**, 1888–90
Oil on canvas, 80.9 × 64.9 cm
The Art Institute of
Chicago, Illinois

Fig. 22
Paul Gauguin
(1848–1903)
Oviri, 1894
Clay, 75 × 19 × 27 cm
Musée d'Orsay, Paris

Cat. 12
Nude with Joined Hands, 1906
Oil on canvas, 153.7 × 94.3 cm
The Museum of Modern Art
(MoMA), New York
The William S. Paley Collection
(SPC27.1990)

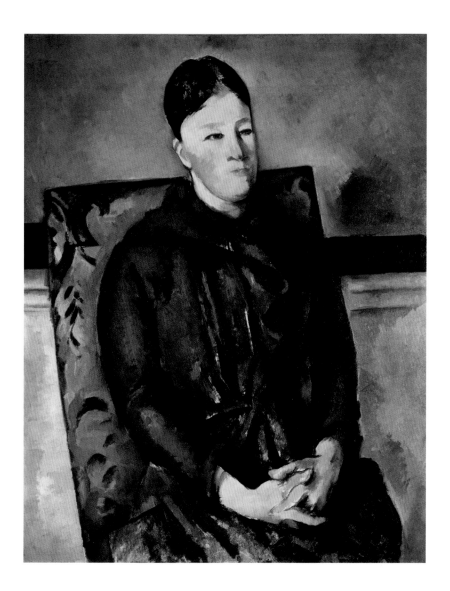

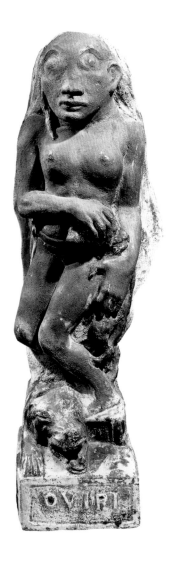

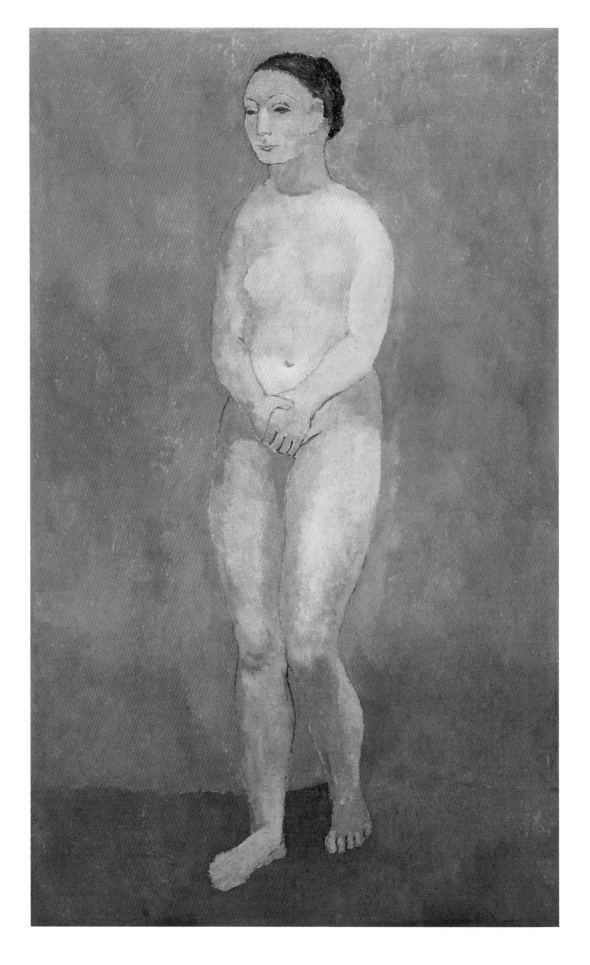

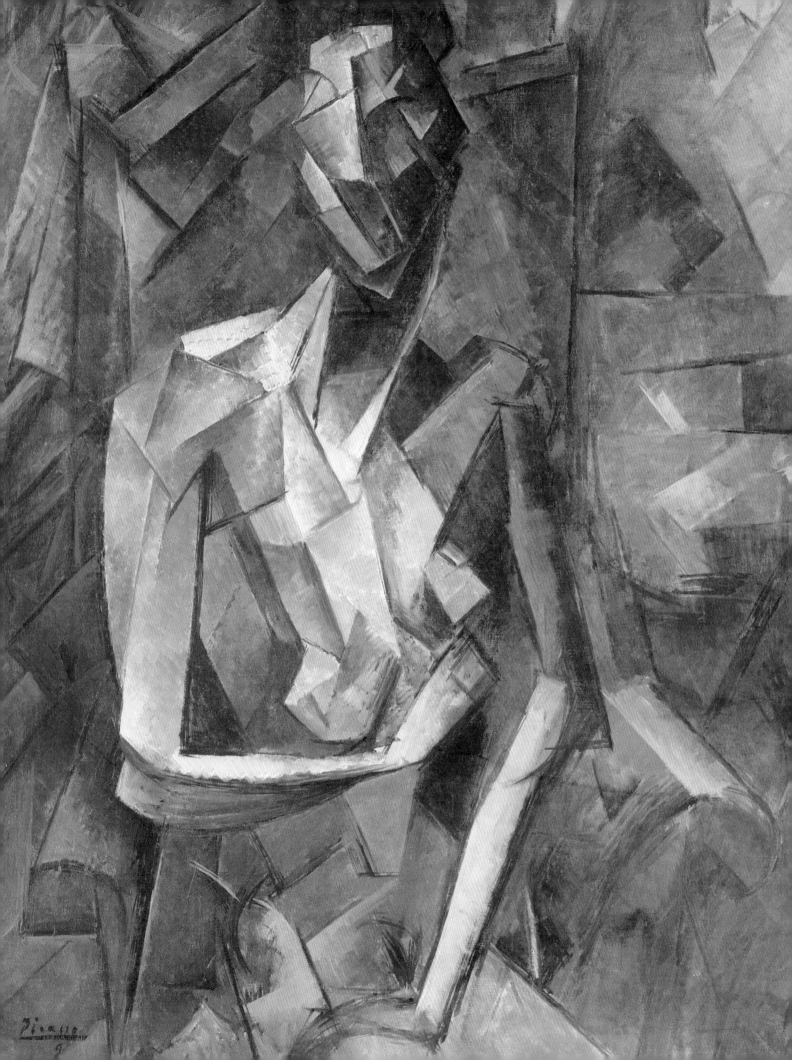

A recent, exhaustive chronology of Picasso's Cubism locates the beginnings of the artist's epic endeavours to the autumn of 1905.[1] It was then that he began work on the portrait of his American patron, the writer and collector Gertrude Stein (fig. 23). The portrait required some ninety sittings, but Picasso remained dissatisfied. In the early months of 1906 he erased Stein's face from the canvas – '"I can't see you any longer when I look", he said irritably'[2] – and, with the sitter no longer present, repainted it from memory. There was nothing radical in that: nineteenth-century academic art theory encouraged painters to work from memory as a way of paring down visual experience to its fundamental components. A portrait was not a snapshot but a series of observations rigorously edited to arrive at the expression of a sitter's essential nature.

Nor was Stein's forthright, seated pose, right elbow on lap, left hand on hip, in any way exceptional, merely unusual for a woman. It derives from an impeccable source in the French academic tradition, J.A.D. Ingres's monumental *Portrait of Monsieur Louis-François Bertin* of 1832 (fig. 24). It has been suggested that in the first version of the portrait, before erasure, Stein might well have been making direct eye contact with the viewer, just as Bertin does.[3] Academically trained, it is not surprising that Picasso should have turned for direction to a master of the genre. Ingres's portrait itself echoes precedents in David and Rembrandt and Raphael. Indeed, the Stein portrait would initiate what has been called a period of 'rivalry' with Ingres – and by extension with those masters he in turn emulated – as, in a series of paintings and sketches, Picasso plumbed the secrets of an admired predecessor who matched technical perfection with unfettered compositional

Something Else Entirely: Picasso and Cubism 1906–1922

CHRISTOPHER RIOPELLE

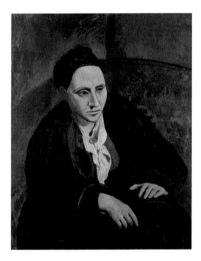

Fig. 23
Portrait of Gertrude Stein, 1906
Oil on canvas, 99.6 × 81.3 cm
The Metropolitan Museum of Art,
New York
Bequest of Gertrude Stein, 1946

Fig. 24
Jean-Auguste-Dominique Ingres
(1780–1867)
**Portrait of Monsieur
Louis-François Bertin**, 1832
Oil on canvas, 116 × 95 cm
Musée du Louvre, Paris

inventiveness.[4] Picasso was an instinctive master of caricature as well, and the humour inherent in transposing the brash and opinionated French newspaper mogul and champion of liberal causes into the earnest and equally verbose female exponent of all things avant-garde would not have been lost on him.

Much about the Stein portrait reveals the 24-year-old Picasso to have been a brash newcomer playing confidently with conventions of portraiture passed down to him by the tradition in which he had been raised. Stein, for her part, was in on the game. Announcing to Picasso her arrival at his studio for yet another sitting, in March 1906 she sent a picture postcard illustrated with Holbein's stolid, plain, seated *Portrait of his Wife and Two Children* (Kunstmuseum, Basle), a visual pun drawn from the portrait tradition on the work which waited in obstinate incompleteness on Picasso's easel.[5] On the other hand, when he came to repaint Stein's features Picasso made it clear he was also prepared to break decisively with the conventions of representation as they had existed in the European tradition for centuries. Now, Stein's face becomes mask-like, radically simplified, a series of facets and planes modelled in paint. Her two eyes, differing in scale and independent in the directions of their gaze, are set into lozenge-shaped frames seemingly carved in stone. Suddenly, the visage takes on characteristics of the African masks and archaic Iberian sculptures of about 500–400 BC which Picasso recently had taken to studying.[6] Henceforth, he would seek direction for his art outside the Western canon. The fracturing of forms on canvas, the shattering of assumptions about how representation works, would become a new, sovereign imperative in his picture making. Much of the drama of Stein's great portrait resides in the tension Picasso creates on canvas, and declines to resolve, between the sanctioned modes and motifs of the portrait tradition and alien interventions of the most daunting strangeness.

In the coming months and years Picasso would push ahead ever more audaciously with his experiments. He would depict figures and objects in terms of a distinctive Cubist vocabulary of angled planes he henceforth developed with relentless determination. He would bring to bear a range of aesthetic allusions far outside the Western canon. At the same time, he set about fashioning a self-consciously brusque and unresolved manner of handling paint; painterly 'finish' too – for Ingres, all but a fetish – would be called into question. The young master's hypnotically staring *Self Portrait* of 1907 (Národní Galerie, Prague), executed in an almost slapdash manner, eyes, nose, hatchet-like head exaggerated to breaking point, has been characterised as his attempt, using his own distinctive features, at 'verifying his ability to carry through the assault on tradition he had already begun' with the Stein portrayal.[7]

But from the beginning of his Cubist adventure Picasso understood one imperative fact: the assault on tradition represented by Cubism communicated itself most powerfully, was most fully provocative, when the lineaments of that tradition were still to be seen in it. Robert Rosenblum once called Ingres's *Monsieur Bertin* the 'ghost' that inhabits the *Portrait of Gertude Stein*.[8] Similarly, the European painting tradition lurks within Cubism: however far Picasso went in his experimentations, however novel the primitive and archaic sources on which he drew, however difficult it would become for a time for viewers to *see* Cubist subject matter amid the unfamiliar faceted planes and rugged facture, Picasso always worked with a repertoire of themes and motifs – the portrait, the still life, the nude – which were of long lineage in the European representational tradition. He meant us to know that the tradition was still in play. Half a century ago Rosenblum revolutionised Cubist studies by insisting that we attend to the content of Cubist paintings.[9] Picasso was making choices about what he represented as well as how, and our understanding of the works oscillates between those poles. While Cubism broke with the past, it nonetheless represented a renewal of painting traditions, an exponential expansion of their potential for the contemporary world, reinvigorated by their brush with raw, new modes of picture making.

In the early years of the twentieth century Picasso had been drawn to multi-figure compositions, often highly colourful and increasingly stylised, which examined the world of the circus and of downtrodden, undernourished itinerant performers; nude horsemen by the sea; allegorical compositions on themes of life, love and death. Intense emotion ruled his visual imagination; pain, suffering and suicide were constantly at hand. So too was the Classical world of the Mediterranean. He saw himself as a history painter ready to compete with the most ambitious Salon artists in the scale and expressive intensity of his work. As he began to focus his attention on the formal problems thrown up by the use of faceted planes and archaic and primitive aesthetic sources, he continued to think in terms of monumental multi-figure painting, but the emotional intensity was redirected into formal experimentation. For a while colour drained from his canvases as well, as he increasingly explored motifs in terms of grey and brown and ochre pigments. The *Demoiselles d'Avignon* of 1907 (fig. 25), his first great statement in a Cubist vocabulary, is set in a brothel where intensity of emotion is hardly the issue. Rather, Picasso slowly evolved a world of weird, confrontational figures like totems and tribal masks, where some kind of raw and primal exchange is under way. It is unlike anything previously seen in Western painting and Picasso would work out the full range of its implications for art for years to come.

Fig. 25
Les Demoiselles d'Avignon, 1907
Oil on canvas, 243.9 × 233.7 cm
The Museum of Modern Art (MoMA),
New York.
Acquired through the Lillie P. Bliss
Bequest

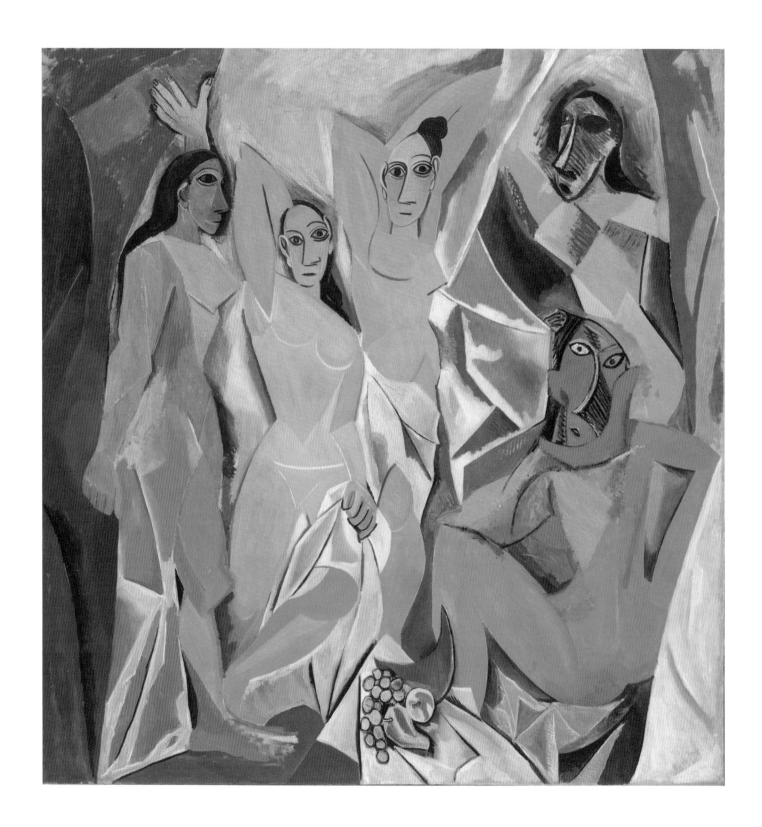

Fig. 26
Paul Cézanne
(1839–1906)
Bathers, about 1894–1905
Oil on canvas
127.2 × 196.1 cm
The National Gallery,
London

Fig. 27
Bather, 1908–9
Oil on canvas,
129.8 × 96.8 cm
The Museum of
Modern Art (MoMA),
New York.
Louise Reinhardt
Smith Bequest

That great canvas achieved, Picasso turned increasingly to smaller-scale paintings on more intimate themes. At the same time, he and Georges Braque (1882–1963), with whom he was in constant communication on the new direction their art was taking, were increasingly intrigued by the art of Paul Cézanne, the subject a year after his death of a major retrospective exhibition in Paris, at the Salon d'automne of 1907. Working in taciturn isolation for many years in distant Provence, Cézanne had evolved a mode of picture making dependent on the independent brush stroke and a careful and continuous balancing of forms on the canvas. His example seemed to show Picasso and Braque a way forward. Time and again, especially in the early phases of Cubism, he was at the forefront of their efforts. A work such as Picasso's standing *Bather* of 1908–9 (fig. 27) owes an evident debt to Cézanne's *Bathers* (fig. 26). They had been a constant theme of Cézanne's art; in his later works, however, they initiated a rupture with conventions of representation, generating their own internal compositional logic on the canvas, free from the constraints of physiological verisimilitude. Picasso understood the implications of Cézanne's struggle. In the younger artist's work, each bodily detail – buttocks, breasts, enormously swollen back, arms and elbows – has become exaggerated, and takes on an enhanced pictorial prominence. The solitary figure stands, colossus-like, in proud isolation from the summarily indicated seaside landscape she inhabits. She, too, is a totem but the ferocity of the *Demoiselles* is softened here by a sense of that classical serenity and communion with nature with which Cézanne invested

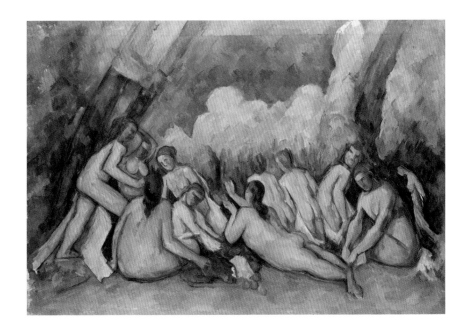

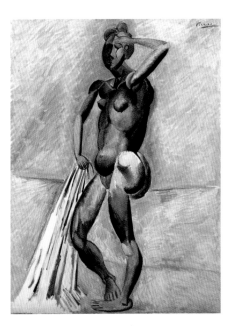

his bathing women. Picasso would go on to own a watercolour and three oil paintings by Cézanne, one of them a multi-figure *Bathers* scene.[10] Throughout his career he would return repeatedly to that benign vision of triumphal, unselfconscious nudity, inspired by Cézanne, when he depicted a favourite theme associated in his mind with personal freedom and urgent sexual allure, women by the sea.[11]

Picasso's *Seated Nude* of spring 1909–10 (cat. 13) is an altogether less visually compelling image, at least at first glance, and far more difficult to interpret. Colour is uniformly sombre. The figure hardly seems to detach itself from the ground as the whole canvas is covered in a more or less consistent grid of small-scale facets and planes. They confer on the composition a monochromatic uniformity close to monotony in which the human presence that is its ostensible subject has been subsumed into a relentlessly modernist and withholding patterning. And yet art historians Cooper and Tinterow have called attention to how very traditional an image it is.[12] Slowly, with closer inspection, the woman's elegantly raised right arm comes into focus, and along with it the demure turn of her head. It is clear that Picasso has used the play of light to pick out the nude form carefully – note the light that falls along the right shoulder and arm and dapples the ovoid head – and to situate it in a fully formed and consistent three-dimensional space. She remains a sculptural presence on the canvas. The rules of perspectival recession are still acknowledged as well: the arms of the chair recede in space but remain distinct from the faceted walls of the room behind. A work such as this makes clear Picasso's faultless grasp of classic European traditions of representation, the better to subvert them.

Only a few months before Picasso painted *Seated Nude*, the 1909 Salon d'automne had devoted an exhibition to the figure paintings of Camille Corot (1796–1875), including numerous austere and grand seated women, many of them painted in muted, earthen tones. Picasso paid attention at the time and here he analyses Corot's art in terms of his own severe aesthetic criteria. He asks us to look until we find the nude female, and behind her to discern the long tradition of nude representation from which, like a form in space, she has emerged over time. Even years later, when he visited Rome for the first time with the Ballets Russes in 1917, by which time rich colour and a renewed monumentality had returned to his art, Picasso saw the Eternal City through Corot's eyes. Jean Cocteau (1889–1963) reports that Picasso spoke of no one else while there and compared the 'grandiose' art of the Italians unfavourably with the simple and immediate painting of the humble French master.[13] His monumental *Italian Woman* of that year (fig. 29), a large-scale composition showing a woman in traditional Italian

Fig. 28
Jean-Baptiste-Camille Corot
(1796–1875)
The Italian Woman, Maria di Sorre,
1825–8
Oil on card, 26 × 18 cm
Musée Picasso, Paris

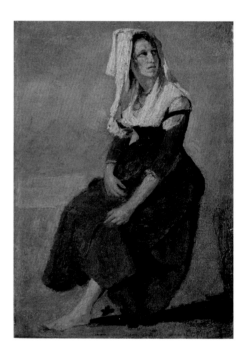

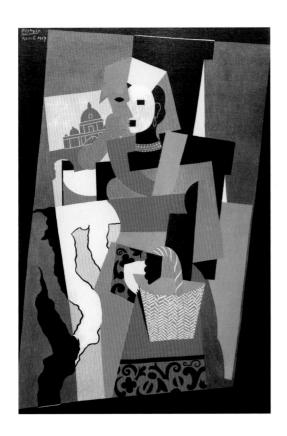

Fig. 29
The Italian Woman, 1917
Oil on canvas, 149 × 101 cm
Stiftung Sammlung E.G. Bührle, Zurich

peasant costume set against the monuments of Rome, is painted in Picasso's richly patterned Synthetic Cubist manner. (The term Synthetic Cubism refers to a later period of Cubism when Picasso felt confident about introducing flat patterning and bright colours in his canvases.) It harks back directly, however, to Corot's small-scale depictions of Italian peasant women, such as *The Italian Woman, Maria di Sorre* (fig. 28), an oil on card of about 1825–8 which an admiring Picasso would later own.

Still-life painting was of particular importance to Picasso throughout the Cubist years. Many of his most far-reaching formal experiments involved the depiction of pottery, foodstuffs and game arrayed on table tops. It was here that his deep knowledge of specifically Spanish still-life practice, characterised by simplicity, directness and intense realism – the *bodegón* tradition – joined forces with his growing understanding of French still-life painting which had its austere side but which also, in the work of an artist like Chardin, celebrated artifice, opulence and rich surface decoration. Chardin was as alive to him as Zurbarán and Goya. A third factor in the still-life equation was contemporaneity. Here, Picasso took delight in depicting fragments of a resolutely modern world, including daily newspapers and their headlines, advertising and product logos and myriad topical allusions, both public and personal.[14] He was free to arrange and rearrange such inanimate motifs, and to build up the range of references to the wider world, making of such images so many reports on quotidian Paris life and on his waxing or waning love affairs. Without losing their tangible corporeality and connections to the real world, they also gave scope to his formal manipulations and deliriously inventive sense of visual play. Further, they allowed him to express aesthetic allegiances. The melon-shaped *chapeau* that dominates *Still Life with Hat* of 1908–9 (private collection) surely alludes to Cézanne, who often depicted himself wearing such a hat and whose own triumphantly complex still lifes served as a provocation to Picasso. Also suggestive of the workings of his imagination are the number of Picasso's still lifes which began as, or metamorphosed from, figure studies, as in the great *Table with Loaves and Bowl of Fruit* of 1908–9 (Kunstmuseum, Basle), which had its origins in sketches for a multi-figure group gathered around a table, or are painted over such figures, as in the *Vase, Two Bowls, Compote and Lemon* of summer 1908 (Philadelphia Museum of Art).[15] The ambiguity between animate and inanimate objects, between the quick and the dead, was always an area of aesthetic delight and mystery for the artist.

Still Life with Glass and Lemon of 1910 (cat. 17) is exemplary of Picasso's Analytic Cubist endeavours. (Analytic Cubism refers to the first, richly experimental period of Cubism when Picasso and Braque, experimenting with a

new formal vocabulary of facets and angles, tended to suppress colour in their work as they concentrated on a complicated new manner of depicting objects in space.) Its carefully modulated play of browns and beiges and blacks, the sense of form congealing at the centre of the canvas while dissipating towards its edges which gives to the work its intense plasticity, the implication of rigorous, almost mathematical control in Picasso's strict ordering of faceted forms, all invest the canvas with something like inevitability. It was towards this kind of high and convincing resolution that he had been working by this time for some four years of untrammelled creativity. But pictorial tension nowhere slackens. Gertrude Stein might have been thinking of it when she wrote of the irresolvable ambiguities of Cubism that it was 'a solid thing, a charming thing, a lovely thing, a perplexing thing, a disconcerting thing … a repellent thing, a very pretty thing'.[16] Some four years later still, with *Fruit Dish, Bottle and Violin* of 1914 (cat. 16), Picasso felt prepared to reintroduce colour and pattern to his canvas, not to mention sand as well, which is worked into the paint surface, and planes composed of enough dots of pigment to do a Seurat proud. Moreover, the picture is incomplete – part of the canvas is bare – an invitation for the viewer to interpret the various elements of the composition and carry them to resolution in the mind's eye. Some of that resolution involves an appreciation of the long tradition of still-life painting from which such a canvas springs.

Picasso would continue to work in various Cubist modes until the early 1920s. One of his most audacious inventions, the sheet metal and wire construction entitled *Guitar* (Musée Picasso, Paris) dates from as late as 1924. By then he would freely combine Cubist motifs in the same work with other, more traditional styles, including Neoclassicism, to which he had begun to return in the aftermath of the First World War. The Cubist adventure was at an end. His greatest artistic invention, it was also the style (or more rightly, series of styles) in which his lifelong debt to the traditions of European painting was most ambiguously acknowledged.

Notes

1 'Chronologie du Cubisme', in Paris 2007a, pp. 333–57.
2 Gertrude Stein, 'The Autobiography of Alice B. Toklas', in Stimpson and Chessman 1998, p. 713.
3 Pierre Daix, 'Portraiture in Picasso's Primitivism and Cubism', in New York 1996, p. 260.
4 Daix in New York 1996, p. 262.
5 The postcard is illustrated in Paris 2008, p. 345.
6 For the bizarre story of Picasso's personal involvement with such Iberian statues, see Richardson 1997, chapter 13, 'L'Affaire des Statuettes', pp. 199–205.
7 London 1983, p. 232.
8 Rosenblum 1967, p. 137.
9 Rosenblum 1961.
10 On Picasso's Cézannes, see Paris 1998, pp. 72–9.
11 See cat. 21.
12 London 1983, p. 254.
13 Paris 1998, p. 84.
14 On his still-life painting, see Cleveland 1992.
15 The x-ray of the Philadelphia painting showing a hieratic nude female figure beneath is published in Cleveland 1992, p. 56, fig. 8a.
16 Stein, 'Picasso' in Cleveland 1992, p. 283.

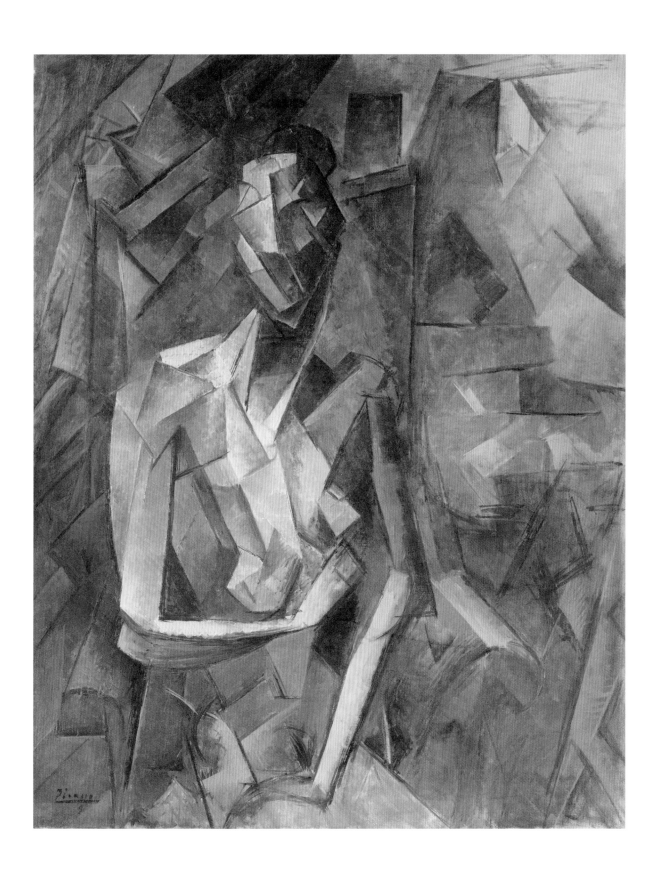

64

Fig. 30
Luis Meléndez (1716–1780)
Still Life with Lemons and Oranges,
1760s
Oil on canvas, 48 × 35.5 cm
The National Gallery, London

Cat. 14
Fruit Bowl with Pears and Apples, 1908
Oil on wood, 27 × 21 cm
Staatliche Museen zu Berlin,
Nationalgalerie, Museum Berggruen
(MB14/2000)

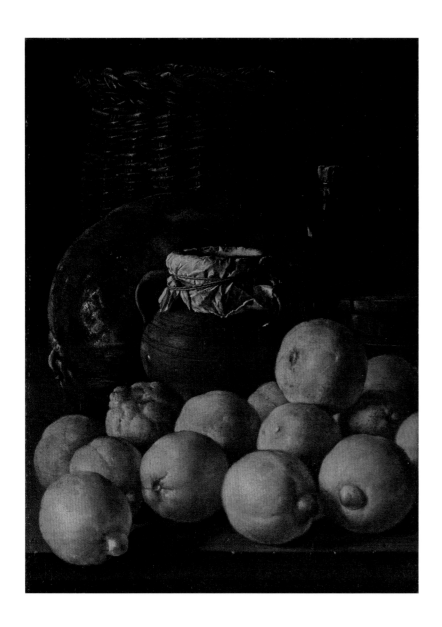

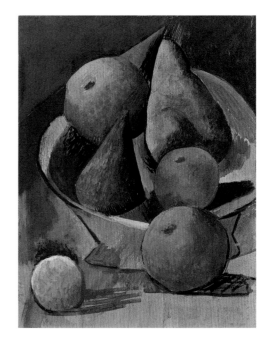

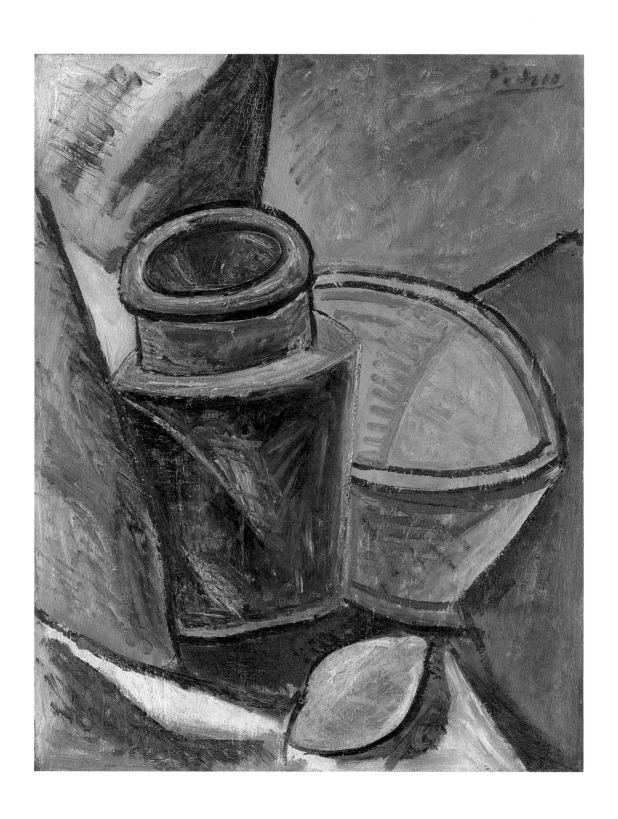

Cat. 16
Fruit Dish, Bottle and Violin,
1914
Oil on canvas, 92 × 73 cm
The National Gallery, London,
on long term loan to Tate
(NG6449)

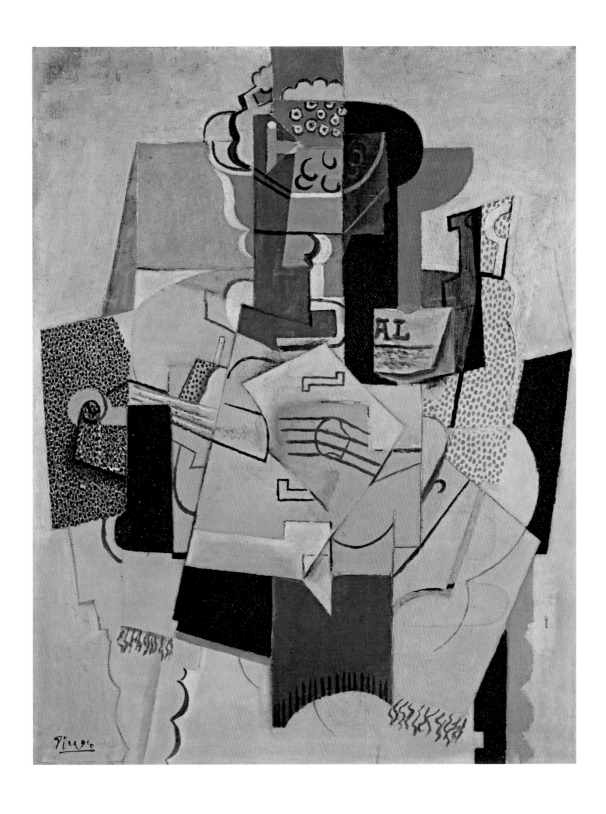

Cat. 17

**Still Life with Glass
and Lemon**, 1910
Oil on canvas, 74 × 101.1 cm
Cincinnati Art Museum, Ohio
Bequest of Mary E. Johnston
(1967.1428)

67

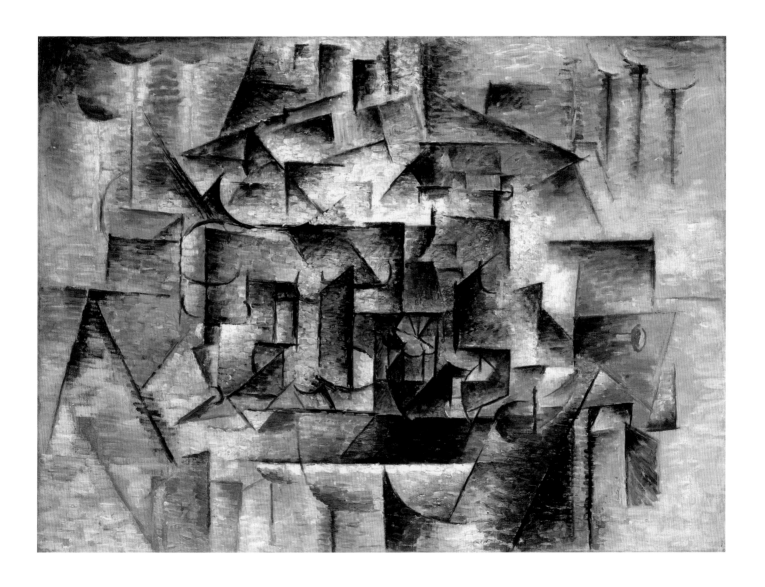

Picasso visited Italy for the first time between February and May 1917 when he travelled to Rome to work on sets and costumes for the much-anticipated new Ballets Russes production, *Parade*. His companions included collaborators on the avant-garde dance extravaganza, the choreographer Léonide Massine (1896–1979), the composer Igor Stravinsky (1882–1971) and that 'gadfly of modernism',[1] the writer Jean Cocteau (1889–1963). Ballets Russes impresario Serge Diaghilev (1872–1929) ensured that his 'talent' lived in style and saw all the sights, not only in Rome but in Naples, Pompeii and Florence as well. Only an audience with the Pope failed to materialise. The studio provided for Picasso to work overlooked the venerable Villa Medici, home of the French Academy, rich in associations with such admired artists as Velázquez, Ingres and Corot. In Rome the artist, previously disappointed in love – two recent marriage proposals had been rejected – promptly met and as quickly wooed a very proper young ballerina with the company, Olga Khokhlova (1891–1955).[2]

His Italian sojourn represented a turning point in Picasso's domestic and social circumstances. Like the well brought-up young Spaniard that he was, he took Olga from Rome to Barcelona to meet his family and gain their approval for the match he intended to make. The couple married in July 1918 and a son, Paulo, was born early in 1921. World fame and dazzling prosperity were on the horizon, and with them a lifestyle far removed from the bohemian penury of the early years. The young family settled down in a grand, elegantly furnished Parisian apartment. The breadwinner kept his cash in the vaults of the Banque de France.[3] Cocteau was determined to introduce Picasso to smart society, and he and his bride were eager to oblige. The period of worldly success that ensued – for a while no costume

Return to a Kind of Order

CHRISTOPHER RIOPELLE

Fig. 31
Olga and Picasso in London, 1919
Photograph, Musée Picasso, Paris

ball or avant-garde art opening in 1920s Paris was complete without an appearance by the fashionably attired Olga and Pablo – would come to be known as Picasso's *époque des duchesses*. While ladies of title fought for his notice, so, too, did a new generation of artists and critics – the Bloomsbury acolyte Clive Bell (1881–1964) was particularly exigent in his attentions – including the Surrealists led by André Breton (1896–1966) who, recognising Picasso as the most significant of contemporary painters, sought to conscript him and his formidable reputation to their cause.

More important, the 1917 visit to Italy signalled the beginning of a new direction in Picasso's art – Neoclassicism is as good a stylistic label as any – which for several years overlapped with his continuing Synthetic Cubist explorations. Departing for Rome, Picasso left behind a grey Paris still under the cloud of war. Friends like Apollinaire, Braque and Derain were in uniform; the first of them would die of his wounds.[4] Admired contemporaries of an older generation like Degas (1834–1917) and Renoir (1841–1919) were nearing the end of their lives. Premature charges had begun to appear in the press that the defining artistic experiment of the still new century, Cubism, had run its course.[5] More threatening still, reactionary critical circles had taken to denouncing Cubism as 'German', an alien invasion of French classical culture by enemy forces.[6] Although he held no truck with notions of cultural purity, none the less Picasso was an outsider in France and conscious of the charge and its implications for the society in which he chose to live. It was plain to see – and Picasso was always finely attuned to changes in the moral and social temperature around him – that the cultural moment which had seen him take his place a decade earlier at the heart of a relentlessly experimental Parisian avant-garde was waning.

Conversely, Italy was a haven of peace. Picasso was returning to the sunny, sensuous Mediterranean culture from which, son of Malaga and Barcelona, he had sprung. The art of Ancient Greece and Rome was at hand, fragments of Antiquity an everyday presence in the streets in which he strolled. The Renaissance masters, not least Michelangelo and Raphael, were to be studied in depth. No less present to Picasso there were those artists whom he most admired, Velázquez, Poussin, David, Corot and Ingres, all of whom, as he knew, had spent formative years in the Eternal City. Like generations before him, Picasso came to Italy to discover what he knew he would find there, a tradition of art-making reaching back millennia, and a vital sense of connection with the classical past in its many guises. In no way, however, could his interest in classical art be construed as an interest in academicism or the academically sanctioned European canon as it had been inculcated in art students for centuries. Rather, what he sought

Fig. 32
Jean-Auguste-Dominique
Ingres (1780–1867)
Madame de Senonnes,
1814
Oil on canvas, 106 × 64 cm
Musée des Beaux-Arts,
Nantes

Fig. 33
Olga posing in the
Montrouge studio, 1918
Photograph, Musée
Picasso, Paris

somehow lay athwart that tradition. As he would later explain to publisher Christian Zervos, 'The academic teaching of beauty is false … The beauties of the Parthenon, Venus, nymphs, Narcissus, are so many lies. Art is not the application of a canon of beauty but what instinct and the mind can conceive independent of the canon'.[7]

Italian themes soon made an appearance in Picasso's art. At the same time as he depicted Italian women in peasant costume in Synthetic Cubist style (fig. 29), he also painted them in a Corot-like realist manner. During the war he had begun to experiment with traditional modes of drawing. Now, drawings of such women came to emulate the austere, linear draughtsmanship of Ingres, as did the elegant, if also slightly comical, drawings of plump classical ballerinas, Olga prominent among them, which he would undertake when he followed the Ballets Russes to London in the summer of 1919. Olga was the muse of the moment. Like the most prominent women in his life before and after her, she now became a constant presence in Picasso's art, most often depicted in a sober manner that cannot help but evoke Ingres. Here, she is like the elegant, enervated Madame de Senonnes in Ingres's 1814 portrait of a luxuriously 'kept' woman in French-occupied Rome (fig. 32), nervous fingers alone suggesting an emotional life not without its ambiguities and tensions. Olga's own innate elegance, poise and reticence of manner perhaps invited such an approach on the part of her initially infatuated swain. Picasso, for his part, disliked it when comparisons were drawn between Ingres's art and the supposedly 'Ingresque' works he himself began to produce at this time, growing 'rather furious' with Clive Bell for doing so in 1921. Roger Fry (1866–1934), always happy to score points off Bell, thought he got away with it by comparing such works to a more *recherché* source instead, the Renaissance master Fra Bartolomeo (1472–1517); doubtless Picasso would have been just as annoyed if that comparison had been offered up too often as well.[8]

Harlequin and other stock characters from the *commedia dell'arte*, immediately evocative of the Italian carnivalesque tradition, made their appearance as well (fig. 35). Picasso found a good-looking young Catalan artist to model for him in harlequin costume: the lad reminded the artist of himself in earlier, leaner times and such works took on the quality of surrogate self portraits.[9] Overtly classical motifs soon followed, such as the Bather themes that had interested him in the early years of Cubism. Works like *Male and Female Bathers* of 1921 (cat. 21), combining male and female figures in a timeless, natural realm, owe an immediate debt to Cézanne, but a much older and deeper one to idealised depictions of the nude stretching back to Antiquity. His palette sometimes assumed a sober, even muted grey tonality when he

worked in this manner, while his Synthetic Cubist canvases more often remained bright and colourful. Still-life painting now was no less susceptible to the influence of the Antique, taking on the simple, ageless and monumental grandeur of the Pompeiian frescos the artist had studied in Naples. 'Dust over layers of history',[10] Robert Rosenblum called the chalky colours of *Still Life with Pitcher and Apples* (fig. 34), and that sense of Picasso's deep imbeddedness in time is a defining characteristic of his art during these years.

Critics have spoken of Picasso's 'return to order' at this moment, as if he felt compelled, as a disastrous war drew to a close, to call into check the supposed anarchic impulses of Cubism. The French original of that phrase, '*retour à l'ordre*', has a more martial air, as if the trumpet of retreat has unmistakably sounded. Certainly, he was not alone among contemporary French artists at that moment in seeking a *rapprochement* with more obviously traditional art forms; this too was a manifestation of the change in temperament in the post-war Paris art world.[11] Whatever the reasons that spurred on Picasso, it is clear that, from about the time of his Italian sojourn, he began to use the art of the past in a recognisably different manner. If before it had been the secret scaffolding, well hidden beneath a welter of fragmented forms, on which he structured his paintings – the sedate female figure by Corot, for example, that informs an abrasive Analytic Cubist canvas like the *Seated Nude* of 1909–10 (cat. 13) – now his references to the past became more overt. They did not become more *self*-conscious – quite the contrary, as Picasso's awareness of the tradition in which he worked was always acute, no matter the mode in which he was painting – but rather more public, more immediately geared to appeal to viewers who wanted to

Fig. 34
Still Life with Pitcher and Apples, 1919
Oil on canvas,
65 × 43 cm
Musée Picasso, Paris

Fig. 35
Harlequin (Portrait of Jacinto Salvado), 1923
Oil on canvas, 130 × 97 cm
Centre Georges Pompidou, Paris, Musée national d'art moderne / Centre de création industrielle

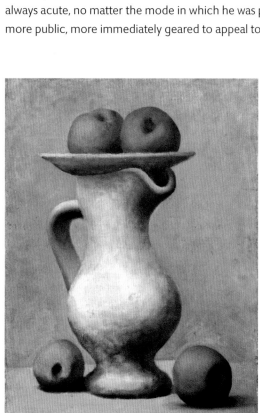

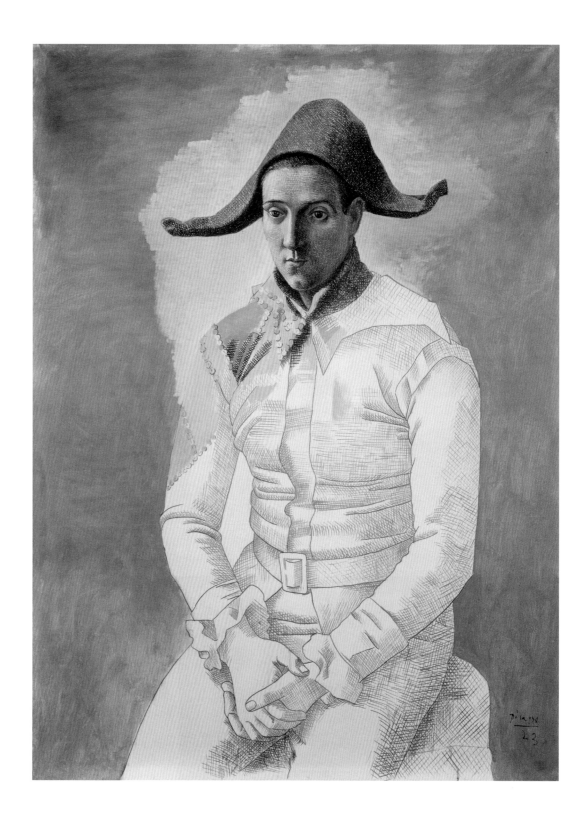

be thought to know their way around the Louvre. Picasso sought now to reach a clientele that would feel flattered to recognise those allusions in his art to the art of the past, which by and large Cubism had held at obstinate bay. If there was a danger of missing the point then Picasso was ready to make it explicit, for example prominently inscribing Manet's signature on his painting *The Lovers* of 1919, itself based on Manet's *Nana* (1877; Kunsthalle, Hamburg). For a while at least, the provocation of Picasso's art would not reside primarily in experimental form; if this strategy was meant to appeal to the supposedly less sophisticated American market, however, it backfired as critical umbrage was taken in New York at the time of Picasso's first exhibition there in 1923 when Cubist paintings were excluded in favour of such more easily accessible recent canvases.[12]

Exposure to Italy was one of many stimuli that conspired in the years around 1920 to return Picasso's attention to his artistic roots. His response was inimitably eclectic. *The Lovers* (cat. 19), a large-scale drawing on canvas, shows the artist's skill at appropriating the linear purity and concision of form of which Ingres was the master, qualities themselves informed by austere Ancient and Renaissance sources, not least Raphael. To the admixture Picasso contributes a captivating sweetness of expression and intimate sense of psychological interaction between the protagonists that have their roots in the *fête galante* tradition of eighteenth-century France. Watteau, Boucher and Greuze are not far from his thoughts here. But the classical tradition was only one of several avenues to be explored. Returning to Paris in 1917, for example, Picasso sought out *Return from the Baptism*, a painting by the seventeenth-century Louis Le Nain in the Louvre (fig. 36) and painted *The Happy Family* (fig. 37) in direct response to it. While proportions are

Fig. 36
Louis Le Nain
(1600/1610–1648)
**Return from the
Baptism**, no date
Oil on canvas, 61 × 78 cm
Musée du Louvre, Paris

Fig. 37
The Happy Family, 1917
Oil on canvas, 162 × 118 cm
Musée Picasso, Paris

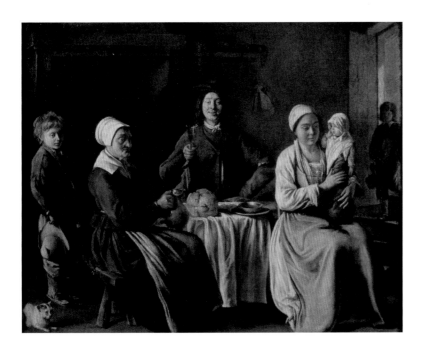

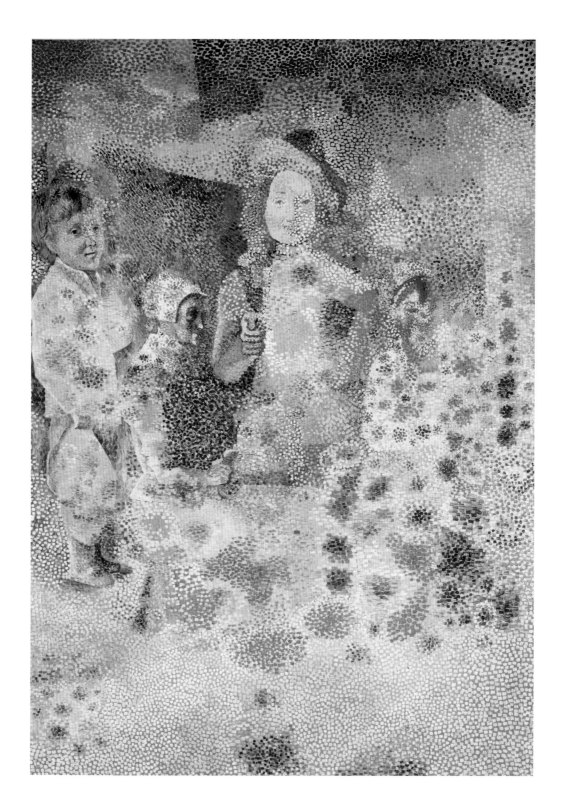

altered, individual figures, their relative positions and relationships one with another are immediately comparable. It is the first instance in Picasso's oeuvre in which a specific old master painting is appropriated in this unambiguous manner, and it anticipates the daring *Variations* of the 1950s in which he paid explicit homage to – or rather, took on in combat – towering masterpieces of the past (see pp. 108–15). Unexpectedly, however, Picasso does not paint his replica in the seventeenth-century realist manner, nor with the subdued brownish palette the Le Nain brothers themselves employed. Rather, he re-conceives the scene in imitation of Georges Seurat's (1859–1891) pointillist painting technique of the 1880s, dots of pure colour dancing across the canvas. He offers no explanation for the unexpected juxtaposition of two such distinct stylistic approaches, but with one sweeping painterly gesture claims swathes of the French painting tradition as his own.

Renoir died on 3 December 1919. A master of form and colour was gone, one who in his later years had anticipated Picasso's interest in the monumental nude female figure. Picasso was a passionate admirer: he

Fig. 38
Jean-Auguste-Dominique
Ingres (1780–1867)
Madame Moitessier, 1856
Oil on canvas, 120 × 92 cm
The National Gallery,
London

Fig. 39
Woman reading, 1920–1
Oil on canvas, 100 × 81.2 cm
Musée de Grenoble

owned at least one painting by Renoir by 1918 and his dealer, Paul Rosenberg (1881–1959), had been hoping to arrange a meeting between the two artists, writing to Picasso in London in the summer of 1919 that the aged master had been overwhelmed by some of the Spaniard's works although shocked by others.[13] Even before his death, Renoir had begun to figure in Picasso's art. Now, for a time, he became the presiding genius. In the early 1920s Picasso acquired two of Renoir's monumental female nudes for his private collection, including his *Seated Bather in a Landscape, called Euridice* of 1895–1900 (fig. 40). He simultaneously turned to painting his own great bather figures, large, rounded, voluptuous females of imperturbable placidity which specifically echo Renoir's late works (cat. 22). Here, radiant pink flesh is framed and thrown into relief by the silvery grey folds of drapery. Such figures seem ready to burst the confines of the canvas. In their pneumatic amplitude they anticipate the biomorphic nudes of the artist's Surrealist period a decade later. Such figures serve to ally Picasso not only with Renoir but, beyond him, with the entire French classical tradition reaching back to Jean Goujon (about 1510–1565) in the sixteenth century and Poussin in the seventeenth, whose inheritance, as Picasso appreciated, Renoir more than any of his contemporaries had kept alive. If Cézanne among the masters of the previous generation had informed many of Picasso's Cubist experiments, it was Renoir who around 1920 pointed the way toward a new repertoire of images imbued with what a critic at the time termed both 'titanic archaism' and 'idyllic repose'.[14]

In one regard, Picasso's grand female figures differ from those of Renoir. For the latter artist, by and large, women were unthinking, sensate beings abandoned to the instinctual pleasures of their bodies and of their existence in a benign, spring-like nature.[15] He once complained of a model that she was not 'the placid and docile kind of woman I like to paint'.[16] Picasso, for his part, was much more drawn temperamentally to women of intelligence and character. A fiery personality, knowing what she wanted and liked, was not unattractive to him. As with Gertrude Stein, he knew, keen intelligence in a woman could serve as a spur and foil to his own creativity. Often, as in the ferocious *Dance* of 1925 (Tate, London), his female figures are furies on the edge of a chaos they themselves have willed into being. Throughout his career, but particularly in the years around 1920, the women Picasso depicts are shown deep in thought or reverie. The *Seated Woman* of 1920 (cat. 20) raises hand to chin in the pose of Rodin's *Thinker* or of the ancient trope of Melancholia. The *Woman reading* of 1920–1 (fig. 39) is lost in thought at the text she peruses. The art historical reference is to Ingres's seated *Madame Moitessier* (fig. 38), finger to cheek, a painting Picasso would have known at

first hand. But he is not so much citing Ingres here as he is finding in the master a motif that allows him to suggest the innate intelligence of his sitter. With Olga too, that sense of a watching, wary presence in some kind of communication with the artist, even if it was increasingly thwarted as the relationship deteriorated in the later 1920s, imbues his portraits (cat. 23). The pensive female of which Renoir would hardly have acknowledged the existence as a type would remain a master theme of Picasso's art.

The sense of artistic tradition, indeed of a specifically French tradition, in which he sought to situate himself was reinforced for Picasso by the summer he spent at Fontainebleau in 1921.[17] It was at the château there, on the edge of the royal hunting forest, at the court of the sixteenth-century Valois king, François I, that the French classical tradition, originally imported from the Italy of the High Renaissance, had been born as a manifestation of newly confident regal taste and patronage. Such works by Picasso as *Three Women at the Spring* (Museum of Modern Art, New York), painted there, allude to that tradition. Classic repose joins with a sense of anticipation reminiscent, ultimately, of classical relief sculpture. But for Picasso, exploring one aesthetic path did not preclude another. Also at Fontainebleau that summer he painted the two versions of *Three Musicians* (Museum of Modern Art, New York, and Philadelphia Museum of Art), his final, hugely ambitious statements of Synthetic Cubism at its most decorative, colouristically rich and visually complex. Inventive Synthetic Cubism still lifes date from the same moment (cat. 18). As he moved in new directions, as he painted pictures that were incontestably easier on the eye than many of his withholding and hermetic Cubist canvases had been, he did not mind reminding viewers that you still had to work hard if you wanted to keep up with Picasso on his journey.

Cat. 18
Violin and Newspaper on a Green Rug (Le jour), 1921
Oil on canvas, 73.3 × 92.1 cm
Nahmad Collection, Switzerland

Notes

1 Garafola 1989, p. 99.
2 On Picasso in Rome, see Richardson 2007, pp. 3–19, and, most recently, Nicosia 2008.
3 Richardson 2007, p. 385.
4 Picasso was not a French national and Spain was not at war so he was exempt from military service.
5 C. Green, *Cubism and its Enemies: Modern Movements and Reaction in French Art, 1916–1928*, New Haven and London 1987, pp. 7–11.
6 On the cultural context of the Great War, see Silver 1989.
7 C. Zervos, 'Conversation avec Picasso', *Cahiers d'Art*, no. special, 1935, pp. 173–8, quoted in M.L. Bernadac, 'Dialogues avec les Grandes Maîtres: Propos de Picasso sur les Maîtres Anciens', unpublished.
8 Roger Fry in a letter to Vanessa Bell of 15 March 1921, quoted in Richardson 2007, pp. 167–8.
9 Richardson 2007, p. 240.
10 Cited in Cleveland 1992, p. 190.
11 See London 1990, p. 11–28, and Green 1987, pp. 187–202.
12 Richardson 2007, p. 246.
13 Paris 1998, p. 202.
14 C. Einstein (1928), cited in London 2008, unpaginated.
15 On this aspect of Renoir's art, see Garb 1985, pp. 3–15.
16 Vollard 1934, p. 124.
17 See Paris 2007b.

Cat. 19
The Lovers (L'entretien), 1923
Oil and soft lead pencil on canvas
150 × 150 cm
Jan Krugier and Marie-Anne
Krugier-Poniatowski Collection

79

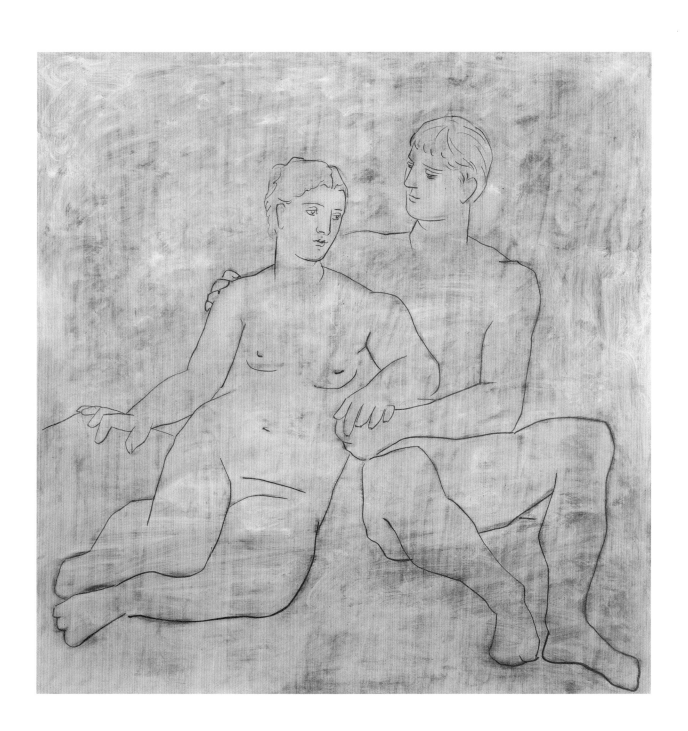

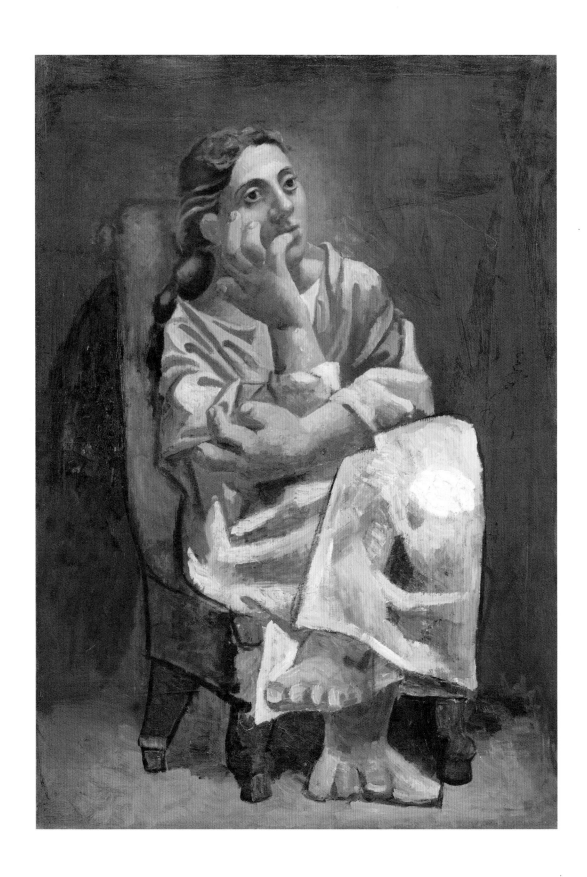

Cat. 20
Seated Woman, 1920
Oil on canvas, 92 × 65 cm
Musée Picasso, Paris (MP67)

Cat. 21
Male and Female Bathers, 1921
Oil on canvas, 54 × 81 cm
Nahmad Collection, Switzerland

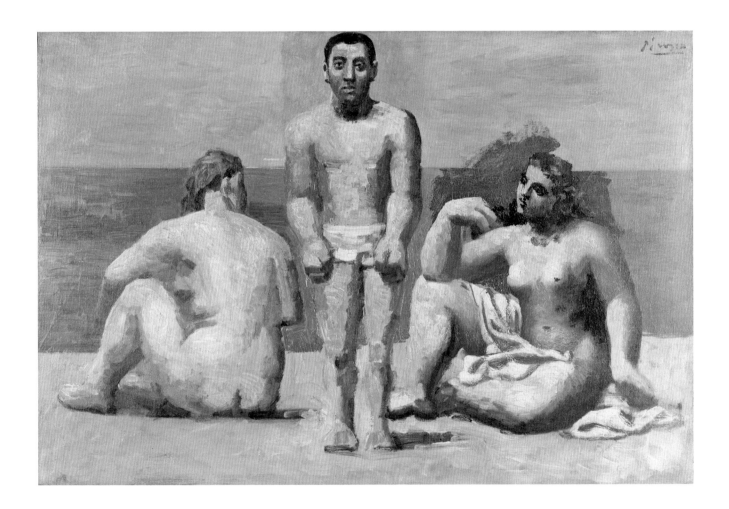

Fig. 40
Pierre-Auguste Renoir (1841–1919)
**Seated Bather in a Landscape,
called Euridice**, 1885–1900
Oil on canvas, 116 × 89 cm
Musée Picasso, Paris

Cat. 22
Large Bather, 1921
Oil on canvas, 182 × 101 cm
Musée national de l'Orangerie, Paris,
Collection of Jean Walter and
Paul Guillaume (RF1963-77)

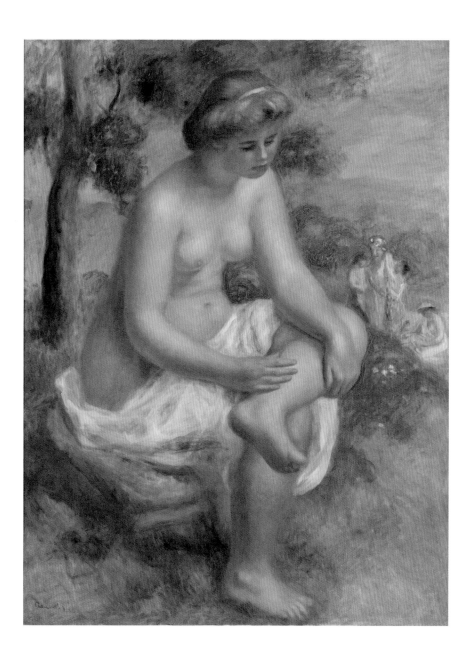

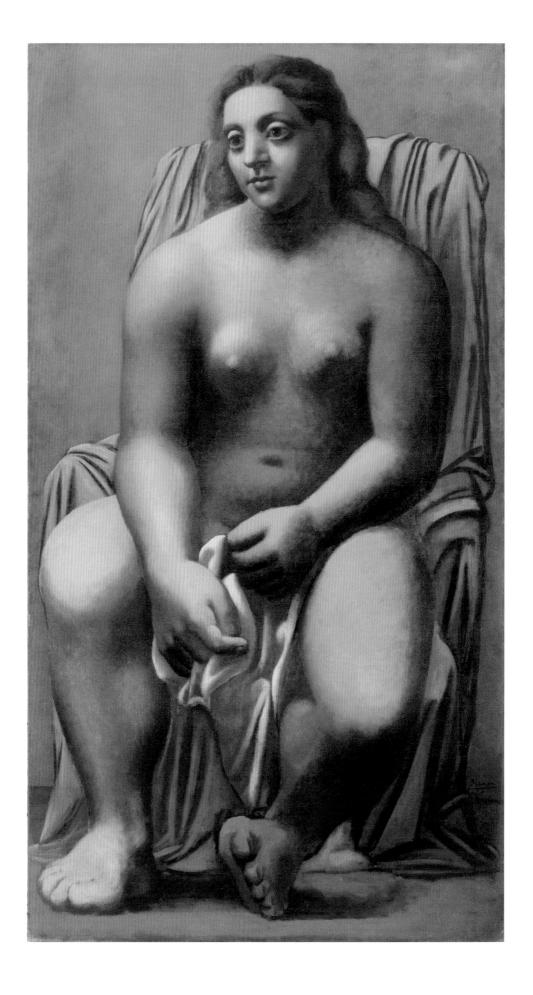

Cat. 23
Portrait of Olga, 1923
Oil on canvas, 130 × 97 cm
Private collection

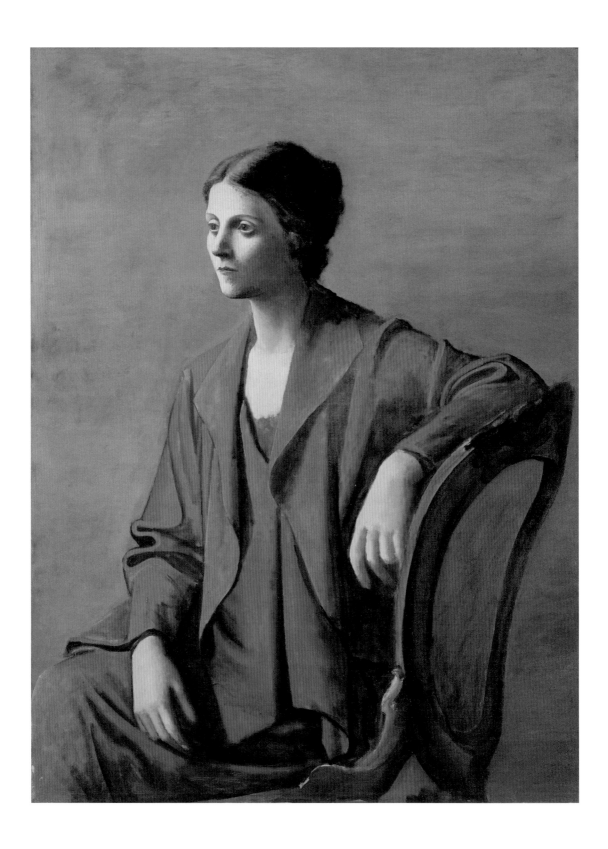

Cat. 24
Olga with Fur Collar, 1923
Oil on canvas, 116 × 80.5 cm
Musée Picasso, Paris,
on long-term loan to
Palais des Beaux-Arts, Lille
(P.2004)

85

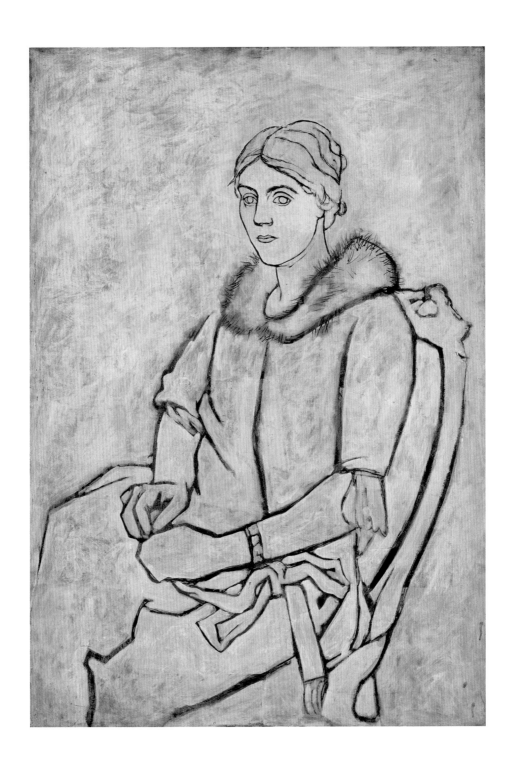

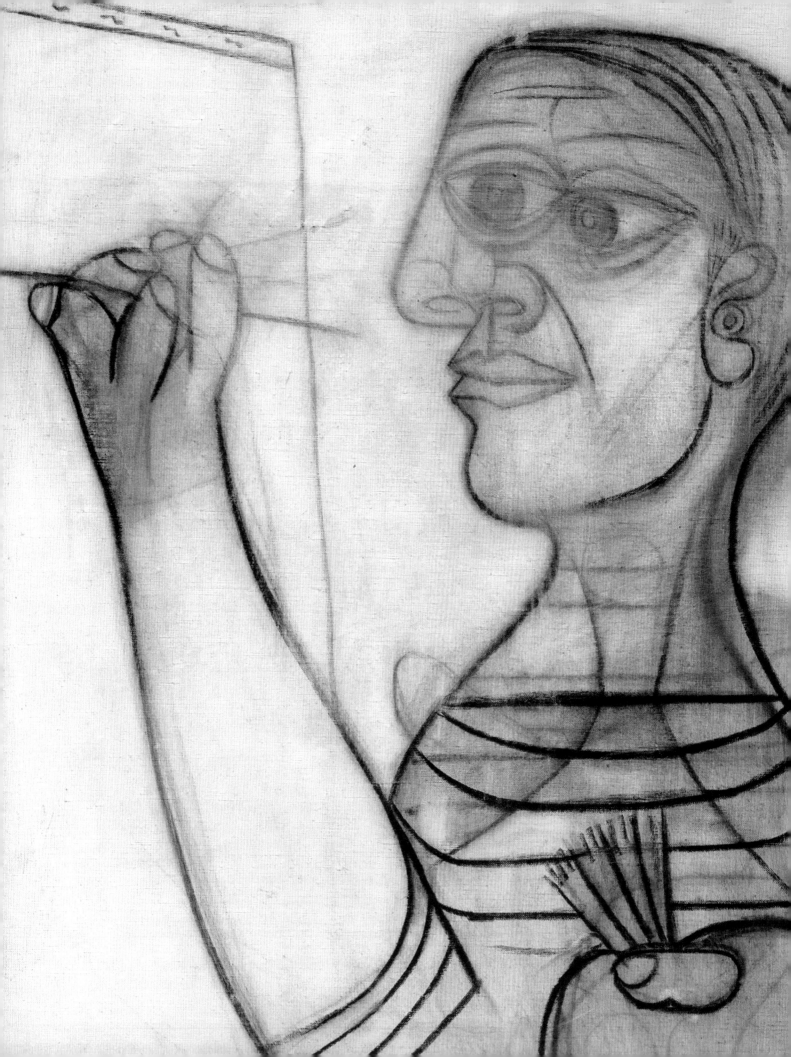

In his impressive book *Painting as an Art*, the late Richard Wollheim discusses what he called the effect of 'naturalism' or 'realism' in certain paintings.[1] Surprisingly, he makes his point in part by insisting that painters as ostensibly unlike each other in their manner as Pieter de Hooch (1629–1684) and Matthias Grünewald (about 1475–1528) both succeed in producing the 'naturalistic effect'. Among Wollheim's comparisons is one that is of great interest here: the juxtaposition of Bronzino's *A Young Woman with her Little Boy* (about 1540; National Gallery of Art, Washington, DC) and Picasso's *Portrait of Dora Maar* (fig. 41). Wollheim's insistence that both works stimulate in our minds a powerful sense of lifelikeness is a provocation: a surprise reading of Picasso's relationship to the European tradition. The comparison is meant to suggest that artists can elicit the naturalistic effect in many different ways. Bronzino can do it with a glassy painted surface rich in static detail, in which we confront the limpid gazes of his subjects; Picasso creates the sense of realism with other-worldly colours, a vibrantly textured surface, and an apparently crude grasp of the difference between cloth, flesh and furniture. Crucially, it is the reciprocity established between the uniquely realised painted surface and the figures, objects and spaces represented in it, which, for Wollheim, makes the Picasso just as 'realist' as the Bronzino. When

The Sur-reality Effect in the 1930s

NEIL COX

Fig. 41
Portrait of Dora Maar, 1937
Oil on canvas, 92 × 65 cm
Musée Picasso, Paris

a picture lights up with that powerful effect of naturalism, we hold a particular relation of the surface and the figures together in our minds. Wollheim makes his comparison in passing, of course, and in order to insist on the range of realisms that we find in the achievements of painting. However, his comparison presents a shift in the possibilities for making reality – a shift that speaks of the difference between the time of Bronzino and that of Picasso.

Picasso's portrait was not, of course, painted in direct response to the Bronzino. But there is no doubt – as this book demonstrates – that Picasso's many and varied representations of seated female figures, and indeed other subjects, often appear to echo specific renowned works in the European inheritance in the visual arts. His *Woman reading* (fig. 39), for example, is often compared to the National Gallery's *Madame Moitessier* (fig. 38) by one of Picasso's constant points of reference, J.A.D. Ingres.[2] For Ingres, the European tradition meant a set of rules and skills for which the paradigm was the art of Raphael (1483–1520); the subsequent three centuries of painting merely perpetuated Raphael's perfection. Picasso painted in the entirely different historical space of a self-conscious modernism: the tradition, the very means of art, was constantly being questioned. So, assuming we agree that Picasso convinces us of the *reality* of Dora Maar, we also have to recognise that his realism is made with *and* against the tradition of Bronzino, or Raphael, or Ingres. What were the terms of Picasso's modernism, then? Or, to put it more clearly, what kinds of representational strategies were, according to Picasso, called for by modernity? And how did these strategies perpetuate, subvert or expropriate the resources of the tradition of painting?

For Picasso the question of 'modernity' was acute in the 1930s and 1940s, since modernity in this period meant a personal life, a nation, a Europe, and indeed a world in crisis. This period in Picasso's art is marked by a succession of shattering events in his personal life that no doubt appeared to him mirrored in the disasters in the world at large (and not, to emphasise the point about his normally distant relationship with political realities through-out his life, the other way around).[3] Personal events included the death of his mother in 1939; the slow breakdown of his marriage to Olga Khokhlova (they eventually separated in 1935); his ongoing secret affair with Marie-Thérèse Walter (from 1927) leading to the birth of a daughter, Maya, in 1935; and new relationships with the artist and photographer Dora Maar (from 1936) and then the painter Françoise Gilot (from 1943). In France Picasso witnessed the resurgence of Fascism and fatal rioting in Paris in February 1934, followed by the excitement and disappointments of a 'Popular Front' government (elected in 1936). Spain had elected a 'Popular Front' government earlier that year, but the country rapidly slid into civil war between the Fascist

forces of Francisco Franco and a Republican government in Barcelona, events that provided the context for the bombing of the Basque town Guernica, which would in turn provide the impetus for Picasso's best-known work (fig. 43). The war that commenced in Europe in 1939 rapidly infected much of the globe; for Picasso it changed everything in terms of his life in Paris, and indeed his public presence. Now personal life and world events often crossed paths in horrible ways: his old poet friend Max Jacob died in a deportation camp in 1944. The surrealist poet Robert Desnos (1900–1945) died in a concentration camp just after its liberation; Picasso, like some others, may have felt compelled to abandon him for fear of his own position. After these painful moral dilemmas and tragic losses, Picasso decided to join the French Communist Party in 1944, becoming one of its prize new recruits. This public act was accompanied by new directions in his art, among which were: Arcadian and Mediterranean themes; 'political' paintings based on a humanist ideal; a celebration of the values of childhood imagination in sculptures and ceramics; and self-analysis, often in the form of parody and burlesque.

Setting these brief details alongside works of the period such as *Woman with a Book* (1932, Norton Simon Museum of Art, Pasadena) or the *Portrait of Dora Maar* suggests that the naturalistic effect is but one aspect of the artist's self-presentation, a way of recording moments in the presence of the artist's lovers that also, in some cases, seem to reflect external events. In *Woman with a Book* the profile in the mirror (or picture) on the wall can be read as the shadowy presence of Picasso the lover. The notable elegance of the 1937 *Dora Maar* is tempered by a meditative, austere mood in which we might be tempted to sense the seriousness of those particular spring days. The 1930s did indeed coincide with Picasso's heightened sense of the

Fig. 42
Picasso painting **Guernica**, 1937.
Photograph commissioned
by Dora Maar for *Cahiers d'Art*.
Photograph, Musée Picasso, Paris

Fig. 43
Guernica, 1937
Oil on canvas, 349.3 × 776.6 cm
Museo Nacional Centro de Arte
Reina Sofia, Madrid

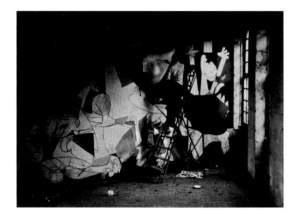

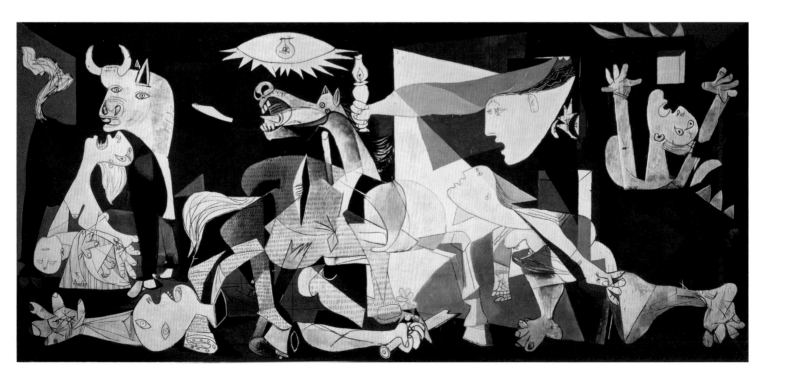

significance of his art as a mirror of his lived life. However, his approach was no mere diary of events or experiences: he construed his artistic output as the very medium of his experience. Thus the complex iconography of the 1930s was itself a kind of vocabulary, or rather, a range of rhetorical devices or voices with which to *live out* the emotional and intellectual vicissitudes of each day.[4] (A list of those subjects might begin with mention of bullfights and suffering minotaurs, women reading or sewing, crazed and serene nudes, artist and model scenes or sculptor's studios, scenes of war and disaster, death's heads both human and animal, and scenes from Classical mythology.) The distancing effect of art in relation to lived life is, perhaps, evident in *The Artist in Front of his Canvas* (cat. 28). There is nothing here that exposes the emotional life or the self-awareness of the artist: this figure drawn in charcoal is a kind of ghostly 'blank' himself, a stand-in for the impassioned and dynamic figure of the modern artist, groping his way intently across the surface of the blank canvas on the easel before him, looking for the representations that might 'bring him to his senses' – bring him to experience.

Even with just the three paintings of the 1930s mentioned so far, it is obvious that whatever the nature of Picasso's pictorial 'reality effect', it is achieved in diverse ways. This already marks an enormous distance between the modernism of Picasso and the tradition represented by Raphael, Bronzino, Velázquez and Ingres, all of whom more or less kept faith with their manner of 'realism' throughout their careers. Things get more acute if we turn to two other works: *Lee Miller* of 1937 and the *Man with a Straw Hat and an Ice Cream Cone* of 1938. *Lee Miller* (cat. 32) is one of a series of caricatural, rictus-grinned 'portraits' of friends made by Picasso in Mougins while holidaying in the summer of 1937, liberated, as he no doubt felt, from the struggles of his campaign to finish *Guernica*. The ostensible reference point for the Mougins paintings is van Gogh's several versions of a figure known as *L'Arlésienne* (fig. 50), one Madame Ginoux who ran a café in Arles frequented by the artist.[5] Picasso's painting shares the acidic colours and the visible wooden chair of the van Gogh, and indeed the hasty surface coverage of the first version. But what is immediately striking is the grotesquely divided gaze of the figure, whose visage appears as a series of organs lost in a field of yellow flesh. This face sits atop a disjointed body: a black shape like a child's drawing of a boat forms the substance out of which cactus hands project; the blue and red armatures on the black indicate breasts, while the back of the chair merges uncannily with the impression of shoulders, or perhaps the 'leg of mutton' sleeves on a Victorian dress. Finally, a blue rectangle, in its load-bearing uprightness, makes do for the lower torso.

Return to that face: the red eyelid on the right pinches at the yellow profile view to become a sign for lashes. The white of the right-hand eye dribbles towards the upper lip to form a fortuitous nose. A blue figure-of-eight ear, green coiffure and what might be a red hairclip complete the signs for the face. Roland Penrose, Lee Miller's husband, bought this 'portrait' almost as soon as it was finished. Of the whole series of portraits painted on this holiday, Penrose later wrote that they 'were strangely like their models but distorted and disguised by surprising inventions'. It was the 'masterful handling … of likeness' that struck him through the wilful deformations.[6] Penrose was an acolyte of Picasso's, so always inclined to see every one of his efforts as 'masterful'; in this case, though, his insistence on the sense of likeness in the portrait seems right. The striking thing is that likeness is made to spring from distortions and grotesqueness, or better still – remembering Wollheim's sense of the reciprocity of surface markings and the things they encourage us to see in them – the likeness of Lee Miller *happens in* those distortions.

The *Man with a Straw Hat* (cat. 29) makes reality in an entirely different way. It is one of a batch of paintings and drawings on a theme (figures with either an ice cream cone or an ice lolly). The 'manner' here is related to a much larger group of works where metaphors of woven materials, spiders' webs and other intricate patterns appear as if the very flesh of the figures represented.[7] Here the coarse and fraying straw hat infects the face of the wearer with the same prickling edges: red, black and green bristles stand for hair, beard and eyelashes. The green geometric structure on the left side of the face is a coarse cheek, linking the oddly rhyming left ear and nose. This man wears a rough shirt, and clutches in his banana-fingers the ice cream, which is, in the idiom of the painting, grossly defiled by his hairy tongue.

Picasso gave his manifold realism a name: he called it 'sur-realism'. The term was, he claimed, his own invention, but the true author of the idea of a new 'realism', one appropriate for modern times, was his friend Guillaume Apollinaire, poet and writer of the First World War, seeking to define the 'new spirit' that would rise from the ashes of the battlefields.[8] As John Richardson has noted, Picasso clung to the hyphenated form of the term, sur-realism, in order to distance himself from the orthodoxies and political machinations of Surrealism proper, the movement founded in 1924 by the poet André Breton (1896–1966) and others, dedicated to the resolution of dream and waking states, to an embrace of a marvellous, 'convulsive' beauty, and, for a time, to organised revolutionary politics.[9] Picasso rejected the key surrealist notion of 'psychic automatism', the idea that art and poetry could be made outside conscious control, exposing the workings of the

unconscious. For Picasso always insisted that every mark made by an artist was the expression of the effect of a particular concrete reality, some thing or experience in the world. We might say that he understood 'sur-reality' as an intensified, superior realism, certainly a concentrated vision of the presence of things in the mind of the artist, but also an opening up of the fixed borders and identities of things under the energy of endless deformations. Yet even these formulations risk missing the inverted thinking that made art the site of experience rather than its record, and sur-realism the source of things rather than the mere re-presentation of pre-existing objects.

For Picasso's modernist realism – his 'sur-realism' – was as much a source of reality as its mirror. This point is underlined by an intriguing remark prompted by another of his preoccupations in 1938: cockerels. Shrieking like the cockerel of the crucifixion story; trussed and ready for the farmer's wife and her knife (*Woman with a Cock*, Baltimore Museum of Art); or with throat already cut. A US soldier asked after this subject, and Picasso replied: 'Cocks, there have always been cocks, but like everything else in life we must discover them, just as Corot discovered the morning [fig. 44] and Renoir discovered girls [fig. 40].'[10] Picasso's modernism demands a detachment of the terms of realism from fixed notions of reality, and the counter-assertion that artists 'discover' realities – or make them.

Picasso's 'girls' of the 1930s are, as we have seen, very different realities from those honeyed possessions of Renoir's imagination. A reclining nude

Fig. 44
Jean-Baptiste-Camille Corot
(1796–1875)
Morning Dance of the Nymphs,
1850
Oil on canvas, 98 × 131 cm
Musée d'Orsay, Paris

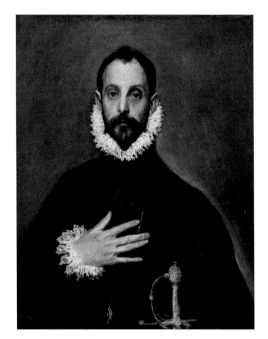

Fig. 45
El Greco (1541–1614)
Knight with Hand to Heart, 1583–5
Oil on canvas, 81 × 66 cm
Museo Nacional del Prado, Madrid

Notes

1 Wollheim 1987, pp. 72–5.
2 See, for example, Madrid 2006, pp. 249–50.
 On the relationship in general, see Paris and
 Montauban 2004.
3 See 'Epilogue', Richardson 2007, pp. 491–9.
4 See N. Cox, 'Picasso's Mirrors: The Mobility
 of Thoughts', in Vancouver 2005, pp. 3–36.
5 K. Hartley, 'Roland Penrose: Private Passions
 for the Public Good', in Edinburgh 2001,
 p. 28, n. 42.
6 Hartley in Edinburgh 2001, p.19.
7 See Cowling 2002, pp. 604–16.
8 See Read 2000.
9 Richardson 2007, esp. pp. 348–50. For a
 very different recent approach to Picasso's
 surrealist affiliations, see Green 2006.
10 New York 1980 p. 348.
11 Tim Hilton sees in this portrait the first sign
 of a decline of Picasso's art into burlesque
 clowning after the Second World War.
 See Hilton 1975, p. 254.
12 Illustrated in Cowling 2002, p. 633.

of 21 December 1932 (cat. 25), one that relates to a series of paintings of a woman being saved from drowning, is a fluid and bizarrely coloured octopus cradling a half moon face sprouting a thick lock of hair. Her breasts roll loosely into each armpit and rhyme absurdly with her buttocks. As a mollusc the woman exposes, perhaps, the lurking mannerisms suppressed by Ingres's Raphaelite code in his *Odalisque with Slave* (fig. 46). Yet Picasso's objective is not necessarily so directly critical: rather, the sur-realism of the figure, construed in an organic-cum-sculptural metaphor, is intended to do nothing else than render the singular reality of this sleeping nude woman, an instant in the flood of meanings that is experience in modernity. For the second element of Picasso's modernism is that his realism is an expression of the mutable realities of personal experience.

Not all of Picasso's works in the 1930s and 1940s aim to manifest a new 'sur-real' vision. His *Death of Marat* (cat. 31), just one of his attempts at 'history' in the 1930s (seen here in a crude and very small etching illustrating a book of poems by Benjamin Peret), depicts a founding moment of modern politics, the assassination of the revolutionary hero, reduced to a graffito showing a frenzied Charlotte Corday and a helpless Marat. Nevertheless, it would be difficult to find the reality effect here: instead Picasso looks for directness and brutality in his reinvention of history as personal turmoil.

Sometimes the binding of self to the brute reality of war, the worst task for Picasso's modernism, finds its means through the self-conscious re-invention of past realisms. A harrowing flayed sheep's head dries out in angular facets on a gloomy table (cat. 30). Its mass, the tension of bone and desiccating tendons, its uncanny grin are all strongly felt. Goya is the reference point: the realism of the historical precedent ratchets up the intensity of Picasso's 'sur-realism' in its modern oblivion.

And just to prove that his 'sur-realism' can acknowledge the bleakness of 1939 as also a black comedy, Picasso makes a portrait of his secretary and poet-friend Jaime Sabartés, dressing him up ridiculously as a member of the noble order of 'Great Spain' (cat. 27). His headdress and ruff frame a face that is both fantastically vivid and also absurdly twisted.[11] Picasso was fluent in this kind of figural doubling, which he practised throughout the late 1920s and 1930s – just how effective the portrait is can be seen when one compares it to a photograph of Sabartés with Picasso taken by Dora Maar.[12] The deformations, however comic, are also, of course, a sinister avatar of the real disfigurements to be suffered in the coming years, and a bitter recollection of those seen in the aftermath of the First World War. Once again, they mark the distance travelled from the Renaissance certainties of El Greco's *Knight with Hand to Heart* (fig. 45) to the reality of modernity.

Fig. 46
Jean-Auguste-Dominique Ingres
(1780–1867)
Odalisque with Slave, 1839–40
Oil on canvas, 72.1 × 100.3 cm
The Walters Art Museum,
Baltimore, Maryland

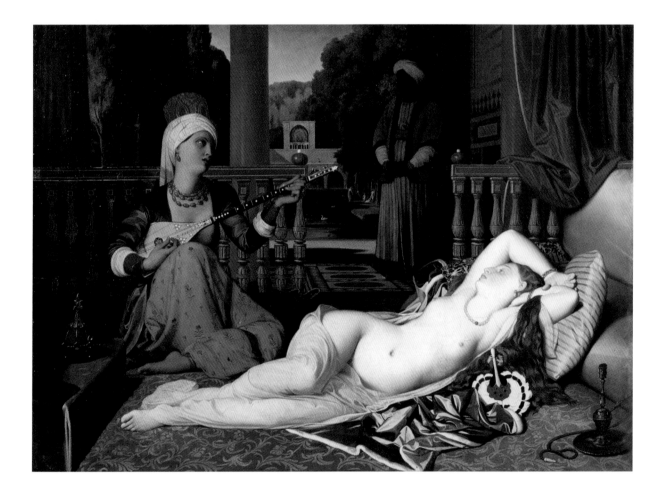

Cat. 25
**Sleeping Nude with
Blonde Hair**, 1932
Oil on canvas, 130 × 162 cm
Nahmad Collection,
Switzerland

95

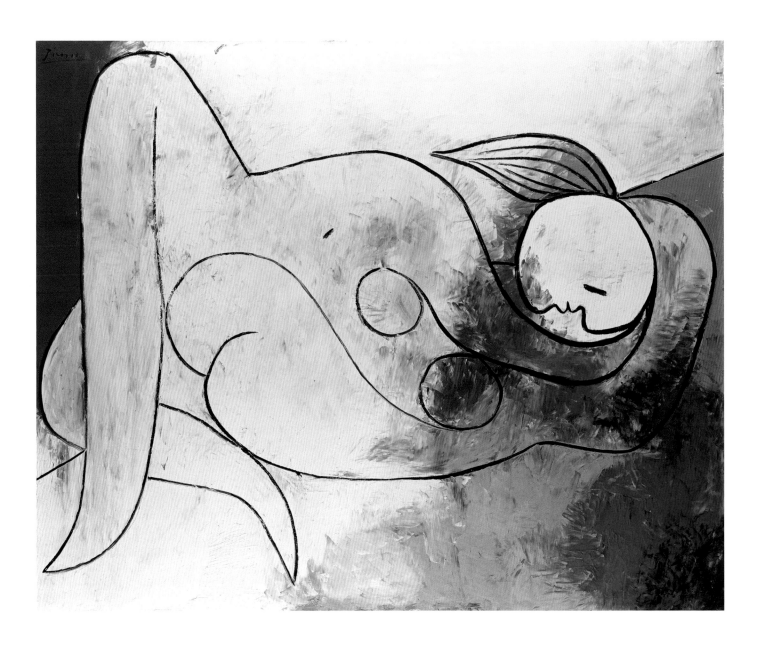

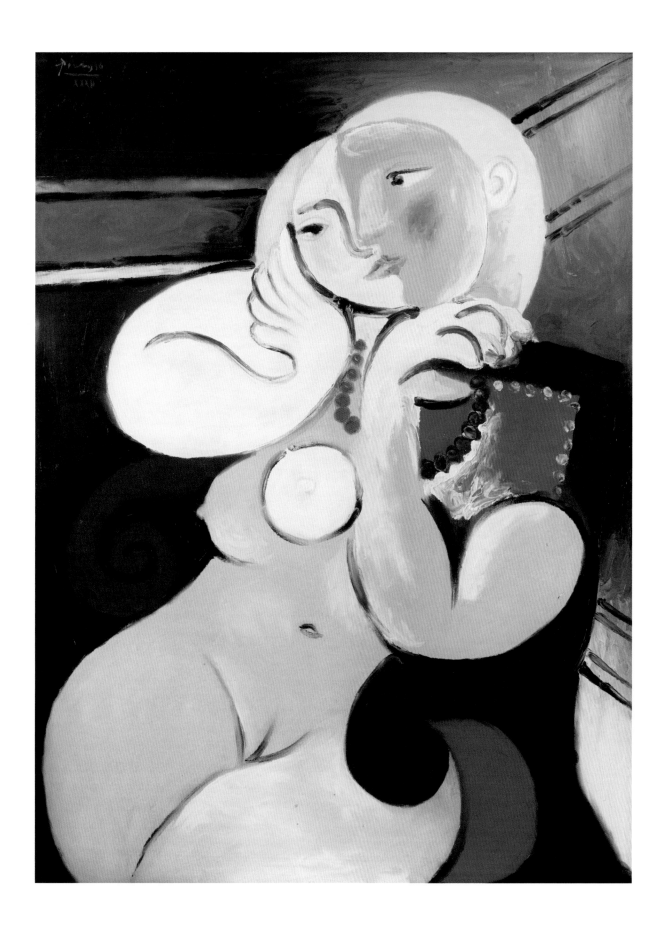

Cat. 26
**Nude Woman in
a Red Armchair**, 1932
Oil on canvas, 129.9 × 97.2 cm
Tate, London (NO6205)

Cat. 27
**Portrait of Jaime Sabartès as
a Spanish Nobleman**, 1939
Oil on canvas, 46 × 38 cm
Museu Picasso, Barcelona
(MPB 70.241)

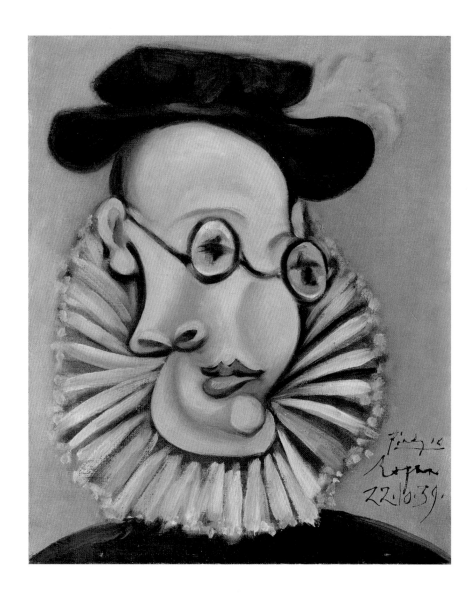

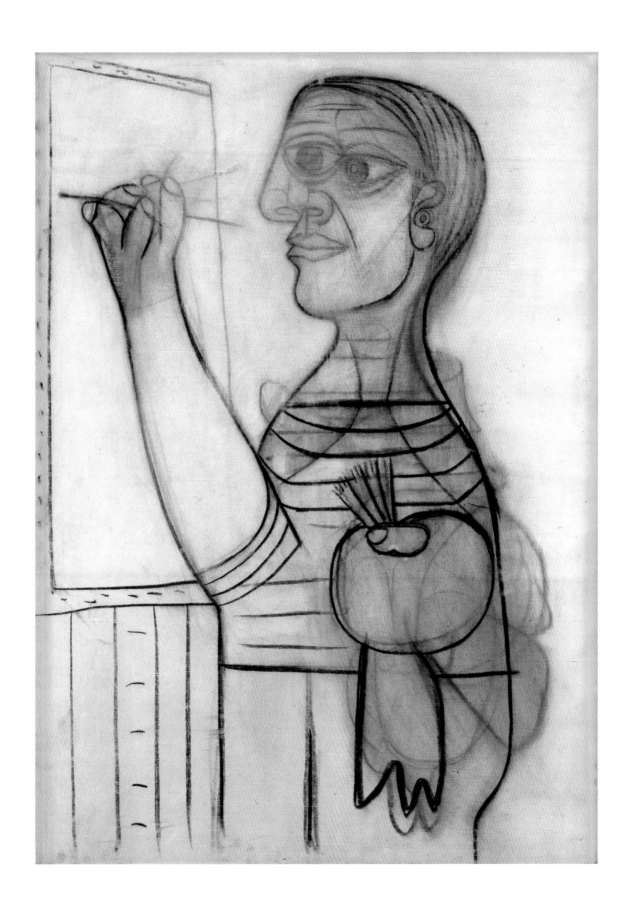

Cat. 28
**The Artist in Front of
his Canvas**, 1938
Charcoal on canvas, 130 × 94 cm
Musée Picasso, Paris
(MP172)

Cat. 29
**Man with a Straw Hat and
an Ice Cream Cone**, 1938
Oil on canvas, 61 × 46 cm
Musée Picasso, Paris
(MP174)

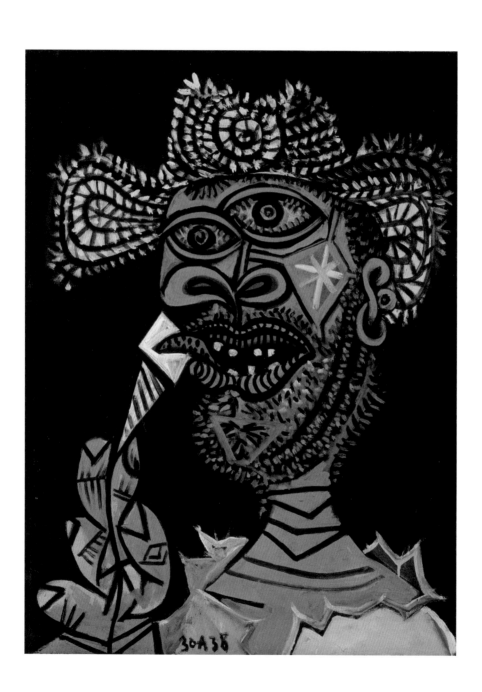

Fig. 47
Francisco de Goya
(1746–1828)
**Still Life with
Sheep's Head**, 1808–12
Oil on canvas, 42 × 62 cm
Musée du Louvre, Paris

Fig. 48
Jean-Baptiste-Siméon Chardin
(1699–1779)
**Kitchen Table with
Slab of Mutton**, 1732
Oil on canvas, 34 × 46 cm
Musée Picasso, Paris

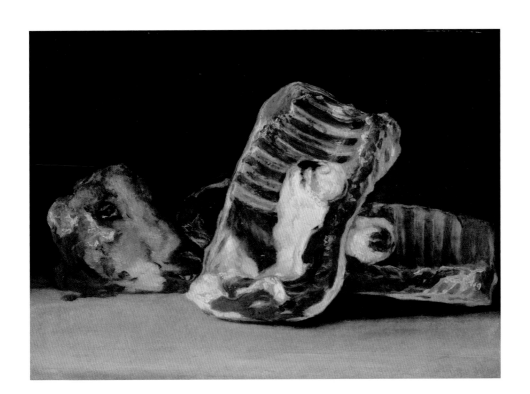

Cat. 30
Flayed Sheep's Head, 1939
Oil on canvas, 50 × 61 cm
Musée Picasso, Paris, on loan
to the Musée des Beaux-Arts,
Lyon (MP1990-20)

101

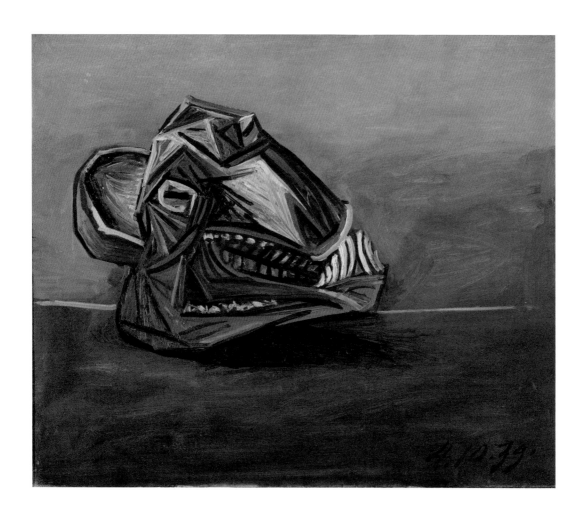

Fig. 49
Jacques-Louis David (1748–1825)
Death of Marat, 1793
Oil on canvas, 165 × 128 cm
Musées royaux des beaux-arts
de Belgique, Brussels

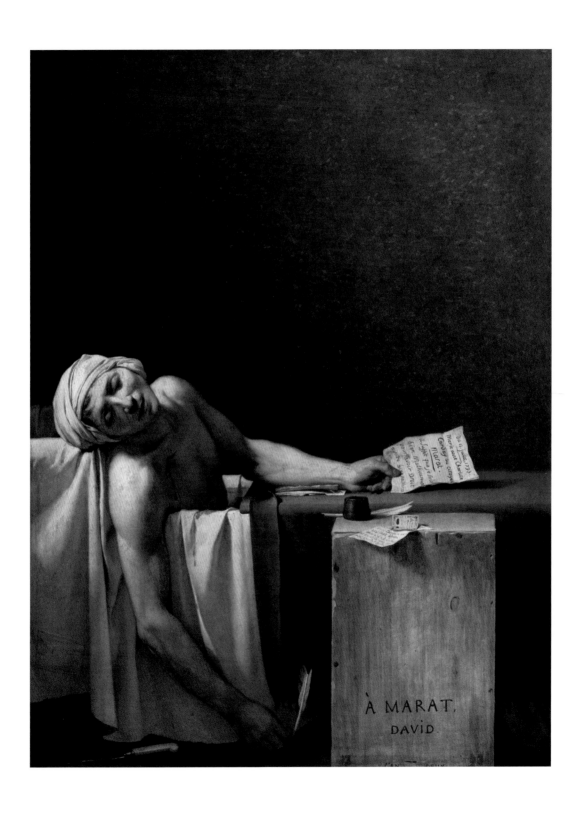

Cat. 31
The Death of Marat, 1934
Drypoint and coloured ink,
20.3 × 15.1 cm
Scottish National Gallery of
Modern Art. Bequeathed by
Gabrielle Keiller, 1995
(GMA 4075)

103

Cat. 32
Lee Miller, 1937
Oil on canvas, 81 × 60 cm
The Penrose Collection
(GML 331)

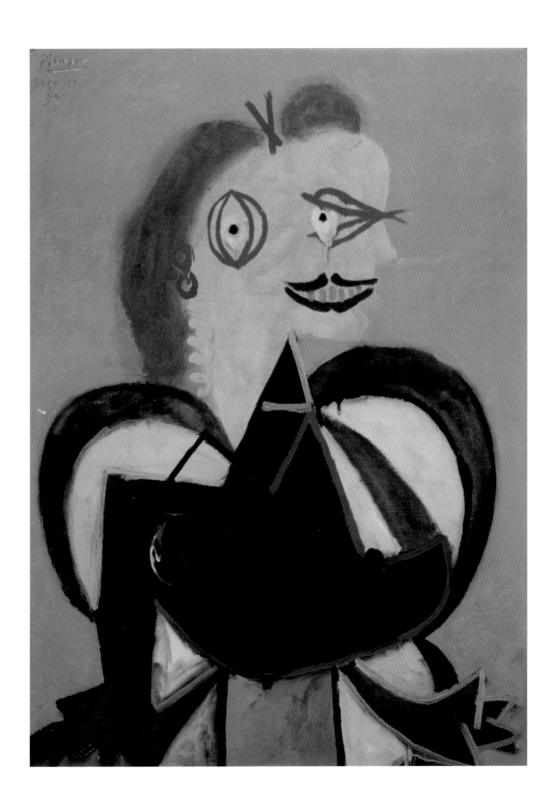

Fig. 50
Vincent van Gogh (1853–1890)
L'Arlésienne (Madame Ginoux), 1888
Oil on canvas, 92.3 × 73.5 cm
Musée d'Orsay, Paris

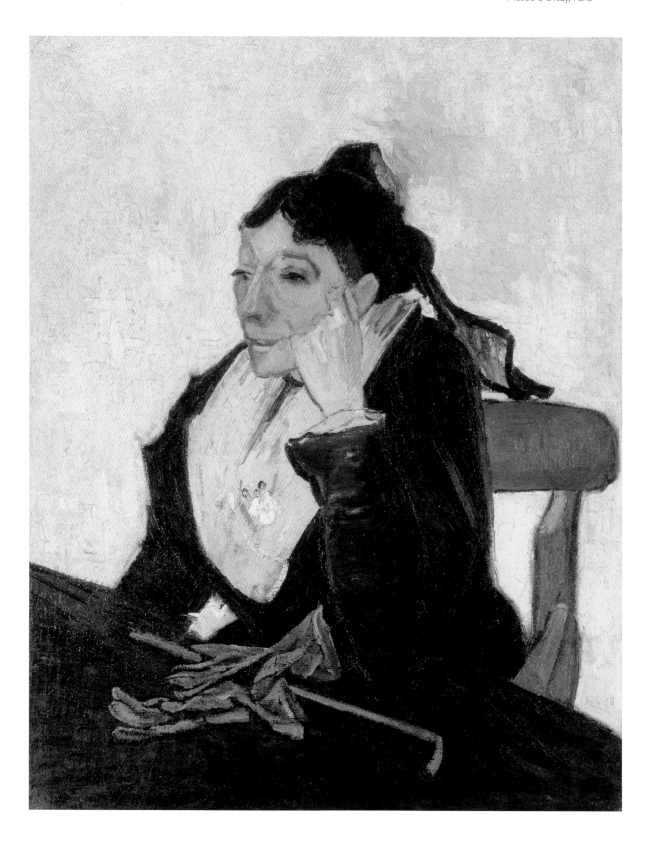

Cat. 33
Rembrandt van Rijn
(1606–1669)
Jupiter and Antiope, 1659
Etching, burin and drypoint,
14 × 20.6 cm
The British Museum, London
(1910,0212.368)

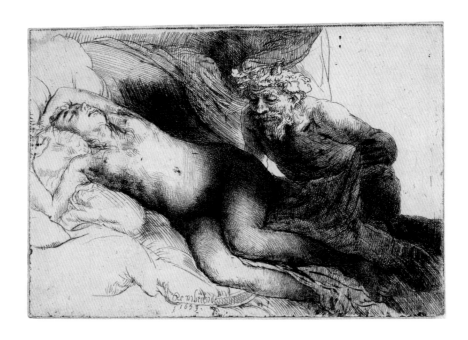

Cat. 34

Faun revealing a sleeping Woman (Jupiter and Antiope, after Rembrandt, from the Vollard Suite), 1936
Etching and aquatint,
31.6 × 41.7 cm
Tate, London (P11360)

107

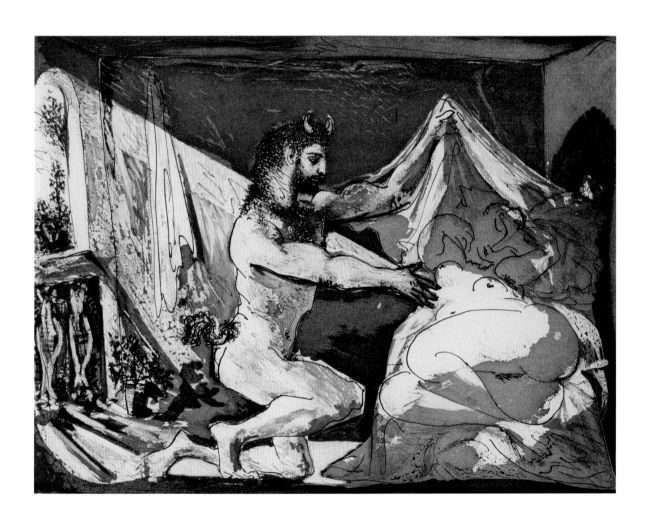

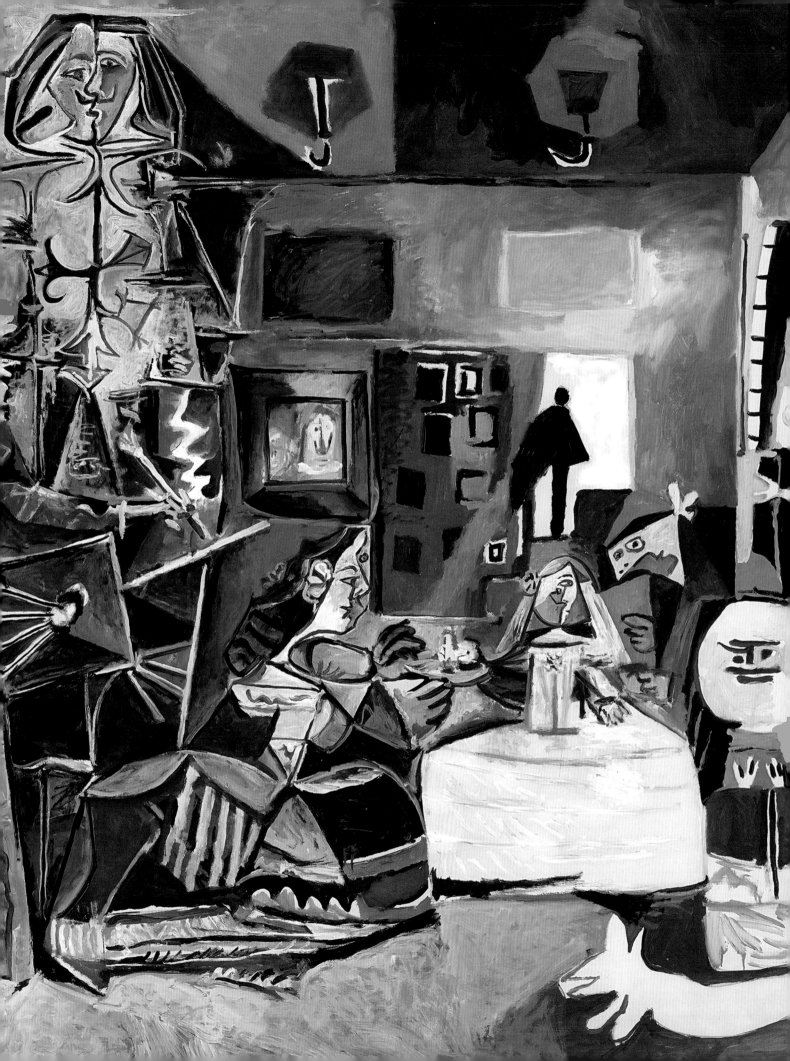

Picasso's 'Old Master' Period

From 1954 to 1962 Picasso devoted much of his creative energy to making variations of iconic masterpieces. He was 73 years old when, late in 1954, he took on Delacroix's *Women of Algiers*, and 15 paintings and numerous drawings poured forth in the space of two months. In 1957 his encounter with Velázquez's *Las Meninas* provoked 45 variations in oil and 13 related works during a four-month bout of activity. Soon after, Manet's *Luncheon on the Grass* served as the springboard for 27 canvases, more than a hundred drawings, and several prints and sculptures produced between 1959 and 1962. A few paintings after canvases on the theme of the Sabine Women by Poussin and David followed, along with prints based on works by Cranach, Rembrandt and Degas; but by the mid-1960s Picasso's most intensive involvement with interpreting works of the past had spent itself.

Picasso frequently employed references and allusions to his artistic predecessors in his work. Variation, however, is different from other forms of citation. There, the formal structure of a specific work of art is used as the basis for a new one, while style, technique and content undergo transformation. A variation can only be fully understood in relation to its generating source, which the viewer must recognise and bridge. While Picasso occasionally made variations on works of the past before the 1950s, it was only in these late years that they became something of an obsession. Yet intense connection with one's forebears is generally thought to belong to the early phase of an artist's development, a stage on the way to creative independence. Why did this deep immersion in the past occur in Picasso's late work, and why did it take the form of sprawling, combative, open-ended episodes – battles to the death – that differ dramatically from similar exercises by other artists, such as the respectful reworkings in his own style that van Gogh made after paintings by Millet, Delacroix and others?

The circumstances of Picasso's life clearly played a role. In his mid-seventies the most radical artist of the century had become an 'old master' himself, a living legend encumbered by his fame. In 1954 he moved permanently from Paris, his home for the previous half-century, to a more secluded life on the Riviera. Paris in the mid-1950s had ceded its position as art capital of the world to New York and, as an artist committed to representation in an age of abstraction, Picasso appeared to be out of step with the avant-garde for which he had previously set the agenda. What greater evidence could there be of his 'retreat' than his painting himself into the *history* of art? Furthermore, death claimed many members of his generation of fellow artists in the 1950s. The greatest loss by far was of his most esteemed rival, Henri Matisse, who died in November 1954; Picasso immediately compensated for his friend's death in his series after Delacroix's *Women of*

SUSAN GRACE GALASSI

Algiers of 1954.[1] As the ageing artist became increasingly withdrawn from the artistic and literary milieu that had nourished his imagination through the early decades of his work, his camaraderie with the greats became more essential. They allowed him to escape the solitariness of the studio and confinement of himself. Through repetition he also staved off one of his greatest fears of old age – that of repeating himself, which he regarded as a form of artistic death. But if loss and compensation were the immediate spurs for launching his three major cycles, it was through its deep roots in core concepts of his aesthetic programme that variation became a means in his late years to both re-examine his achievement and to push further the limits of his art.

Variation shares its birth in Picasso's art with Cubism and is intimately connected with the revolutionary ideas with which he challenged the concept of art as an imitation of reality and replaced unity of style – an underlying principle of classical art – with plurality and disruption. In a group of studies of single nudes that immediately followed his explosive *Demoiselles d'Avignon* of 1907, Picasso submitted Ingres's *Grande Odalisque* (fig. 51) – a challenge to Classicism in its own right – to analysis and re-creation in his newly developed faceted vocabulary of form (fig. 52). In his gouache two representational systems come together in a new disjunctive unity. Picasso's first formal variation is almost an emblem for his new concept of visual art as a kind of structural language made up of signs.[2] In his 1917 interpretation of a seventeenth-century painting by Louis Le Nain he takes the concept one step further by layering historical references one on top of the other. Here he borrows the compositional structure of the peasant scene and his technique of painting from the colourful Neo-Pointillism of the late nineteenth and early twentieth centuries. Picasso once remarked: 'Basically I am perhaps a painter without a style. Style is something that locks a painter into the same vision, the same technique, the same formula…. I thrash around too much. I am never fixed and that's why I have no style.' In the Le Nain translation, he made clear his view of style as a set of historically changing codes from which the artist may choose and re-combine, rather than the direct expression of an individual sensibility or of a group at a particular moment in time.

Picasso went on to use variation sporadically. In 1932 he produced a series of extraordinarily inventive and nearly abstract surrealist pen-and-ink drawings after Matthias Grünewald's Crucifixion panel from the Isenheim Altarpiece, an icon of the movement. During the tumultuous days of the Liberation in Paris in August 1944 he translated Poussin's *Bacchanale* (1635–6; National Gallery, London) into a biomorphic Cubist style (location unknown),

Fig. 51
Jean-Auguste-Dominique Ingres (1780–1867)
La Grande Odalisque, 1814
Oil on canvas, 91 × 162 cm
Musée du Louvre, Paris

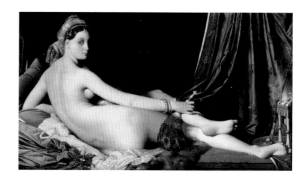

Fig. 52
Grande Odalisque, 1907
Ink and gouache on paper,
47.7 × 62.5 cm
Musée Picasso, Paris

bridging contemporary events with a mythological timelessness. A few years later, Lucas Cranach's *David and Bathsheba* (fig. 57) became the basis for a series of beautiful lithographs (cats. 35–6): he uses the German master's precise, linear style and crisp contours as an armature while renewing his interest in lithography and converts the biblical story of the ageing King David and the beautiful young Bathsheba into a witty allegory of his own relationship with the youthful Françoise Gilot (born 1921).

Picasso's 'old master period' opens with two impressive paintings based on El Greco's portrait of *An Artist* (figs. 61–2) and Courbet's *Young Ladies on the Banks of the Seine* (Petit Palais, de la Ville de Paris), made within weeks of each other early in 1950. The choice of works – one from nineteenth-century France and the other from the Spanish Golden Age – is significant. In his grand series of the 1950s after Delacroix, Velázquez, and Manet, he remains in these periods, two of the most significant in his artistic formation. The El Greco and Courbet paintings presage the themes of the large cycles as well: the female figure (clothed or nude) – the chief protagonist of all three – and the artist at work. While the female nude provides a continuous chain through the history of art, the subject of making art becomes the model for re-creation, leading the viewer to contemplate the

self-referential nature of art. Variation gains momentum and becomes essential to Picasso's artistic programme at the point at which looking back at his achievement is a natural part of the life cycle and the process itself becomes the focus of his ongoing experimentation. Though he had occasionally worked in serial form in his variations, it now became the rule. His long cycles explore the degree to which new creations can diverge from the source formally and thematically while still keeping it in evidence. These later variations take a more improvisational form akin to ruminations on the themes, styles, and creative process.

The idea of redoing Delacroix's *Women of Algiers* of 1834 (fig. 58) dates back to January 1940, when Picasso made drawings of some of the figures from the painting in a sketchbook in Royan. However, it took a combination of events and circumstances in the early 1950s – Gilot's departure with their two children in 1953, Matisse's death on 3 November 1954, and the chance resemblance of the new young woman in Picasso's life, Jacqueline Roque (1926–1986), to one of the figures in the painting – to propel Picasso through the door of the harem. The 15 canvases (eight small, intense and animated, followed by seven larger, more abstract and decorative), lithographs, aquatints and numerous drawings express his new-found libidinal bliss with Jacqueline, 45 years his junior, on Matissean ground. They continue in painting and drawing the spirit of his conversations with Matisse, in which they had affirmed their friendship through their mutual understanding of the same masters.[3] While the series was in progress, Picasso commented to his friend and biographer Roland Penrose: 'When Matisse died he left me his odalisques as a legacy, and this is my idea of the Orient, though I have never been there.'[4] Contemporary political events would also have made the *Women of Algiers* freshly relevant: on 1 November 1954 the revolt by the Front de Libération launched the long and bloody struggle for Algerian independence from France, which was finally achieved in 1963.[5]

In canvas A (cat. 38) Picasso zooms in, extracting three of the four figures from the dark recesses of the work – two wives and their black servant – and propels them into the foreground and bright light. As Leo Steinberg noted in his classic essay on the series, Picasso took off from both the familiar 1834 masterpiece in the Louvre and Delacroix's later version of 1849 from the Musée Fabre in Montpellier (fig. 53).[6] He immediately condenses the format of the original from large to small in a composition of jumbled bodies, decorative furnishings and colourful patterns. The coffee pot resting on the outstretched hand of the servant is Picasso's own addition – perhaps a nod to Cézanne's *Afternoon in Naples* (about 1875; National Gallery of Australia, Canberra). Jacqueline's counterpart, the hookah smoker in the original, has

Fig. 53
Eugène Delacroix (1798–1863)
Women in an Interior, 1847–9
Oil on canvas, 85 × 112 cm
Musée Fabre, Montpellier

now receded into sleep in a distinctly Matissean attitude, with head resting on folded arms. The servant gracefully exiting at the right in the original work now hurtles along, while the dreamy middle figure of the original here takes over the hookah and sits erect and alert, her semi-nude body nuzzling up to the phallic ogive niche. In subsequent versions Picasso explored the composition with all four figures (cat. 39), and by canvas E (cat. 40) returns to three. With the 'Jacqueline' figure now recumbent, legs hoisted in air, Picasso dives in to a formal problem, analysed by Steinberg, that absorbed him through much of the series: combining prone and supine positions of the body in a single contour.[7] Matisse's presence is made clear through a reference to his revolutionary *Blue Nude (Souvenir de Biskra)* of 1907 (Baltimore Museum of Art), which dates to the earliest years of the artists' friendship and competition. The backward-looking servant is here moved in front of an invented doorway leading out of the back of the room. Picasso appears to be thinking of the chamberlain pausing on the steps leading out the back in *Las Meninas* (fig. 59) – a synecdoche of the whole – in antici-pation of his next interpretive journey. The tripartite composition of this variation brings to mind Ingres's *Odalisque with a Slave* (fig. 46), a painting in which Ingres appears to intrude on Delacroix's artistic territory, as does Picasso on Matisse's here. Picasso's relationship to his contemporary is mirrored in the aesthetic opposition of their predecessors – two of the artists they both most admired.

In the final canvas (cat. 41) the space of the interior is re-created in Picasso's late Cubist style, while the intense colour, decorative patterning and subject of the odalisque are distinctly Matissean. The two artists are joined by the ghosts of others who had haunted the harem in their time – Cézanne, Courbet, and Renoir – while Velázquez's *Las Meninas*, again alluded to in the servant in the doorway, remains a latent theme. A triumphant bare-breasted figure with a hookah now dominates the others through her size and naturalistic idiom, a descendant of Matisse's Nice-period seated odalisques, while her face is distinctly Jacqueline's. In the continuing transformation of his harem/studio/brothel, in which identities are in flux, Picasso extends in serial form his view of art as a language made up of codes in which nothing is fixed. In a 1923 interview with Marius de Zayas, Picasso said: '... from the point of view of art there are no concrete or abstract forms, but only forms that are more or less convincing lies. That those lies are necessary to our mental selves is beyond any doubt, as it is through them that we form our aesthetic point of view of life.'[8]

Diego Velázquez's *Las Meninas* (fig. 59) was the ultimate challenge for Picasso. He had known the painting since his first visit to the Prado aged 14 with his father, a visit that occurred just months after the tragic loss of the youngest Ruíz child, the 7-year-old, blond-haired Conchita, to diphtheria. In August 1957, 62 years later, Picasso sequestered himself in an improvised workplace on the unused third floor of his villa La Californie, near Cannes, and moved into Velázquez's studio. Over a four-month period, 45 paintings, from pocket-sized oil sketches of the Infanta's head to brilliant interpretations of the ensemble, poured forth. The sense of arrested motion in a quiet drama immediately draws the viewer into a scene, which appears on the surface to be almost a factual document of an actual event – a sitting taking place in the royal studio. On closer examination, however, the relations between the artist, models and figures beyond the confines of the depicted space are extraordinarily complex – a challenge seemingly created for a latter-day descendant of Velázquez, who relentlessly pursued questions about representation, and the relation of perception and conception.

The first painting in this series (cat. 44) is by far the largest. Picasso turns the vertical format of the original to horizontal and reorganises the composition, pulling the central figures into a triangle with the chamberlain at the top. The composition and grisaille tonality bring to mind his own last masterpiece, *Guernica* (fig. 43) – for which *Las Meninas* was in fact among his sources. Working from left to right, he recreates the artist and his easel in a painterly Cubist idiom and endows this 'giant' with two facing profiles and two brushes and palettes. As he progressed, Picasso adopted a simpler,

Fig. 54 (Detail of fig. 59)
Diego Velázquez (1599–1660)
The Family of Philip IV ('Las Meninas'),
1656
Museo Nacional del Prado, Madrid

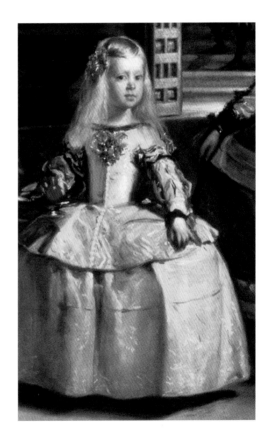

childlike style for the Infanta and her retinue, leaving in outline the boy dwarf and the dog, replacing the royal mastiff with his own mascot, his dachshund Lump. This first painting in the series is the closest to the original and the most naturalistic; through abstract means he conveys the sense of depth of the atmospheric space. At the back of the room a small but threatening shadow figure stands in the stair – the chamberlain – who had, as we have seen, already appeared in different guises in the *Women of Algiers* in an announcement of coming attractions. Here the chamberlain becomes Picasso's surrogate, the seer from the back who holds the key to the mystery of *Las Meninas*.

After this initial study, Picasso devoted the next 26 canvases to studies of individual figures alone or in small groups. The chief protagonist of the series, the radiant Infanta (fig. 54), steps forward in a suite of canvases. She leads Picasso through his repertoire of styles, beginning with several Cubist grisailles in which he analyses her in terms of light and dark and mimics Velázquez's own painterly spontaneity (cat. 45). In one of these works, the Infanta resembles Picasso's own young Paloma while the suite perhaps pays tribute to the memory of his sister.

From 9 to 16 September Picasso refreshed his senses with nine paintings of the pigeons flying in and out of the dovecote on the balcony of the studio. On 14 September he returned to the Infanta in a farewell image, bathing her in the brilliant light of his window scenes (cat. 46). Here her frontal body clothed in her wide, geometric dress, is surmounted by a large head with her usual combined profile and frontal face. Her squat proportions suggest a conflation with her dwarf. The sun-struck radiance of her yellow dress and the greens, blues and touches of red of her head and hair are set off against a dark reddish-brown 'old master' background. Picasso's series, which occupied him on and off until 30 December, reached a climax in works devoted to the composition as a whole in brilliant colour in a crystalline Cubist style that resemble stained glass.

Edouard Manet's *Luncheon on the Grass* of 1863 (fig. 60) provided another kind of testing-ground for Picasso. As with the previous two series, the idea of intervening in this particular masterpiece was longstanding and imbued with a sense of inevitability. On the back of an envelope of the Galerie Simon in 1932 he wrote: 'When I see Manet's *Déjeuner sur l'Herbe* I say to myself: grief for later'.[9] He had known the work, however, since his early years in Paris. In reinterpreting the *Luncheon on the Grass*, the *succès de scandale* of the famous Salon des Refusés of 1863, Picasso takes on the modernist masterpiece of 'art after art' – a re-creation of works of the past in a spirit of parody and disruption. Manet intended to shock his audience through his appropriation of the subject matter of the *Concert Champêtre*

in the Louvre by Titian (once attributed to Giorgione) and the figural
arrangement of the river gods in Marcantonio Raimondi's famous engraving
after Raphael's *The Judgement of Paris*. In Manet's hands, the mythological
figures are brought down to earth to become two studio models –
undressed and semi-clothed – picnicking with fashionably dressed male
artist companions on a leafy bank of a stream, which appears as nothing
more than a painted backdrop. Picasso pits his own powers of creative
appropriation against those of Manet, while taking the transformation in
new directions. This may account in part for the looser nature of the
connection with his theme and the free and sporadic flow of works in
several different media that make up the cycle, comprising 27 paintings,
140 drawings, three linogravures, and cardboard maquettes for sculpture
carried out between 1959 and 1962. Picasso's move to the remote château
of Vauvenargues near Cézanne's home in Aix-en-Provence in September
of 1958, which brought him back to the land and landscape painting, was
a spur for taking on the project.

The three paintings included here show the range of expression. The first
Luncheon on the Grass (cat. 47) is a large, bold canvas from the beginning
of the series forming part of a thematic group which has been loosely
designated as a country outing.[10] Here, Picasso follows more or less faithfully
the composition of the figures and the pervasive green tonality of his source,
with touches of blue for the water, and yellow and orange for the fruit.
Everything else is transformed: the figures are now Picassoid in character,
while the strong contrast of light and dark and shallow space of the original
is pushed to an extreme of poster-like flatness. Manet's curvaceous nude is
subjected to highly sophisticated simplification in which she is seen from
multiple persectives. In an empty, flat, fleshy pink pyramidal form, Picasso
inscribes minimal signs for face, hand, breasts, buttocks and genitals. The
nude's female companion stooping over in the stream (now a puddle)
refers both to her Manet counterpart and to Rembrandt's *Woman Bathing
in a Stream* (1654; National Gallery), while the male in the foreground who
holds forth in conversation sports a pair of checked trousers, a style Picasso
himself favoured.

All vestiges of the narrative and of mondaine life are shed in another
thematic group, to which the other two *Luncheons* (cat. 48–9) belong.
In both paintings, all four figures are completely nude and enclosed in a
grotto-like setting in which the male in the foreground continues to lecture
to the seated female nude, while the others read and wade. Daylight is
replaced with an indeterminate light, and the figures appear as if cast in
plaster. There is a sense of timelessness, if not stagnation and captivity,

Fig. 55 Detail of fig. 60
Edouard Manet (1832–1883)
The Luncheon on the Grass, 1863
Oil on canvas, 208 × 264.5 cm
Musée d'Orsay, Paris

Fig. 56 Detail of cat. 47
**Luncheon on the Grass
(after Manet)**, 20 February 1960
Oil on canvas, 60 × 73 cm
Nahmad Collection, Switzerland

Notes

1 See Martin and Doka 2002, on the ways
 in which men process loss by immediately
 filling the void.

2 Y.A. Bois, 'The Semiology of Cubism', in Rubin and
 Zelevansky 1992, p. 175. With thanks to Robert
 Lubar for an initial discussion of the linguistic
 nature of Cubism.

3 Françoise Gilot, Picasso's companion of the late
 1940s and early 1950s, who was present during
 several conversations between the
 two ageing titans, noted that they 'wanted
 to verify that the very foundation of their
 friendship was on solid ground: *a mutual
 understanding of the same artists and the same
 principles*' (Gilot 1990, p. 95).

4 Penrose 1958, pp. 351–2.

5 Daix 1993.

6 Steinberg 1972, pp. 125–234.

7 Steinberg 1972, p. 142.

8 M. de Zayas, 'Picasso Speaks', reprinted in Ashton
 1972, p. 64.

9 'Quand je vois le Déjeuner sur l'herbe de Manet,
 je me dis, des douleurs pour plus tard' (Archives
 Picasso, Paris).

10 Cooper 1962, p. 34.

11 G.R. Utley, '"Más Meninas": Through the
 Looking Glass, Repeatedly', in Barcelona 2008.

12 Gilot 1990, p. 90.

13 See expanded discussion in Galassi 1996, pp. 8–24.

14 See M. Beard and J. Henderson on imitation
 in Classical art in Beard and Henderson 2001, p. 71.

15 Utley in Barcelona 2008.

within the grotto, a kind of primal space. Here the figures become more sculptural and the luncheon party metamorphoses into the timeless realm of Cézanne's late bathers. Picasso's homage extends now to both of his most significant modernist forefathers, Manet and Cézanne. In the paintings that follow, the figures are subjected to whimsical transformation as they loom up and dominate one another, while others shrink in a dream-like sequence. Picasso continued to mine the rich vein of formal and thematic issues that kept Manet's *Luncheon on the Grass* a continuous source of inspiration for several years.

Picasso's lengthy excursions into art history have often been regarded by critics as evidence of a failure of imagination, or worse, an embarrassing demonstration of envy, rage and braggadocio. Painted at a time when Abstract Expressionist artists were trumpeting the values of individuality and originality, Picasso's obsession with large multi-figure compositions and narrative subject matter seemed distinctly old guard.[11] Variation did serve an important retrospective function in his work and a means of situating himself in the 'great chain of artists'.[12] As we have seen, it was also a means of extending the limits of artistic expression through continual transformation of current and historic styles, which are themselves treated as sign systems and subject to change depending on the context in which they are used.[13] Variation was also a means of directly confronting the relation between originality and imitation, and of foregrounding the critical component of all creative activity in which each new work builds on the achievements of its predecessors. In some of his variations Picasso appears to leave his source behind in the extremity and at times brutality of his re-creations. Yet even in ruthless parody, he affirms his roots in the classical tradition in which imitation and originality are recognised as reciprocal parts of each other; indeed, imitation is considered essential to creativity.[14] He would have absorbed this concept through his earliest school exercises in which he learned to draw by copying works which were themselves variations – modern plaster casts of Roman copies of Greek originals. In his interpretations of works of the past that held him captive over a lifetime, he lays bare his creative firmament as well as the process through which he worked his way out of them to add something uniquely his own. With this last chapter he closes the circle of his art and at the same time opens the way for the younger generation of artists, those who followed the Abstract Expressionists and reacted against their dogmatic cult of originality.[15] For the 1960s Pop artists and the succeeding generations of postmodernists, Picasso's variations entered into the mainstream of iconic masterpieces and served themselves as sources for re-creation.

Fig. 57
Lucas Cranach the Elder
(1472–1553)
David and Bathsheba, 1526
Oil on canvas, 38.8 × 25.7 cm
Gemäldegalerie, Berlin

Cat. 35
David and Bathsheba, state 8,
10 April 1949
Lithograph, 64.4 × 48.5 cm
The British Museum, London
(1995,6-18-27)

119

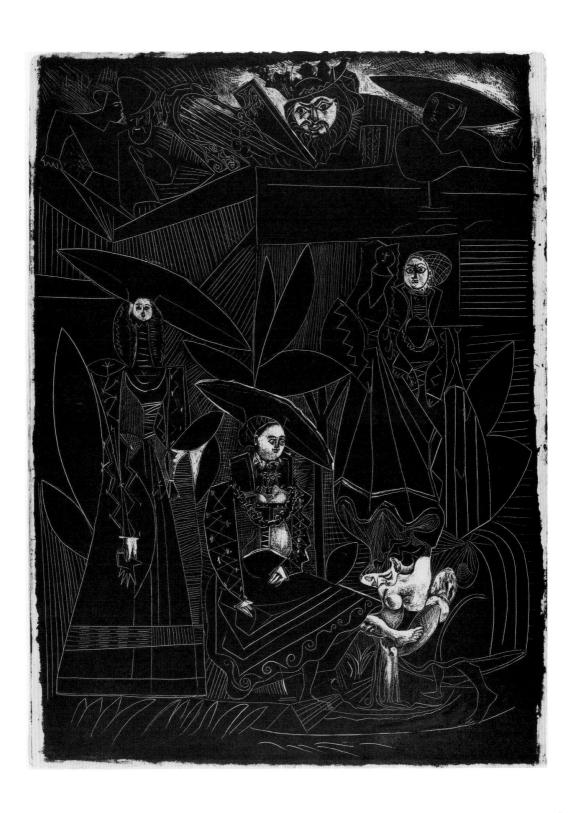

Cat. 36
David and Bathsheba, state 2,
30 March 1947
Lithograph, 65.5 × 48.8 cm
The British Museum, London
(1966,7-23-4)

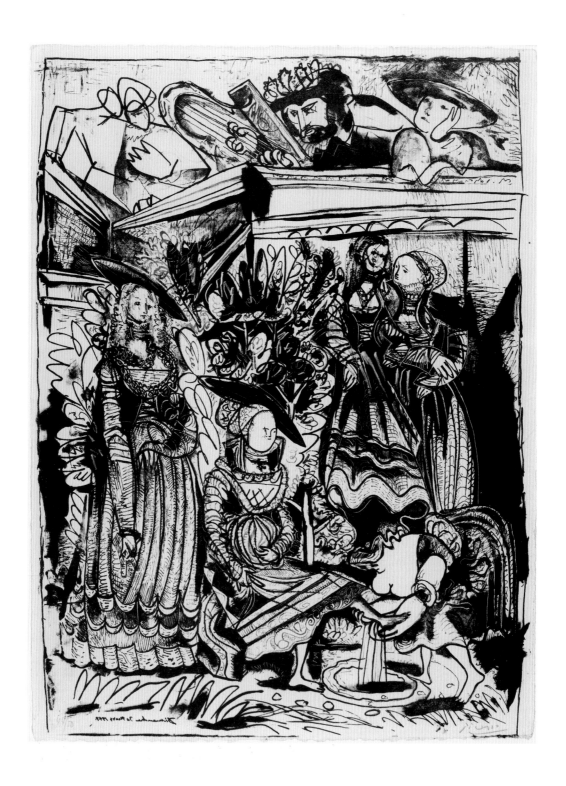

Cat. 37
**Portrait of a Woman (after
Cranach the Younger)**, 1958
Linocut, 64.5 × 53.5 cm
Tate, London (P11368)

121

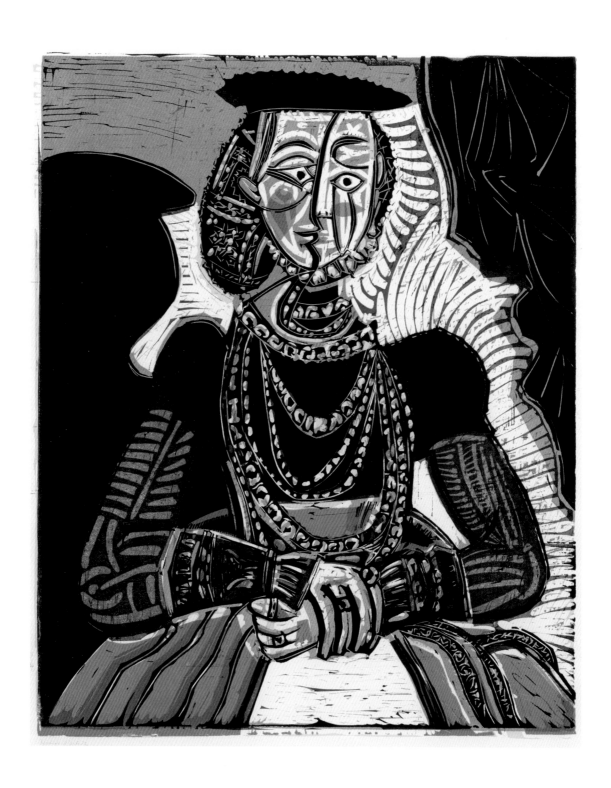

Fig. 58
Eugène Delacroix (1798–1863)
Women of Algiers, 1834
Oil on canvas, 180 × 229 cm
Musée du Louvre, Paris

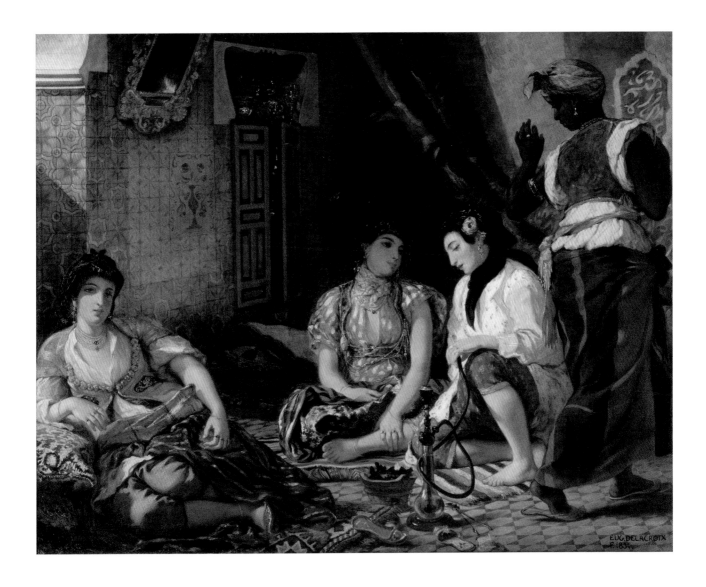

Cat. 38
**Women of Algiers (A)
(after Delacroix**),
13 December 1954
Oil on canvas, 61.5 × 72.2 cm
Wadsworth Atheneum Museum
of Art, Hartford, Connecticut
Gift of the Carey Walker
Foundation (1994.2.2)

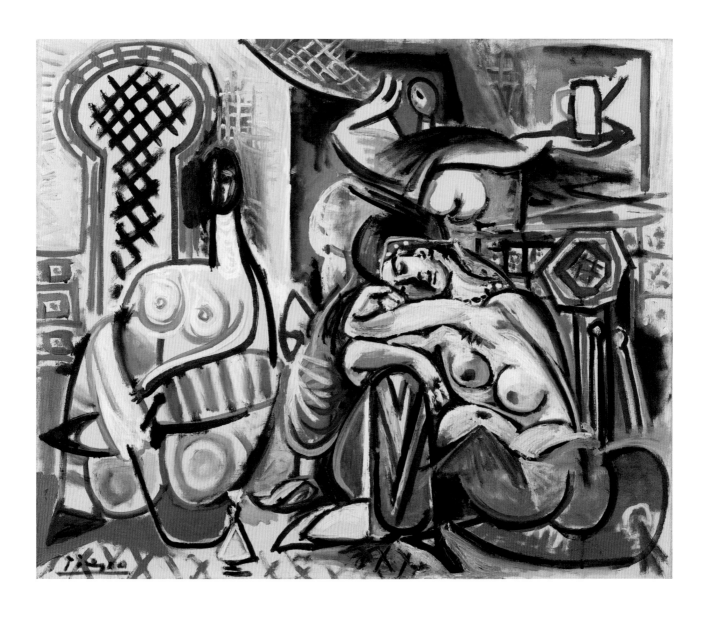

Cat. 39
Women of Algiers (C)
(after Delacroix),
28 December 1954
Oil on canvas, 54 × 65 cm
Nahmad Collection, Switzerland

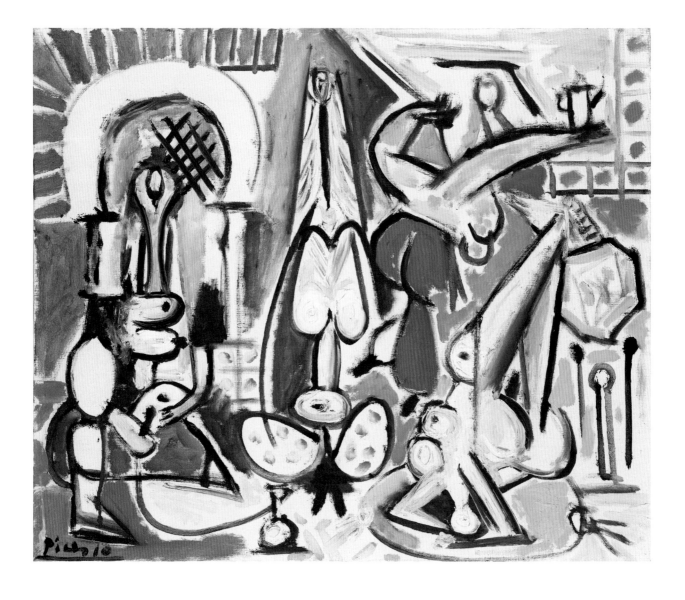

Cat. 40

Women of Algiers (E)
(after Delacroix), 16 January 1955
Oil on canvas, 46.1 × 55 cm
San Francisco Museum of Modern Art
Gift of Wilbur D. May (64.4)

125

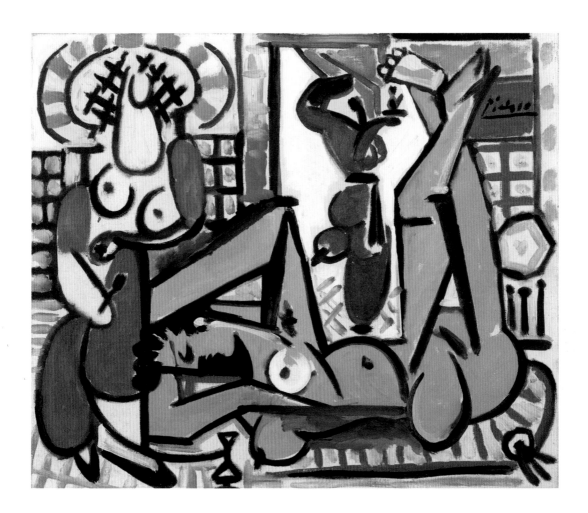

Cat. 41
Women of Algiers (O)
(after Delacroix),
14 February 1955
Oil on canvas, 114 × 146.4 cm
European private collection,
courtesy of Libby Howie

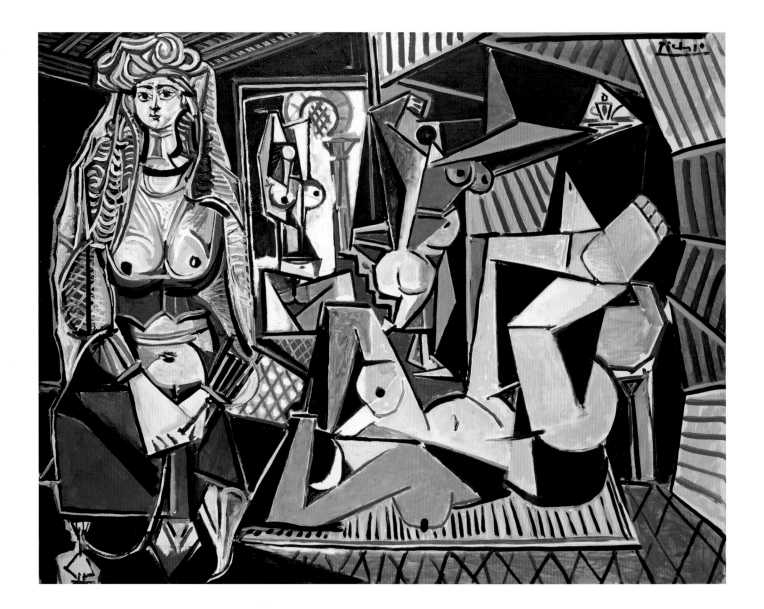

Cat. 42
**Portrait of Jacqueline in
Turkish Costume**,
20 November 1955
Oil on canvas, 100 × 81 cm
Private collection

Cat. 43
Nude in Turkish Head-Dress,
28 December 1955
Oil on canvas, 116 × 89 cm
Centre Georges Pompidou, Paris,
Musée national d'art moderne /
Centre de création industrielle
Gift of Louise and Michel Leiris 1984
(AM1984-637)

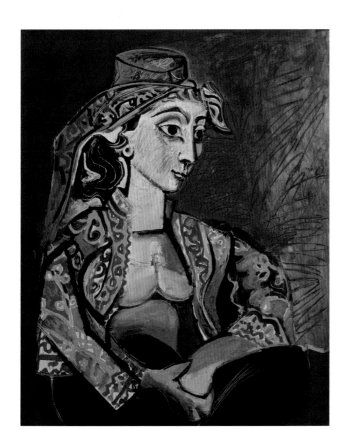

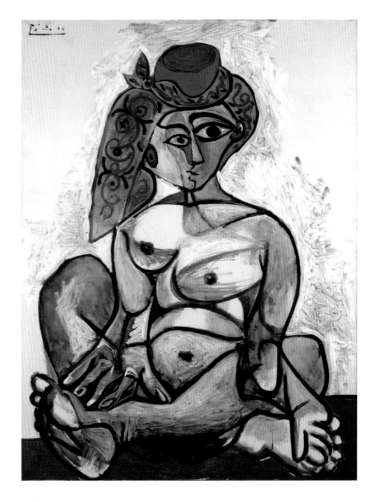

Fig. 59
Diego Velázquez (1599–1660)
The Family of Philip IV ('Las Meninas'),
1656
Oil on canvas, 318 × 276 cm
Museo Nacional del Prado, Madrid

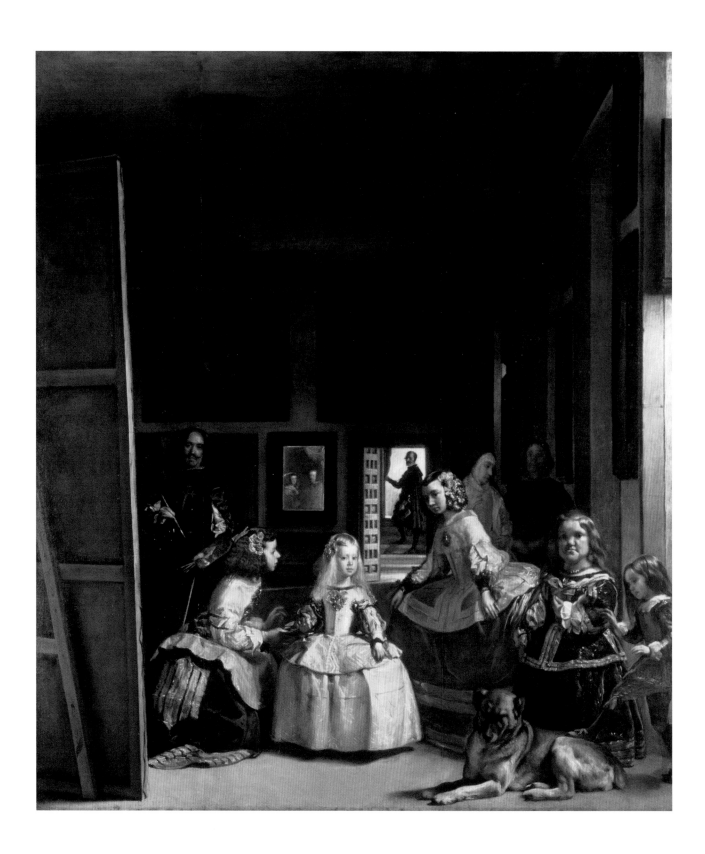

Cat. 44
Las Meninas (after Velázquez),
17 August 1957
Oil on canvas, 194 × 260 cm
Museu Picasso, Barcelona
(MPB 70.433)

129

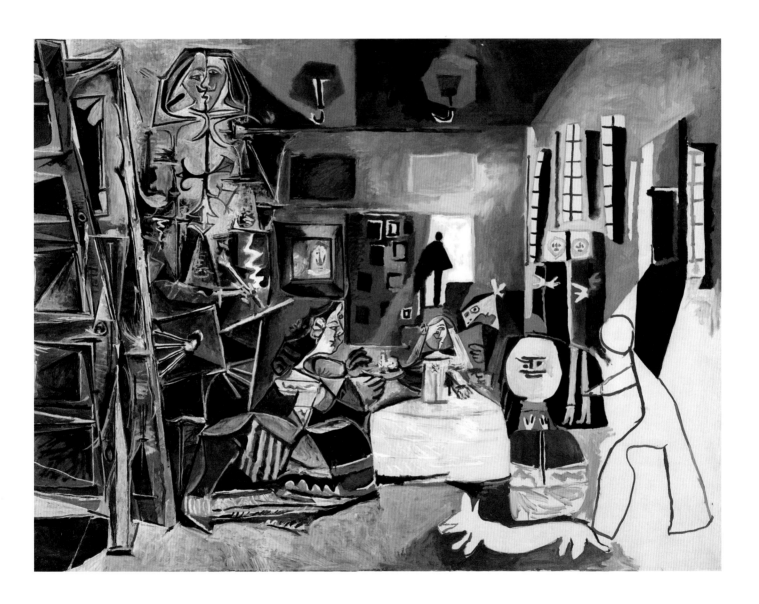

Cat. 45
The Infanta Margarita María,
21 August 1957
Oil on canvas, 100 × 81 cm
Museu Picasso, Barcelona
(MPB 70.436)

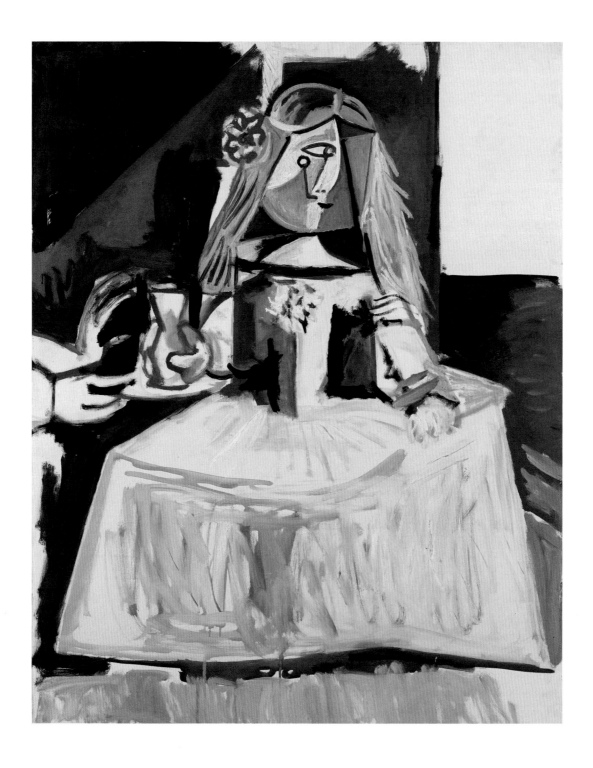

Cat. 46
The Infanta Margarita,
14 September 1957
Oil on canvas, 100 × 81 cm
Museu Picasso, Barcelona
(MPB 70.459)

131

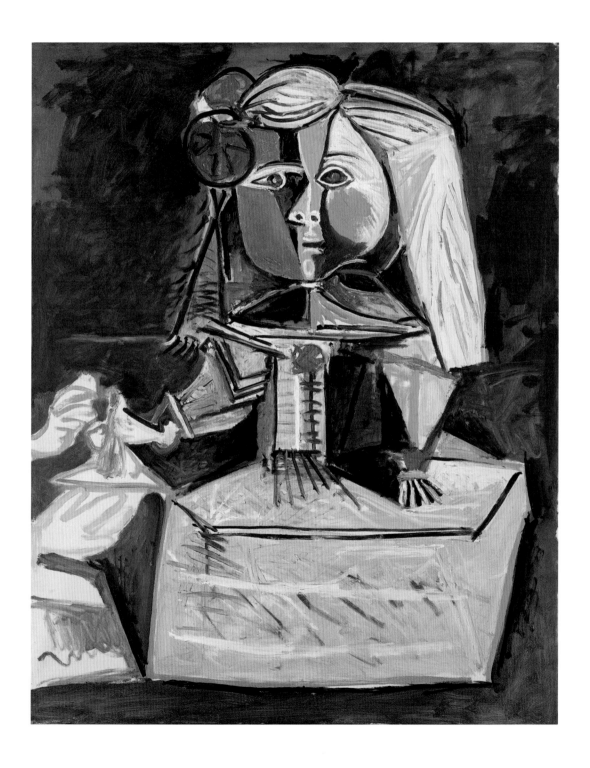

Fig. 60
Edouard Manet (1832–1883)
Luncheon on the Grass, 1863
Oil on canvas, 208 × 264.5 cm
Musée d'Orsay, Paris

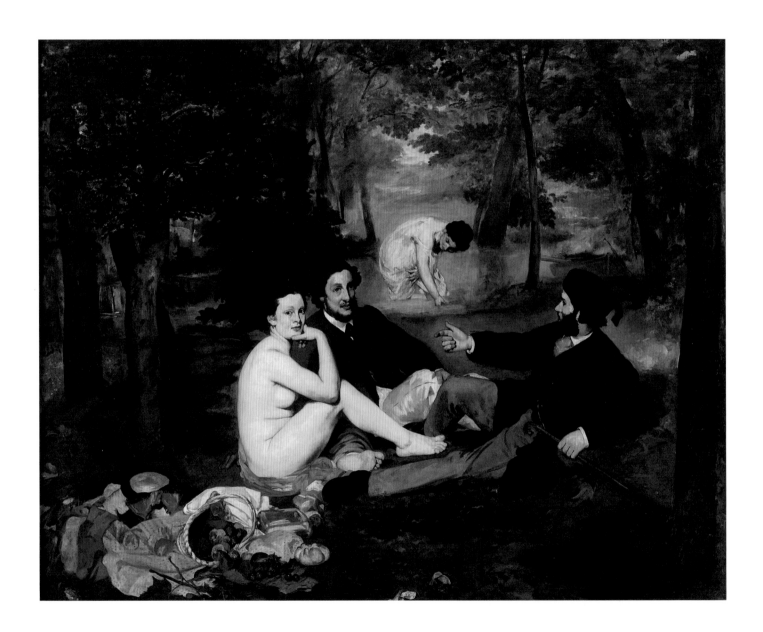

Cat. 47
**Luncheon on the Grass
(after Manet)**,
20 February 1960
Oil on canvas, 60 × 73 cm
Nahmad Collection,
Switzerland

133

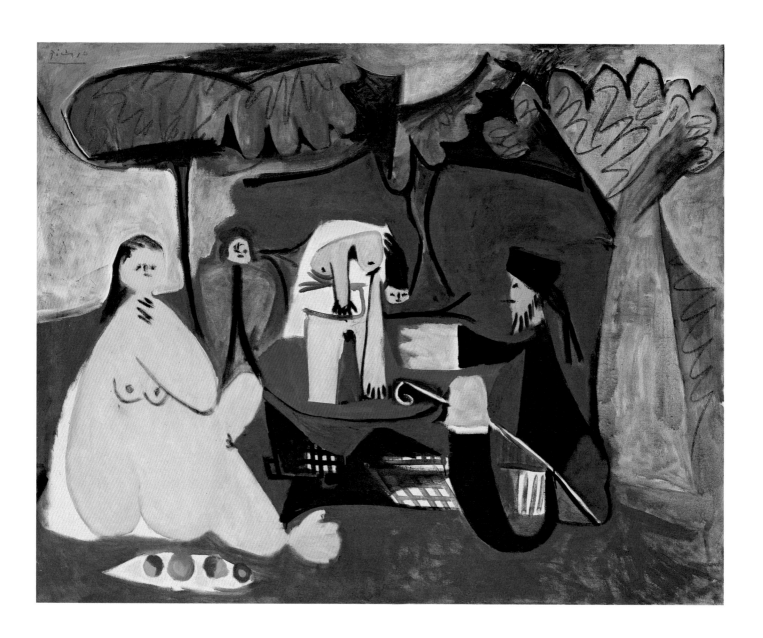

Cat. 48
**Luncheon on the Grass
(after Manet)**, 12 July 1961
Oil on canvas, 81 × 99.8 cm
Musée Picasso, Paris (MP216)

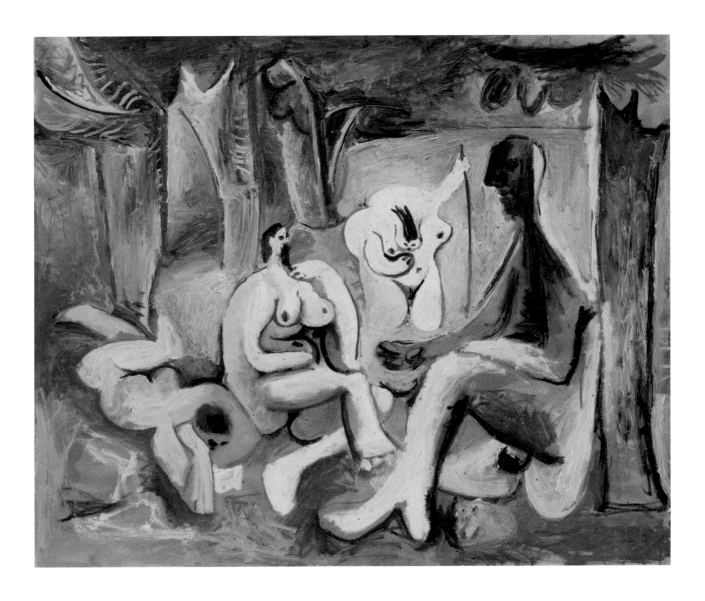

Cat. 49
**Luncheon on the Grass
(after Manet)**, 13 July 1961
Oil on canvas, 60 × 73 cm
Musée Picasso, Paris (MP217)

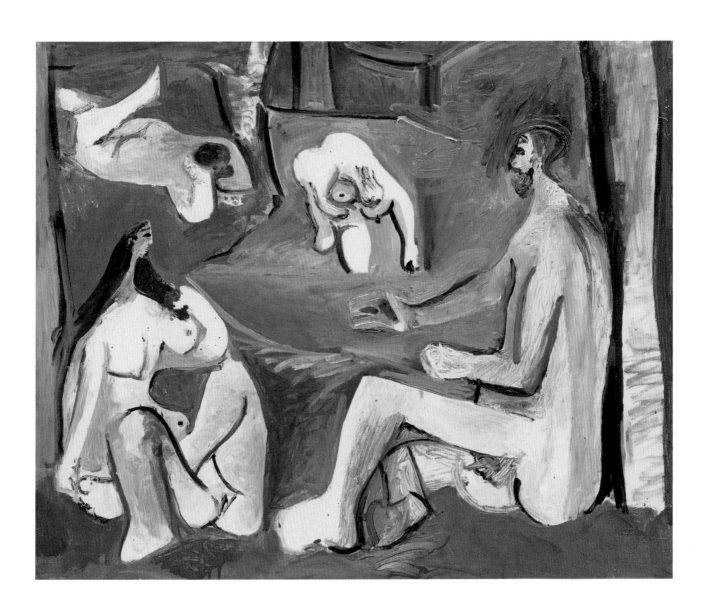

Cat. 50
Seated Woman (after Manet's Luncheon on the Grass),
26 August 1962
Pencil on both sides of cut-out
and folded cardboard
Musée Picasso, Paris (MP1831)

Cat. 51
Seated Man resting on Elbow (after Manet's Luncheon on the Grass), 26 August 1962
Pencil on both sides of cut-out
and folded cardboard
Musée Picasso, Paris (MP1841)

Cat. 52
**Bathing Woman
(after Manet's Luncheon
on the Grass)**, 27 August 1962
Pencil on both sides of cut-out
and folded cardboard
Musée Picasso, Paris (MP1834)

Cat. 53
**Seated Man resting on Elbow
(after Manet's Luncheon
on the Grass)**, 31 August 1962
Pencil on both sides of cut-out
and folded cardboard
Musée Picasso, Paris (MP1847)

Cat. 54
Female Nude by a Spring, 1962
Linocut, 1st state of 3, pure line proof,
begun 20 April, 52.7 × 63.8 cm
The British Museum, London.
Purchased with the assistance of
The Art Fund
(2000,05-21.1)

Cat. 55
Female Nude by a Spring, 1962
Linocut, 1st state of 3,
progressive proof, 52.8 × 63.8 cm
The British Museum, London.
Purchased with the assistance of
The Art Fund
(2000,05-21.2)

Cat. 56
Female Nude by a Spring, 1962
Linocut, 2nd state of 3,
pure line proof, 52.8 × 63.8 cm
The British Museum, London.
Purchased with the assistance of
The Art Fund
(2000,05-21.3)

Cat. 57
Female Nude by a Spring, 1962
Linocut, 3rd state of 3,
pure line proof, 52.8 × 63.8 cm
The British Museum, London.
Purchased with the assistance of
The Art Fund
(2000,05-21.5)

Cat. 58
Female Nude by a Spring,
8 May 1962
Linocut, 2nd state of 3,
progressive proof, 52.9 × 64 cm
The British Museum, London.
Purchased with the assistance of
The Art Fund
(2000,05-21.4)

Cat. 59
Female Nude by a Spring, 1962
Linocut, 3rd state of 3,
progressive proof, final stage
before the edition, 52.8 × 64 cm
The British Museum, London.
Purchased with the assistance of
The Art Fund
(2000,05-21.6)

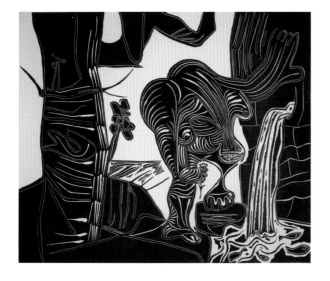

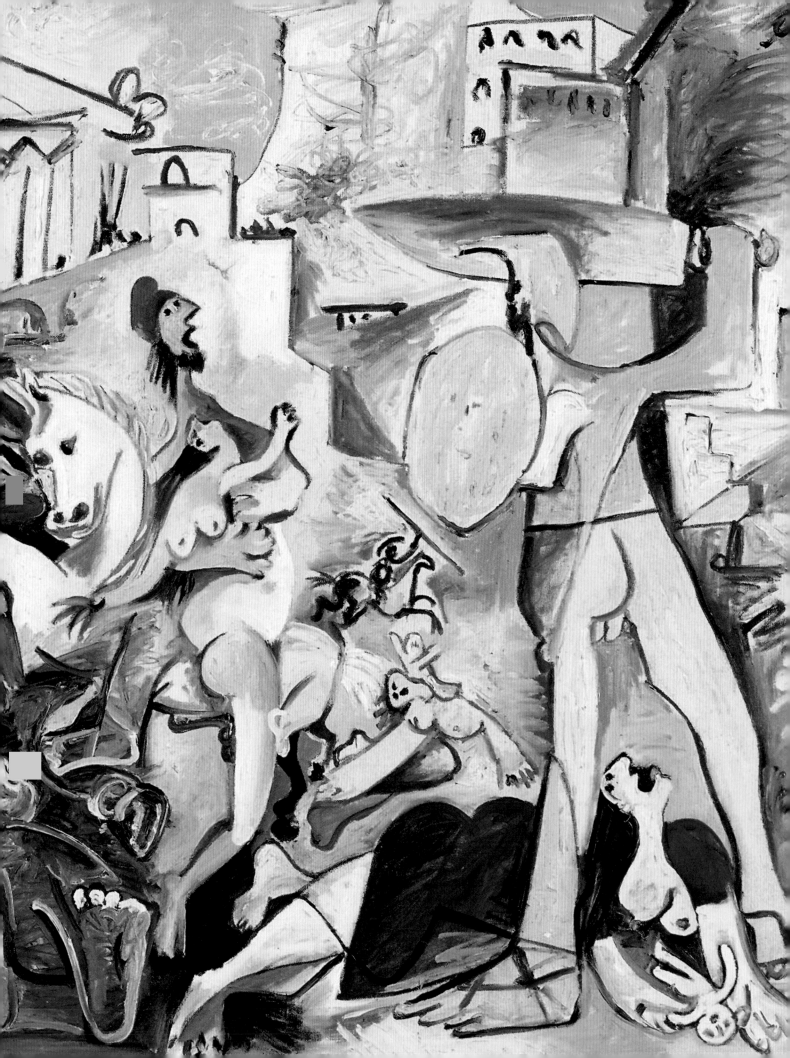

In August 1944, during the days of the Liberation of Paris, Picasso painted a watercolour and gouache entitled *Bacchanale, The Triumph of Pan*,[1] after Poussin. The intense revelry of the scene, with its vibrant colours, corresponded to the jubilation of the Parisian people. Picasso too felt liberated from the virtual 'imprisonment' he had endured in Paris during the German Occupation, and the fact that he chose to emulate the emotionally charged image by the great classicist was not fortuitous. Nicolas Poussin represented the hegemony of the great Western tradition, a tradition with which Picasso identified and through which he sought to renew the language of art. By making art from art, Picasso would set out to 'liberate the present through the past'.[2] His neo-Cubist interpretation of the bacchanal[3] was to herald a whole series of paraphrases and variations on the work of past masters, which would occupy him for the remaining decades of his life.

Picasso joined the French Communist Party in October of the same year.[4] He had admired the Communists for their role in the French Resistance and also for their continued hostility to General Franco's Fascist regime in Spain, to which he was violently opposed. For the next few years he tried to demonstrate his support for the Party through his art, but he never adopted the social realist style which they advocated. His adherence to Communism was to provoke heated debates among French critics – Left and Right – as they tried to re-establish what they perceived to be the superior virtues of French culture in the aftermath of the war. Those in favour of the revolutionary Communist ideals criticised him for not adhering to the Party's artistic policies, while right-wing critics questioned whether as a 'foreigner' he had any place at all within the pantheon of French art.[5] Picasso's reaction to these debates was to remove himself from the fray. In 1946, having been offered a place to work in the Château Grimaldi in Antibes, he decided to move to the South of France with his young lover, Françoise Gilot.[6] Although he kept an apartment in Paris, and occasionally travelled – most notably to attend peace conferences – he was to spend much of the rest of his life on the Côte d'Azur.[7]

Picasso became more and more concerned with his place within the history of art. This could have been prompted by the recent debates concerning French art and his role in it, or simply by advancing age. In many respects he saw himself as the last great master of classical painting.[8] Throughout his career he had pillaged the art of the past and the present, not through a lack of imagination, but in a desire to confront the masters he venerated. By dissecting (some have called it 'cannibalising'[9]) their masterpieces to create new works, Picasso achieved a 'metaphoric communication' with other great masters .[10] Unable to return to his native country,[11] and also distanced from the great repositories of earlier art in the museums of Paris,

Looking at the Past to Defy the Present: Picasso's Painting 1946–1973

SIMONETTA FRAQUELLI

Picasso began working primarily from memory or with *aides-mémoire* such as photographs and postcards.

The return to the Mediterranean environment had provoked a nostalgia for his native land and led him to re-engage with the pictorial tradition of his Spanish heroes, El Greco, Velázquez and Goya. Picasso had participated in the 're-discovery' of El Greco during his years in Barcelona in the late 1890s and he had first admired the paintings of the two other masters while visiting Madrid in 1895.[12] He was drawn to the unconventional classicism of this Spanish triumvirate, which the art historian Jonathan Brown has referred to as a form of counter-classicism.[13] They eschewed the emphasis on harmony and balance of the Italians, choosing often to ignore the laws of perspective and to shun foreshortening. Instead, they employed austere monochrome backgrounds which intensified the presence of their figures.

In February 1950 Picasso painted two handsome 'paraphrases'. In his *Young Ladies on the Banks of the Seine, (after Courbet)* (Öffentliche Kunstsammlung Basel, Kunstmuseum) he retained the sexual ambiguity of Courbet's image and translated his painterly drapery into a series of intricate linear patterns. Courbet's 'young ladies', who are not young at all, anticipate the picnickers of Edouard Manet's luncheon party which were to engage Picasso almost a decade later in his variations on *Luncheon on the Grass* (fig. 60). Picasso's *Portrait of an Artist, (after El Greco)* (fig. 62), with its striking palette of blacks, browns, ochre and white, evokes the drama of the original image and launched Picasso's direct homages to the masters of Spain's Golden Age. This would reach its zenith with his variations after Diego Velázquez's *Las Meninas* (fig. 59). For four months during 1957 Picasso dedicated himself to the Andalusian master's great work, devoting 58 artworks to the masterpiece, in which he re-analysed the complex network of visual relationships between painter, subject and model, and viewer (cats. 44–6).[14]

The recurrent theme of death in Spanish art is also omnipresent in Picasso's still lifes of the 1940s and early 1950s. Mementi mori – reminders of mortality – appear in many guises: skulls, dead animal heads, candles, even leeks;[15] their sombre tones and foreboding backgrounds recall the *vanitas* paintings, the Spanish *bodegón*, of artists such as Juan Sánchez Cotán (1560–1627), Francisco de Zurbarán (1598–1664) or Antonio de Pereda (1611–1678). Death was very much on his mind when he painted his *Goat's Skull, Bottle and Candle* in 1952 (fig. 63), for it was around this time that the partisan and Communist leader Nikos Beloyannis was executed by the Greek government. Picasso had followed his case closely and was deeply saddened by the death. As was often the case he referred to this current event only implicitly in his painting.

Fig. 61
El Greco (1541–1614)
An Artist (Jorge Manuel Theotokopoulos), 1600–5
Oil on canvas, 81 × 56 cm
Museo de Bellas Artes de Sevilla

Fig. 62
Portrait of an Artist, (after El Greco), 1950
Oil on canvas, 100.5 × 81 cm
Rosengart Collection, Lucerne

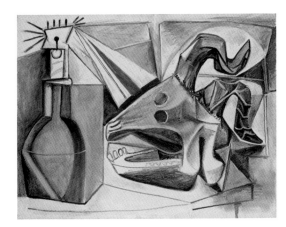

Fig. 63
Goat's Skull, Bottle and Candle, 1952
Oil on canvas, 89 × 116 cm
Musée Picasso, Paris

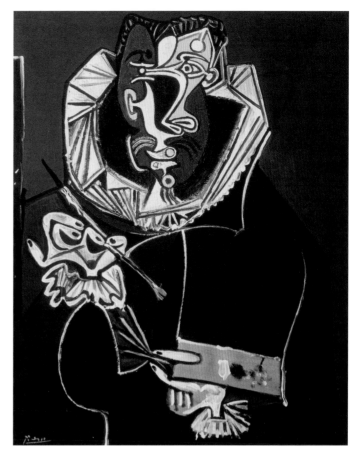

In 1954 Picasso embarked on his series of variations after Eugène
Delacroix's *Women of Algiers* (fig. 58; see cats. 38–41). He had recently
become close to a young divorcee, Jacqueline Roque (see cat. 42), whom he
had met in 1952 and would marry in 1961. It was partly her physical similarity
to one of the female figures represented in the *Women of Algiers* that
inspired his re-examination of the painting (see p. 110 above).

Delacroix's image (in which the women are the models for the orientalist
painter) re-introduced the theme of artist and model that was to preoccupy
Picasso for much of the latter part of his life.[16] In April 1955 he purchased
a villa in Cannes called 'La Californie'. The *grand salon* of the villa, which
became Picasso's main atelier, features in a series of works he painted during
the six years he lived there. He referred to these as 'interior landscapes': like
a self portrait they record and reveal the life and work of the artist. The
decorative vein of some of the works in the series, with their bright colours,

recall the paintings of Matisse, while others with more muted tones and structured compositions seem to have been painted in response to the audacious compositions of George Braque's contemporaneous studio paintings.[17]

Picasso's evocation of the art of earlier masters also emerged in two of his last major political statements. The first of these, *Massacre in Korea* of 1951 (fig. 64), was intended to reflect the anti-American stance of the Communist Party vis-à-vis the Korean War. However, the artist's decision not to identify the aggressors, depicted as cartoon robot-like warriors shooting at a group of terrified women and children, disappointed his comrades.[18] He had drawn on two related and highly successful political statements of the art of the past for his grisaille composition of the *Massacre*: Goya's indictment of formalised slaughter in his image of the firing squads, *The 3rd of May 1808* (fig. 65) and Manet's traumatic image of the *Execution of Maximillian* (1868–9; Kunsthalle, Mannheim). That Manet should often provide the impetus for Picasso's later works is not surprising. The nineteenth-century artist was a strong advocate for Spanish art and although he visited Spain only once, in 1865, where he was particularly taken with the art of Velázquez, he had been painting images with a distinctly Spanish flavour since the late 1850s.[19]

After the failure of the *Massacre* painting to win the approval of the Communist Party, Picasso withdrew his support, although he would remain a member for the rest of his life. A series of works entitled the *Rape of the Sabines*, begun in 1962 (cats. 73–4) in response to the Cuban missile crisis

Fig. 64
Massacre in Korea,
18 January 1951
Oil on wood, 110 × 210 cm
Musée Picasso, Paris

Fig. 65
Francisco de Goya (1746–1828)
The 3rd of May 1808, 1814
Oil on canvas, 266 × 345 cm
Museo Nacional del Prado,
Madrid

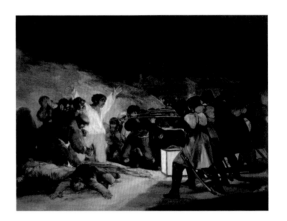

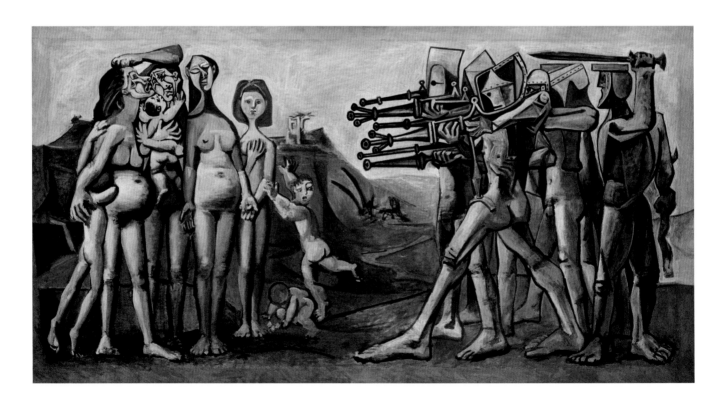

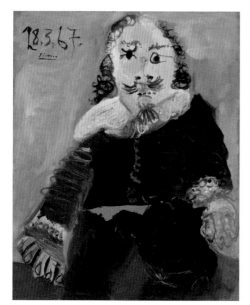

Fig. 66
Seated Musketeer, 28 March 1967
Oil on plywood, 101 × 81.5 cm
Ludwig Museum – Museum of
Contemporary Art, Budapest
Peter und Irene Ludwig Stiftung,
Aachen

and culminating in the large version of 1963, would become a more generic indictment of violence and war. In this powerful and beautifully crafted painting, elements of the composition and the individual figures are derived from two well-known masterpieces by Poussin and one by Jacques-Louis David (figs. 73–4). The image also recalls the reckless fury of the warriors displayed in Goya's Black paintings, such as *Dos Forasteros* (1821–2; Museo del Prado, Madrid).[20]

In the late 1950s and early 1960s Picasso painted several spectacular female nudes. Related in part to the theme of the artist and model paintings of the period, this subject was not new for Picasso, who had reworked the traditional theme of the female nude throughout his career. However, now in his eighties, he revised the usual ideal of beauty with particular aggression, and subjected the body – usually that of Jacqueline – to repeated attacks in paint.[21] His fear of impotence, both sexual and artistic, is revealed in his obsessive flaunting of the female form. The artist often exaggerates or reshuffles parts of the female body, giving his nudes a deceptive clumsiness which disguises his virtuosity in handling the paint (cats. 67–9). Many of the late nudes imply voyeurism, while others are concerned with the pathos or comedy of old men lusting impotently after beautiful young women. Again the old master precedents are numerous: the Venuses of Titian (1485–1576; fig. 20), Goya's *Nude Maja* (fig. 68) and Manet's confrontational *Olympia* (1863; Musée d'Orsay, Paris). As Richard Morphet has written of *Nude with a Necklace* of 1968 (Tate, London), 'Picasso's flaunts her sex and the image's general sense of sexual availability is enhanced by the harem-like ambience, and by the close analogy with Manet's *Olympia*, which extends to the cushions, the figure's direct gaze and the fact that though naked she wears an ornament around her neck'.[22]

In a bid for more privacy, Picasso and Jacqueline moved to the hilltop villa 'Notre Dame de Vie' near Mougins in 1961. The artist became more reclusive and this is reflected in his paintings which are more strikingly intimate and self-reflective, often concerned with his own mortality. For him, passivity signified death and the energy of his last works, with their summary abbreviation and speed of execution, demonstrate his desire to recapture a childlike form of expression. As the palette becomes looser and brightly coloured, the wilfully naive style serves to emphasise their spirit of directness and intimacy.

Picasso's last great series of images come in the form of swashbuckling cavaliers or 'musketeers'.[23] The figure of a musketeer had first appeared in one of the artist's painter-and-model images of 1963. As he told his friend Hélène Parmelin, this was based on Rembrandt's image of himself and his wife Saskia (fig. 67). However, it was not until 1967 that the musketeer, in his

various incarnations, would appear in earnest in Picasso's imagery. In 1965 Picasso had surgery at the American Hospital in Neuilly, near Paris. Returning to the South for his convalescence, he re-read Alexandre Dumas's novel *The Three Musketeers* and – as Jacqueline informed André Malraux – once again turned to Rembrandt (1606–1669) for inspiration.[24] This was by no means the only time he looked at the oeuvre of a northern master. His prints of the late 1940s, with their stylised images of Françoise, had drawn on the linear qualities of Lucas Cranach's graceful figures (fig. 57, cats. 35–6), while the anguish of van Gogh's paintings permeated his last self portraits.[25] In their seventeenth-century garb, Picasso's musketeers appear in many guises, some holding swords and some wearing wigs or ornate shoes, others smoking (cats. 70–1). Some are young, others old, some participate while others are voyeurs. They represent many of the possible ages of the artist, ranging from a child genius to an impotent old man. Like Rembrandt, with whom he now became obsessed, Picasso liked to insert himself into his paintings, in one guise or another. The parallels between the two masters, the Dutchman and the Spaniard, are many: both enjoyed a long and fulfilling career; both felt isolated and misunderstood, if not derided, in their old age; and both obsessively recorded their own decline in their numerous self portraits. Ultimately, however, Picasso's musketeers were not Dutch. In spirit they remained closer to the Spanish masters and, as Gert Schiff has pointed out, 'even the most diagrammatic ones are imbued with Spanish fervour, more *hidalgos* rather than *staalmeesters*'.[26]

At the age of 65, when most people are thinking of retiring, Picasso had embarked upon the last and perhaps most fruitful phase of his long career. He confronted his fear of old age by becoming defiantly productive. Between 1946 and his death in 1973 he produced an astounding number of paintings, drawings, prints, ceramics and sculptures.[27] Despite this intense creativity and his international fame at the time, his painting was no longer considered avant-garde. In an era when non-figurative art prevailed over figurative art and a linear progression of 'style' was considered more relevant than emotion or subject, it was customary for many younger artists and art critics to think that late Picasso was lesser Picasso.[28] However, the extensive re-evaluation of his late work since his death has highlighted its undiminished power and originality. His capacity for emotional depth and painterly freedom in his later paintings, together with his wide-ranging engagement with the imagery of the great painting of the past, was to have a lasting influence on the development of neo-expressionist art from the early 1980s onwards.[29]

Fig. 67
Rembrandt van Rijn
(1606–1669)
Self Portrait with Saskia,
about 1636
Oil on canvas, 161 × 131 cm
Gëmaldegalerie, Alte Meister,
Dresden

Notes

1 The location of this work is unknown.

2 Galassi 1996, pp. 8–24.

3 In the Renaissance Pan was often represented as the personification of Lust. With its references to renewal and recreation Picasso subverts the classicism of Poussin's masterpiece; see Beck Newman 1999.

4 See Hoving Keen 1980 and Utley 2000.

5 See G. Utley, 'Picasso and the French Post-War "Renaissance"', in Brown 1996, pp. 95–117.

6 His move to the South prompted a renewed interest in the Classical world. His mural *La Joie de Vivre* (1946; Musée Picasso, Antibes) – a title borrowed from Matisse – with its fauns and centaurs, not only represents an Arcadian idyll, which reflected his current personal life, but also a sense of nostalgia for a Classical past. See Malaga 1992.

7 He attended peace conferences in Warsaw (1948), Paris (1949) Sheffield (1950) and Rome (1951).

8 In 1947 Picasso was invited to take a selection of his paintings to the Louvre to compare them with the old masters; see Cowling, p. 11 in this volume.

9 J. Richardson uses this term, which comes from Freud, in 'L'epoque Jacqueline', in London 1988, p. 31. See also Marie-Laure Bernadac, 'Picasso Cannibale: Deconstruction-Reconstruction des Maîtres', in Paris 2008, pp. 37–51.

10 See London 1994, p. 37. Also: 'When I paint I feel that all the artists of the past are behind me…' (Parmelin 1964, p. 142); 'Picasso is often heard to say that when he paints, all the painters are with him in the studio. Or rather behind him. Watching him. Those of yesterday, and those of today' (Parmelin 1969, p. 40).

11 A sworn enemy of Franco, after the war Picasso vowed not to return to Spain until democracy had been reinstated.

12 See Washington, DC, and Boston 1997.

13 Brown 1996.

14 For a discussion of Picasso's variations see pp. 109–17 above. Picasso's pre-occupation with the studio as the setting for the creative act was central to his variations on Velázquez's *Las Meninas*. Like most of the paintings Picasso chose for his variations, *Las Meninas* actively solicits the participation of the viewer.

15 J. Richardson, 'L'epoque Jacqueline', in London 1988, p. 19. Claude Picasso recounts that his father thought of leeks as symbols of death: when it goes off, this simple vegetable smells like 'death'. His mother, Françoise Gilot, confirmed this. Related in conversation with author, November 2008.

16 Picasso had pursued the theme of the studio, with artist and model, earlier in his career, e.g. his *Studio* paintings of the late 1920s. See Galassi, p. 109 in this volume.

17 Braque was responsible, with Picasso, for many of the innovations and experiments associated with Cubism; although the artists were no longer very close in the 1950s, Picasso's competitive spirit remained. This discussion on 'La Californie' is largely based on Marilyn McCully, 'Picasso's Private World at La Californie', in London 2006, pp. 5–12.

18 Picasso continued to be outraged by the Korean War and in 1952 he decided to decorate a deconsecrated fourteenth-century chapel in Vallauris as a temple of peace. It included two panels, one depicting war, the other peace. For a discussion on the *Massacre in Korea* see Jean Sutherland Boggs, 'The Last Thirty Years', in Penrose and Golding 1981, pp. 127–60.

19 Spanish culture had fascinated French writers, musicians and artists since Napoleon's invasion of the Iberian Peninsula in 1808. The growing enthusiasm for *espagnolisme* was invigorated in 1838–48 when the collections of the Louvre were amplified by a spectacular collection of Spanish paintings, known as the *Musée Espagnole*. See Atlanta 2008.

20 See also Nicolas Poussin's *Massacre of the Innocents* (about 1928; Musée Condé, Chantilly). Gert Schiff likens the three paintings to Goya in 'The Musketeer and his *Theatrum Mundi*', in New York 1983, p. 16.

21 Even though Jacqueline never posed for Picasso, she was the principal model of the last decades of his life. Her dominance of this late phase has prompted John Richardson to call the period 'l'epoque Jacqueline'; see Richardson, 'L'Epoque Jacqueline' in London 1988, pp. 16–48.

22 Morphet 1984.

23 These paintings form part of the rich variety of human forms which Picasso created in his late paintings and prints. There are men and women of all ages: toreros, painters, poets, harlequins, cupids, and women with birds, children with buckets and spades, entire families. They read, write, play cards, smoke, drink, and make love. See Morphet 1984 (note 23).

24 Malraux 1976, p. 4.

25 Picasso shared a deep spiritual identification with the Dutch master. 'Picasso talks about van Gogh all the time, and thinks about him all the time; he often contrasts him, not without bitterness, with the spoilt, self-satisfied arrogance of the times we are living through in painting. For him, Van Gogh is the one painter who life was exemplary, up to and including his death' (Parmelin 1969, p. 37).

26 G. Schiff, 'The Musketeer and his *Theatrum Mundi*', in New York 1983, p. 37.

27 Owing to the scope of this text, it has not been possible to discuss Picasso's inventive use of the art of past masters in his print-making of the period. Between March and October 1968, for example, he made 347 engravings, containing a rich mixture of motifs from the circus, the bullfight, theatre and Spanish literature. The series culminated in a group of erotic scenes of love-making – drawn from Ingres's painting of Raphael and La Fornarina – in which Picasso intermingles the themes of creation and procreation. See B. Baer, 'Seven Years of Printmaking: The Theatre and its Limits', in London 1988, pp. 95–135.

28 'Picasso's art ceased being indispensable. It no longer contributed to the ongoing evolution of major art: however much it might intrigue pictorial sensibility, it no longer challenged and expanded it'. Greenberg 1966, p. 28.

29 See Basle 1981 and New York 1983. For Picasso's influence on the neo-expressionist artists of the 1980s, see London 1982.

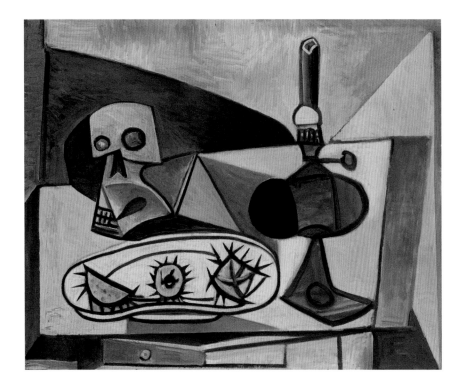

Cat. 60
**Skull, Sea Urchins and Lamp
on a Table**, 1946
Oil on plywood, 81 × 100 cm
Musée Picasso, Paris (MP198)

Cat. 61
Skull with Jug, 15 August 1943
Oil on canvas, 65 × 54 cm
Nahmad Collection,
Switzerland

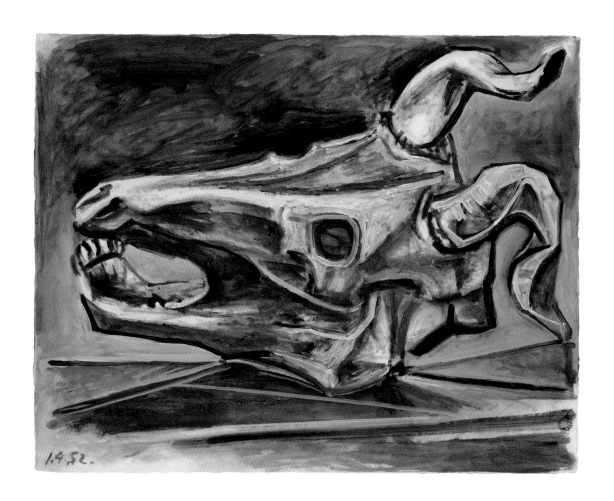

Cat. 63
**In the Garden (Picasso and his
Daughter Paloma)**, 28 December 1953
Oil on canvas, 150.4 × 98.4 cm
Nahmad Collection, Switzerland

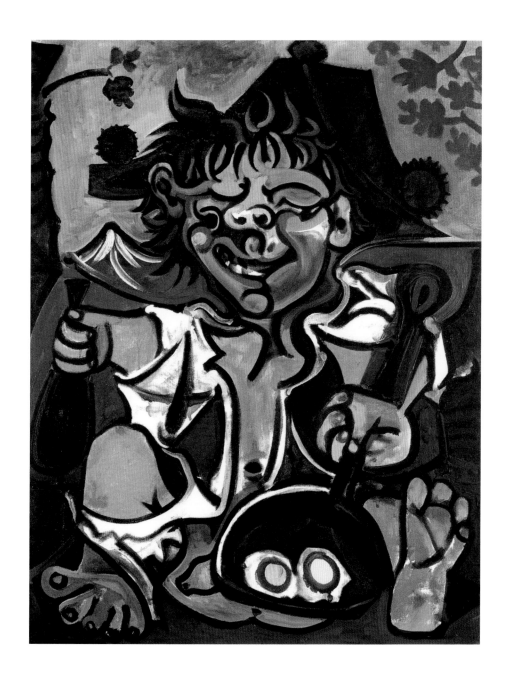

Cat. 65
Minotaur, 30 April 1958
Oil on canvas, 92 × 73 cm
Nahmad Collection, Switzerland

Cat. 66
Women at their Toilette,
4 January 1956
Oil on canvas, 195.5 × 130 cm
Musée Picasso, Paris (MP210)

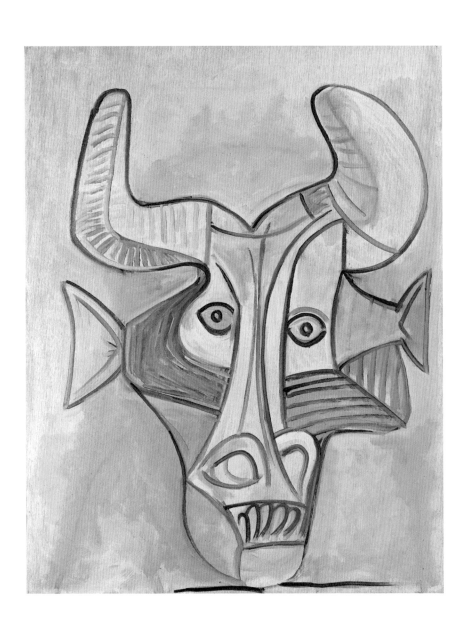

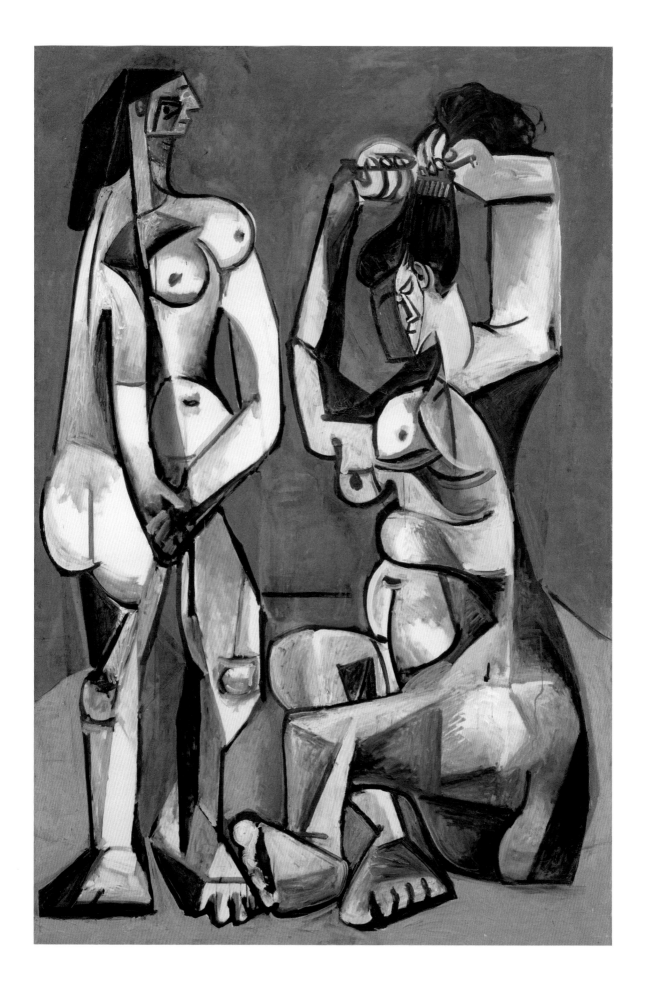

154

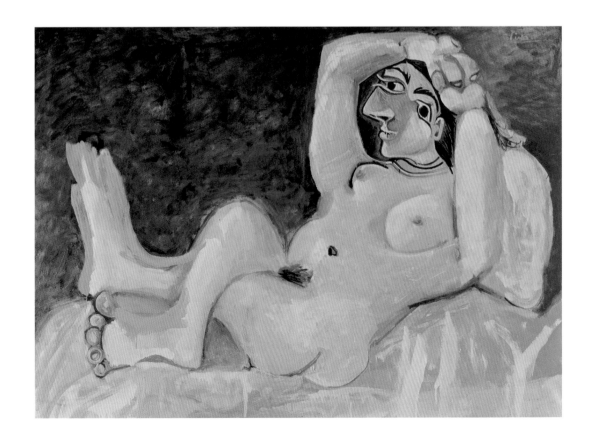

Cat. 68
Reclining Nude playing with a Cat,
8–9 March 1964
Oil on canvas, 130 × 195 cm
Staatsgalerie Stuttgart,
Mariann Steegmann Stiftung (L1354)

Cat. 69
Reclining Nude, 2 November 1969
Oil on canvas, 130 × 195 cm
Private collection

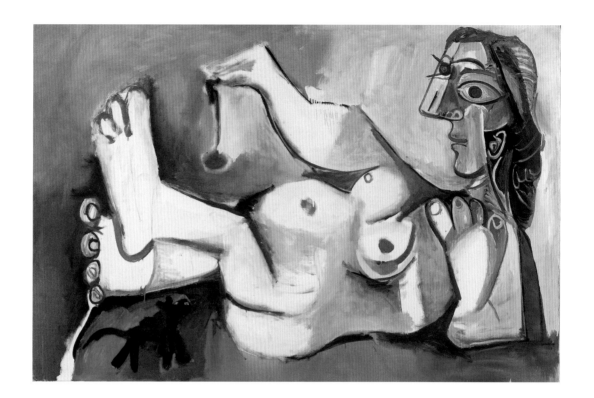

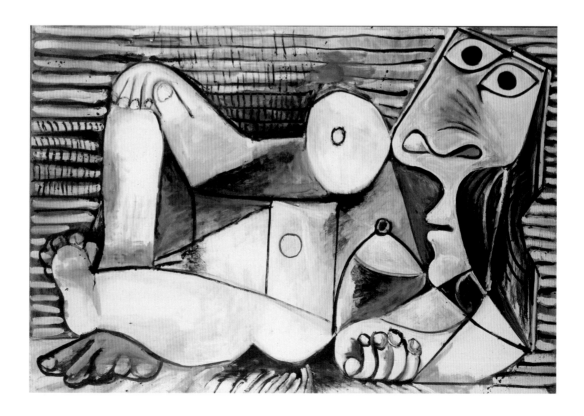

Fig. 69
Philippe de Champaigne (1602–1674)
Triple Portrait of Cardinal de Richelieu, about 1642
Oil on canvas, 58.7 × 72.8 cm
The National Gallery, London

Cat. 70
Head of a Musketeer (Cardinal de Richelieu), 27 March 1969
Oil on canvas, 81 × 64.8 cm
The Montreal Museum of Fine Arts/
Musée des Beaux-Arts de Montréal
(2004.135)

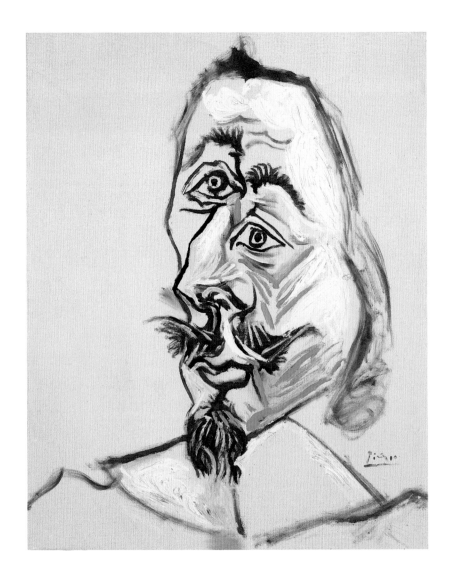

Fig. 70
Frans Hals (1582/3–1666)
Young Man holding a Skull,
1626–8
Oil on canvas, 92.2 × 80.8 cm
The National Gallery, London

Cat. 71
**Seated Musketeer with
a Sword**, 19 July 1969
Oil on canvas, 195 × 130 cm
Private collection

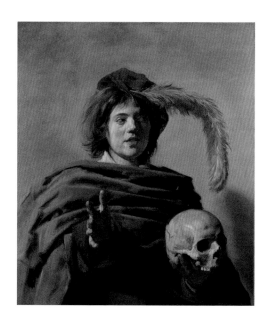

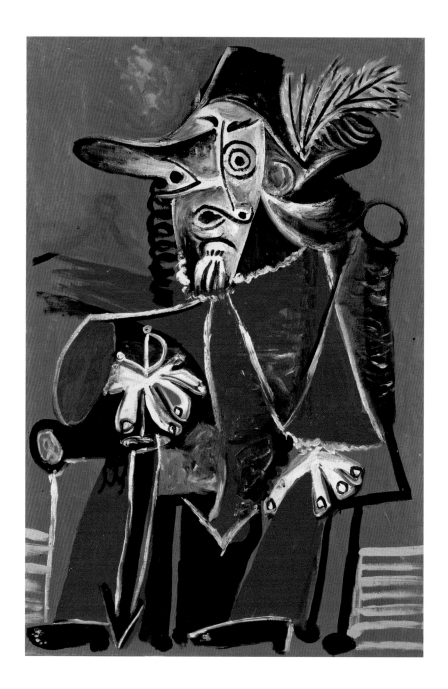

158

Fig. 71
Henri Rousseau
(1844–1910)
Self Portrait with a Lamp,
1902–3
Oil on canvas, 23 × 19 cm
Musée Picasso, Paris

Fig. 72
Henri Rousseau
(1844–1910)
**Portrait of Rousseau's
Second Wife**, 1903
Oil on canvas, 23 × 19 cm
Musée Picasso, Paris

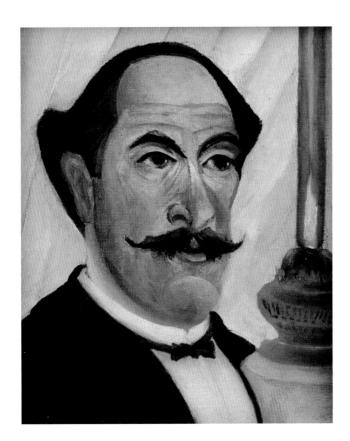

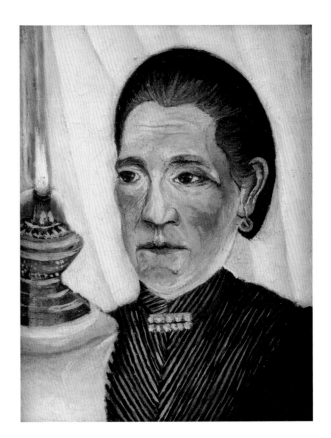

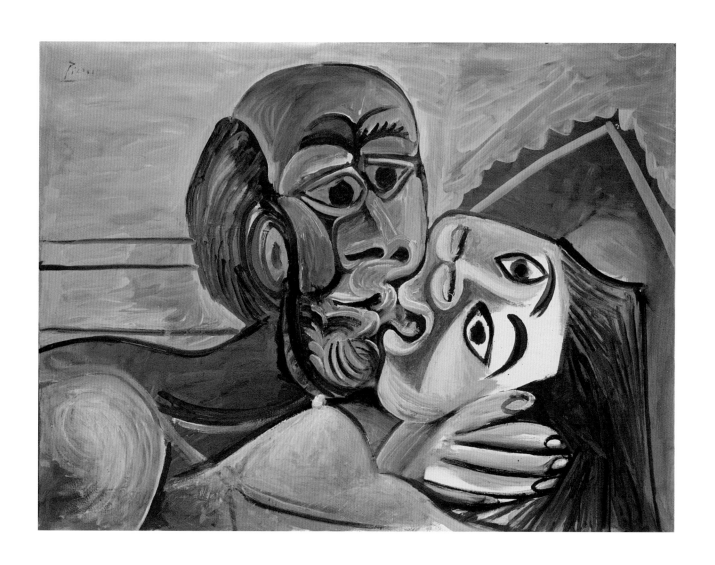

Fig. 73
Nicolas Poussin (1594–1665)
The Rape of the Sabine Women,
1637–8
Oil on canvas, 159 × 206 cm
Musée du Louvre, Paris

Cat. 73
Rape of the Sabine Women
(after Poussin), 2–4 November 1962
Oil on canvas, 161.5 × 130 cm
Fondation Beyeler, Riehen/Basel (93.3)

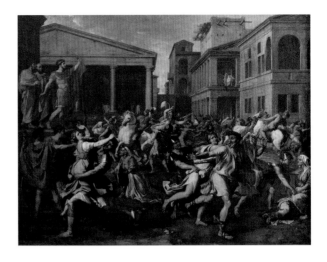

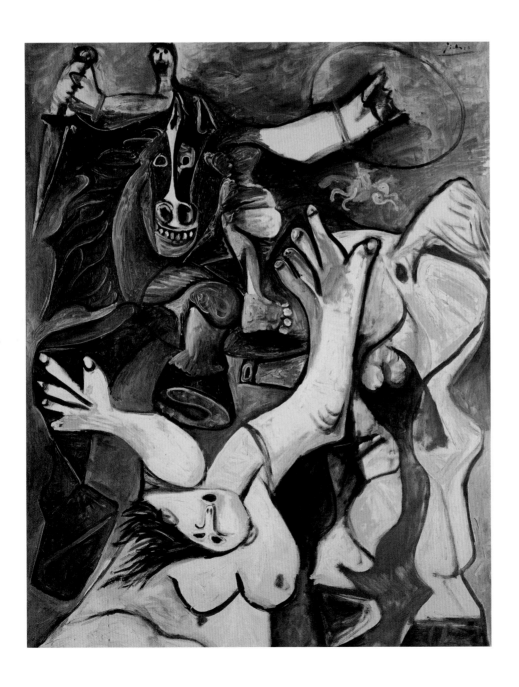

Fig. 74
Jacques-Louis David (1748–1825)
Intervention of the Sabine Women,
1799
Oil on canvas, 385 × 522 cm
Musée du Louvre, Paris

Cat. 74
**Rape of the Sabine Women
(after Poussin**), 4–8 November 1962
Oil on canvas, 97 × 130 cm
Centre Georges Pompidou, Paris,
Musée national d'art moderne /
Centre de création industrielle
Gift of Daniel-Henri Kahnweiler 1964
(AM4248P)

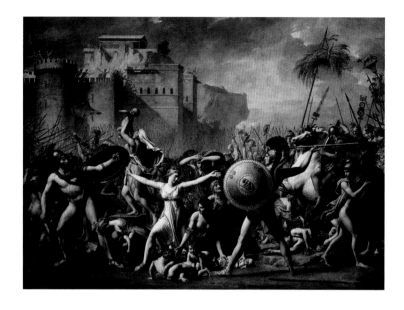

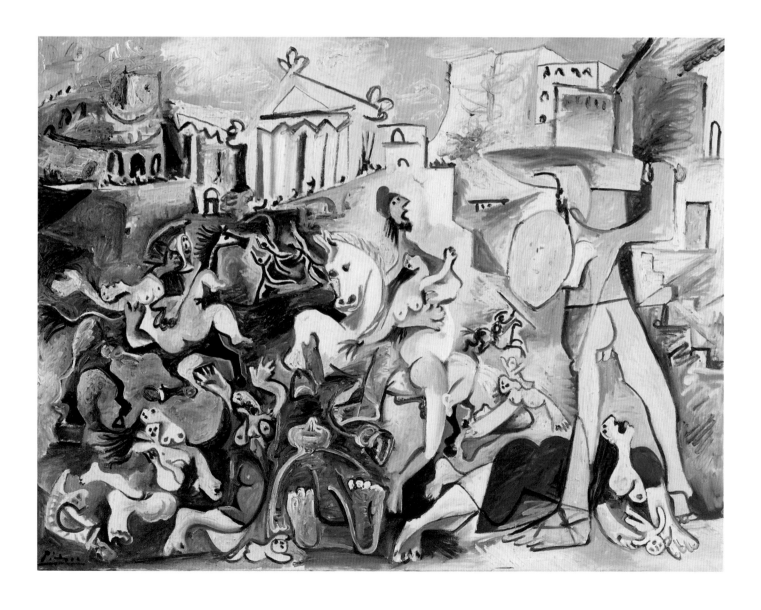

Cat. 75
Rembrandt van Rijn (1606–1669)
Christ presented to the people, 1655
Drypoint, 35.8 × 45.6 cm
The British Museum, London
(1895,0915.423)

Cat. 76
**Ecce Homo: Le Théâtre de Picasso
(from 156 series)**, 1970
Etching and aquatint, 50 × 42 cm
Tate, London (P77583)

Cat. 77
Brothel. Prostitutes chatting,
with Parakeet, Célestine and
the Portrait of Degas, 4 April 1971
Etching, 36.6 × 49.2 cm
The British Museum, London
(1993, 10-3-2)

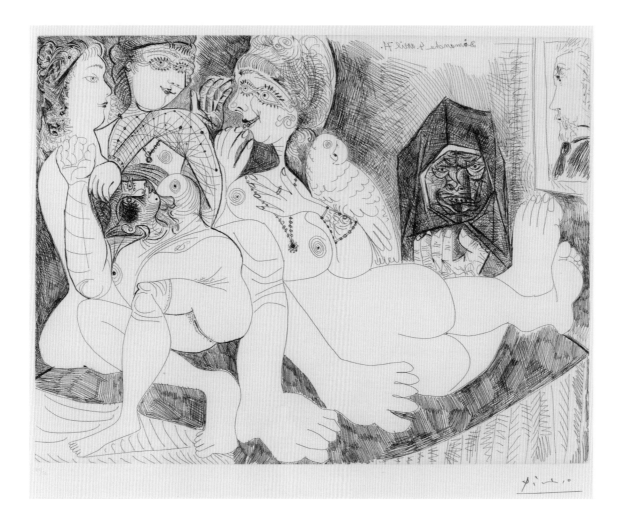

Cat. 78
**Head of a Man with
a Straw Hat**, 26 July 1971
Oil on canvas, 91.5 × 73 cm
Musée Picasso, Paris, on loan to
Musée d'Unterlinden, Colmar
(MP1990-44)

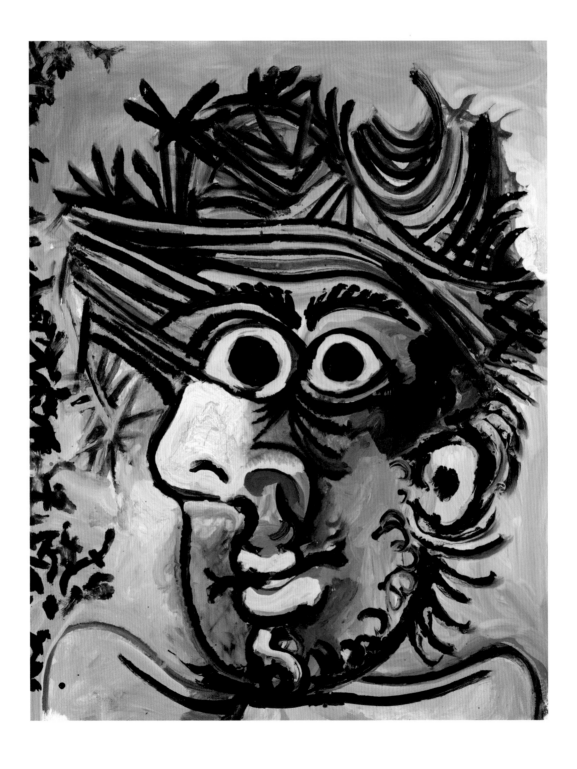

Cat. 79
Head of a Man, 31 July 1971
Oil on canvas, 73 × 60 cm
Private collection

165

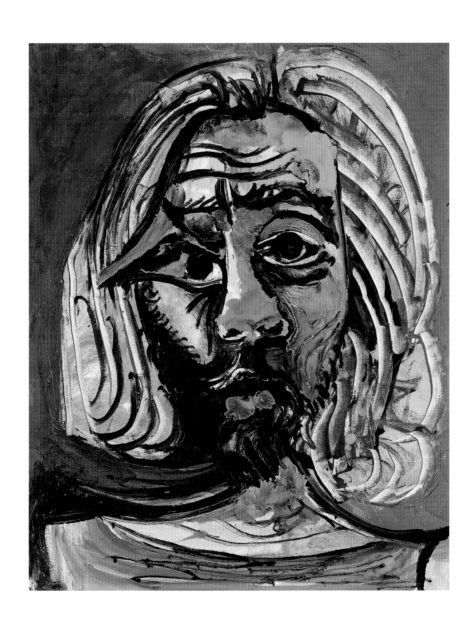

1881
25 October Pablo Picasso is born to José Ruíz y Blasco (1841–1913) and María Picasso y López (1855–1939) in Malaga, Spain.

1888
Receives his first drawing lessons from his father, a painter and teacher at the Escuela Provincial de Bellas Artes, Malaga.

1892
Enrols in his father's drawing classes at the Escuela de Bellas Artes at La Coruña on the Atlantic coast.

1895
April or May Visits the Prado for the first time and makes two sketches after Velázquez.
September His family moves to Barcelona and he enrols in the Escuela de Bellas Artes, known as Lonja (La Llotja in Catalan), where his father is teaching. In Barcelona he will establish his first studio with Manuel Pallarés and will begin to exhibit his work.

1896
Copies two altarpieces by Murillo for a nuns' convent in Barcelona.

1897
September Settles in Madrid and enrols in the Academia Real de San Fernando. He visits the Prado especially to see El Greco and copies a portrait of Philip IV by Velázquez.

1899
February Returns to Barcelona, where he will meet Carles Casagemas (1880–1901) and Jaime Sabartés (1881–1968).
Autumn/winter Paints the *Head in the Style of El Greco*.

1900
February Exhibits 150 drawings at Els Quatre Gats, a tavern in Barcelona.
Autumn Travels to Paris for the first time to see his work, *Last Moments*, on exhibition in the Spanish Pavilion at the Exposition Universelle.

1901
January–April Moves to Madrid and adopts his mother's name to sign his works.
17 February Casagemas commits suicide.
May 1901–January 1902 Visits Paris for the second time, sharing quarters with the poet Max Jacob (1876–1944), ostensibly for an exhibition including 64 of his paintings, which opens at the Vollard Gallery on 24 June.
Autumn Begins to paint monochromatic works of social outcasts, initiating his so-called Blue Period.

1902
October 1902–January 1903 Returns to Paris and then to Barcelona.

1904
April Settles permanently in Paris, renting a studio in the Bateau-Lavoir in Montmartre.
Summer Meets Fernande Olivier (1881–1966), who becomes his mistress and moves into his studio a year later.
Beginning of his so-called Rose Period, dominated by soft pink colours and a cast of circus characters.

Fig. 75 Picasso in 1904

1905
Spring Retrospectives of the work of Vincent van Gogh and Georges Seurat at the Salon des Indépendants.
Autumn The Salon d'automne shows the first works of the Fauves, an Ingres retrospective, and works by Manet, Cézanne and Henri Rousseau.
Winter An exhibition of ancient Iberian sculpture opens at the Louvre.

1906
Completes the portrait of his friend and patron Gertrude Stein (1874–1946), who introduces him to Henri Matisse (1869–1954).
Spring Work by Paul Gauguin and Puvis de Chavannes is included in the Salon des Indépendants.
Summer Travels to Gósol with Fernande, where his painting becomes increasingly sculptural and 'primitive' in style.
23 October Paul Cézanne (born 1839) dies.

1907
Paints the *Demoiselles d'Avignon*, although it is only publicly exhibited in 1916.
Autumn The Salon d'automne includes a retrospective of the work of Paul Cézanne. Picasso meets Georges Braque.

1908
Beginning of close working relationship with Braque, which lasts until the outbreak of the First World War. Together they develop the revolutionary style known as Cubism.
November Organises a dinner in honour of Rousseau (1844–1910), celebrating his purchase of Rousseau's *Portrait of a Woman* (about 1895).

1909
The Salon d'automne exhibits several figure paintings by Camille Corot.

1909–1912
His paintings show a fragmentation of form approaching, but never reaching, abstraction, labelled Analytic Cubism by art dealer Daniel-Henri Kahnweiler in 1920.

Chronology

COMPILED BY SCOTT NETHERSOLE

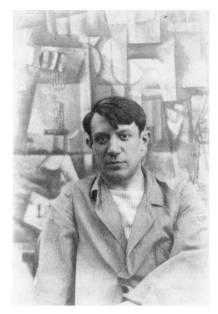

Fig. 76 Picasso seated in front of *L'aficionado*, 1912.
Photograph, Musée Picasso, Paris

1912

Begins experimenting with collages and, a few months later, with *papiers collés*. Later in the year he produces his first three-dimensional constructions. A change in style is evident at around this date, which historians label 'Synthetic Cubism'. Flat geometric forms (either invented or constructed) and a wider colour range appear. The resulting works differ in their spatial effects, the relationship between represented and real objects and the lucidity of the subject matter.

1916

May Jean Cocteau (1889–1963) introduces him to Serge Diaghilev of the Ballets Russes, for whom he will design four productions by 1924.

1917

February–May Visits Italy for the first time, in the company of the Ballets Russes, where he meets the ballerina Olga Khokhlova (1891–1955), whom he will marry the following July. From Rome he travels to Naples, Pompeii and Florence. He has been producing the occasional naturalistic or classicising work since 1914, but in Italy this tendency becomes more pronounced. Back in Paris he paints *The Happy Family*, a variation of a Le Nain painting in the Louvre.

1919

Summer Designs *Le Tricorne (The Three-Cornered Hat)* in London for the Ballets Russes, staying in the Savoy Hotel. Visits the National Gallery and the British Museum.
3 December Death of Renoir (born 1841), whose influence is evident at around this date.

1921

4 February Birth of his son, Paulo (died 1975).
Summer Spends the summer months at Fontainebleau, where he works simultaneously in Cubist and classical styles.

1925

November Exhibits Cubist works at the first Surrealist Group Exhibition.

1927

Meets Marie-Thérèse Walter (1909–1997), who becomes his companion and will appear in his paintings from 1930.

1932

Produces 'sur-realist' variations of Grünewald's Isenheim *Crucifixion* (1515).

1933

Designs the cover of the surrealist periodical *Minotaure*, and works on etchings later gathered together as the *Vollard Suite*, both of which introduce the minotaur into his personal iconography.

1934

Visits Spain with his family and sees the Romanesque art in the Museu d'Art de Catalunya, Barcelona.

1935

June Separates from Olga.
July Sabartés becomes his secretary.
5 October Marie-Thérèse gives birth to a daughter, Maya.

1936

18 July Outbreak of the Spanish Civil War. The Republican Government offers him the directorship of the Prado.
Begins a relationship with the photographer Dora Maar (1907–1997).

Fig. 77 Olga and Picasso, 1917
Photograph, Musée Picasso, Paris

Fig. 78 Picasso painting *Guernica*, 1937. Photograph commissioned by Dora Maar, for *Cahiers d'Art*. Musée Picasso, Paris

1937
June *Guernica* is installed in the Spanish pavilion of the Exposition Universelle, Paris, recalling the bombing of the Basque town in late April of that year.
Summer Paints six portraits of Lee Miller at Mougins.

1940
With the invasion and occupation of France, he remains in Paris, working from the studio on the rue des Grands-Augustins where he painted *Guernica*.

1942
Executes his first work, a drawing, after Lucas Cranach the Elder. He will produce further variations after Cranach (both the Elder and Younger) in 1947–9 and again in the 1950s.

1943
Begins a relationship with the painter Françoise Gilot (born 1921). They will live together from 1946 and she will bear two children, Claude (born 15 May 1947) and Paloma (born 19 April 1949).

1944
August Liberation of Paris, at which time he draws variations of Poussin's *Triumph of Pan* (1636).
October *L'Humanité* announces that Picasso has joined the French Communist Party.

1947
May Georges Salles invites him to display the works he has donated to the French state alongside the old masters in the Louvre for a day while the museum is closed.

1950
Paints variations of Courbet's *Young Ladies on the Banks of the Seine* (1856–7) and El Greco's *Portrait of An Artist* (*Jorge Manuel Theotokopoulos*) (around 1603).
November Visits London and Sheffield to attend World Peace Conference.

1952
Meets Jacqueline Roque (1926–1986), prompting the departure of Françoise with their two children the following year

1954
1 November Revolt by the Front de Liberation for Algerian independence from France.
3 November Matisse dies.
November–December Picasso paints 25 variations on Delacroix's *Women of Algiers* (1834)

1955
Buys a villa in Cannes and moves permanently to the French Riviera.

1957
Paints 45 variations of Velázquez's *Las Meninas* (1656).

1958
September Purchases the château of Vauvenargues, near Cézanne's home at Aix-en-Provence.

1959–1962
Creates variations on Manet's *Luncheon on the Grass* (1863) in various media.

1961
2 March Marries Jacqueline, Olga having died on 11 February 1955.
Purchases the estate of Notre-Dame-de-Vie in Mougins, which becomes his home until his death.

1962–1963
Begins the variations on Poussin and David's paintings of Sabines.

1965
Undergoes surgery at the American Hospital near Paris.

1966
Musketeers appear in his paintings.

1973
8 April Pablo Picasso dies intestate at Mougins.

Fig. 79 Picasso, photograph taken about 1971

Fig. 80 Picasso looking out of his apartment, Paris, 1944

Ashton 1972
D. Ashton, *Picasso on Art: A Selection of Views*, London 1972

Atlanta 2008
A. Dumas (ed.), *Inspiring Impressionism. The Impressionists and the Art of the Past*, exh. cat., High Museum of Art, Atlanta, Denver Art Museum and Seattle Art Museum, 2008

Barcelona 2003
V. Bozal et al., *Pablo Picasso: From Caricature to Metamorphosis of Style*, exh. cat., Museu Picasso, Barcelona, 2003

Barcelona 2008
J. Hereu et al., *Olvidando a Velázquez. Las Meninas*, exh. cat., Museu Picasso, Barcelona 2008

Basle 1981
C. Geelhaar, *Pablo Picasso, Das Spätwerk, Themen 1964–1972*, exh. cat., Kunstmuseum, Basle, 1981

Beard and Henderson 2001
M. Beard and J. Henderson, *Classical Art: From Greece to Rome*, Oxford 2001

Beck Newman 1999
V. Beck Newman, 'The Triumph of Pan: Picasso and the Liberation', in *Zeitschrift für Kunstgeschichte*, vol. 62, no. 1, 1999, pp. 106–22

Berger 1965
J. Berger, *The Success and Failure of Picasso*, Harmondsworth 1965

Berne 2000
M. Fehlmann and T. Stoos, *Picasso und die Schweiz*, exh. cat., Kunstmuseum, Berne, 2000

Brassaï 1966
Brassaï, *Picasso and Company*, New York 1966

Brown 1996
J. Brown, *Picasso and the Spanish Tradition*, London and New Haven 1996

Cleveland 1992
J.S. Boggs, *Picasso & Things*, exh. cat., Cleveland Museum of Art, Philadelphia Museum of Art and Musée Picasso, Paris, 1992

Cooper 1962
D. Cooper, *Les Déjeuners*, Paris 1962

Cowling 2002
E. Cowling, *Picasso: Style and Meaning*, London 2002

Cowling 2006
E. Cowling, *Visiting Picasso: The Notebooks and Letters of Roland Penrose*, London 2006

Daix 1993
P. Daix, *Picasso: Life and Art*, New York 1993

Daix and Boudaille 1966
P. Daix and G. Boudaille, *Catalogue raisonné des periodes bleue et rose, 1900–1906*, Neuchâtel 1966 [rev. edn 1989]

Daix and Rosselet 1979
P. Daix and J. Rosselet, *Picasso, The Cubist Years 1907–1916. A Catalogue Raisonné of the Paintings and Related Works*, London 1979

Douglas Duncan 2006
D. Douglas Duncan, *Picasso & Lump: A Dachshund's Odyssey*, New York 2006

Edinburgh 2001
Roland Penrose/Lee Miller: The Surrealist and the Photographer, exh. cat., National Galleries of Scotland, Dean Gallery and the Gallery of Modern Art, Edinburgh, 2001

Edinburgh 2007
P. Elliot, *Picasso on Paper*, exh. cat., Dean Gallery, Edinburgh, 2007

Galassi 1996
S.G. Galassi, *Picasso's Variations on Masters: Confrontations with the Past*, New York 1996

Garafola 1989
L. Garafola, *Diaghelev's Ballets Russes*, New York and Oxford 1989

Garb 1985
T. Garb, 'Renoir and the Natural Woman', *Oxford Art Journal*, vol. 8, no. 2, 1985, pp. 3–15

Geneva 1988
S. de Pury (ed.), *Berggruen Collection: Musée d'art et d'histoire Genève*, exh. cat., Geneva 1988

Georges-Michel 1923
M. Georges-Michel, *Ballets Russes: Histoire anecdotique*, Paris 1923

Gilot 1990
F. Gilot, *Matisse and Picasso: A Friendship on Art*, London 1990

Gilot and Lake 1966
F. Gilot and C. Lake, *Life with Picasso*, Harmondsworth 1966

Green 2006
C. Green, *Picasso: Architecture and Vertigo*, London 2006

Greenberg 1966
C. Greenberg, 'Picasso after 1945', *Artforum*, October 1966

Guillén 1973
M. Guillén, *Picasso*, Madrid 1973

Hilton 1975
T. Hilton, *Picasso*, London 1975

Hoving Keen 1980
K. Hoving Keen, 'Picasso's Communist interlude: the murals of "War" and "Peace"', *Burlington Magazine*, July 1980, pp. 464–70

Lieven 1986
A. Lieven, *The Musée Picasso, Paris*, London 1986

London 1960
Picasso, exh. cat., Tate, London, 1960

London 1982
A New Spirit in Painting, exh. cat., Royal Academy of Arts, London, 1982

London 1983
D. Cooper and G. Tinterow, *The Essential Cubism: Braque, Picasso & their Friends 1907–1920*, exh. cat., Tate, London, 1983

London 1988
Late Picasso, exh. cat., Tate, London, 1988 [French edn, Musée National d'Art Moderne, Paris, 1988]

London 1990
E. Cowling and J. Mundy (eds), *On Classic Ground: Picasso, Léger and the New Classicism*, exh. cat., Tate, London, 1990

London 1994
J. Golding, *Picasso Painter and Sculptor*, exh. cat., Tate, London 1994

London 1998
J. Hyman, *Picasso*, exh. cat., Helly Nahmad Gallery, London, 1998

London 2006
Picasso La Californie, exh. cat., Helly Nahmad Gallery, London, 2006

London 2008
Les Années Folles: Paris in the Twenties, exh. cat., Helly Nahmad Gallery, London, 2008

Bibliography

McCully 1981
Marilyn McCully, *A Picasso Anthology: Documents, Criticism, Reminiscences*, London 1981

Madrid 1973
M. Guillén, *Picasso*, Madrid 1973

Madrid 2006
F. Calvo Serraller et al., *Picasso: Tradition and Avant-Garde*, exh. cat., Museo Nacional Centro De Arte Reina Sofia, Madrid, 2006

Malaga 1992
Francisco Calvo Serraller et al., *Picasso Clásico*, exh. cat., Palacio Episcopal, Malaga, 1992

Malraux 1976
A. Malraux, *Picasso's Mask*, London 1976

Martin and Doka 2002
T.L. Martin and K.J. Doka, *Men Don't Cry, Women Do: Transcending Gender Stereotypes of Grief*, Philadelphia 2002

Morphet 1984
R. Morphet, 'A Late "Reclining Nude" by Picasso: a new acquisition for the Tate', *Burlington Magazine*, February 1984, pp. 84–8

New York 1980
W. Rubin (ed.), *Pablo Picasso: A Retrospective*, exh. cat., Metropolitan Museum of Art, New York, 1980

New York 1983
G. Schiff, *Picasso, The Last Years, 1963–1973*, exh. cat., Solomon R Guggenheim Museum, New York, 1983

New York 1996
W. Rubin (ed.), *Picasso and Portraiture*, exh. cat., Metropolitan Museum of Art, New York, 1996 [French edn Grand Palais, Paris, 1996]

Nicosia 2008
A. Nicosia (ed.), *La Roma di Picasso: Un grande palcoscenico (17 febbraio – 2 maggio 1917)*, Rome 2008

Ostfildern 2004
F.A. Baumann, P. Karmel, P. Kropmanns and F. Leemann, *Cézanne Auflbruch in die Moderne*, exh. cat., Museum Folkwang, Ostfildern, 2004

Palau i Fabre 1981
J. Palau i Fabre, *Picasso: Life and Work of the Early Years*, London 1981

Paris 1914
G. Coquiot, *Cubistes, futuristes, passéistes: Essai sur la jeune peinture et la jeune sculpture*, Paris 1914

Paris 1998
H. Seckel-Klein, *Picasso collectionneur*, exh. cat., Musée Picasso, Paris 1998

Paris 2007a
A. Baldassari (ed.), *Picasso Cubiste*, exh. cat., Musée Picasso, Paris, 2007

Paris 2007b
A. Baldassari (ed.), *Picasso à Fontainebleau*, exh. cat., Château Fontainbleu, Paris, 2007

Paris 2008
Picasso et les maîtres, exh. cat., Réunion des musées nationaux, Paris, 2008

Paris and Montauban 2004
L. Madeline, *Picasso Ingres*, exh. cat., Musée Picasso, Paris, and Musée Ingres, Montauban, 2004

Parmelin 1963
H. Parmelin, *Picasso Plain*, London 1963

Parmelin 1964
H. Parmelin, *Picasso Women, Cannes and Mougins (1953–63)*, London 1964

Parmelin 1969
H. Parmelin, *Picasso says …*, London 1969

Penrose 1958
R. Penrose, *Picasso: His Life and Work*, London 1958

Penrose and Golding 1981
R. Penrose and J. Golding (eds), *Picasso in Retrospect*, London 1981

Quimper and Paris 1994
H. Seckel-Klein and E. Chevrière, *Max Jacob et Picasso*, exh. cat., Musée des Beaux-arts, Quimper, and Musée Picasso, Paris, 1994

Read 2000
P. Read, *Apollinaire et les mamelles de Tirésias: La revanche d'Éros*, Rennes 2000

Richardson 1991
J. Richardson, *A Life of Picasso, Volume 1: 1881–1906*, London 1991

Richardson 1997
J. Richardson, *A Life of Picasso, Volume 2: 1907–1917*, London 1997

Richardson 2007
J. Richardson, *A Life of Picasso, Volume 3: 1917–1932*, London 2007

Richet 1988
M. Richet, *The Musée Picasso, Paris. Catalogue of Collections, Volume II*, London 1988

Rosenblum 1961
R. Rosenblum, *Cubism and Twentieth-Century Art*, New York 1961

Rosenblum 1967
R. Rosenblum, *Jean-Auguste-Dominique Ingres*, New York 1967

Rubin and Zelevansky 1992
W. Rubin and L. Zelevansky (eds), *Picasso and Braque: A Symposium*, New York 1992

Silver 1989
K.E. Silver, *Esprit de Corps: The Art of the Parisian Avant-Garde and the First World War, 1914–1925*, Princeton, NJ, 1989

Stein 1938
G. Stein, *Picasso*, Paris 1938

Steinberg 1972
L. Steinberg, 'The Algerian Women and Picasso At Large', in *Other Criteria: Confrontations with Twentieth-Century Art*, New York 1972, pp. 125–234

Stimpson and Chessman 1998
C.R. Stimpson and H. Chessman (eds), *Gertrude Stein: Writings 1903–1932*, New York 1998

Utley 2000
G.R. Utley, *Picasso: the Communist Years*, New Haven and London 2000

Vancouver 2005
Picasso: Eleven Paintings from International Collections, exh. cat., Vancouver Art Gallery 2005

Vollard 1934
A. Vollard, *Renoir: An Intimate Record*, New York 1934

Washington, DC, 2003
J. Weiss, *Picasso: The Cubist Portraits of Fernande Olivier*, exh. cat., National Gallery of Art, Washington, DC, 2003

Washington, DC, and Boston 1997
M. McCully (ed.), *Picasso. The Early Years, 1892–1906*, exh. cat., National Gallery of Art, Washington, DC, and Museum of Fine Art, Boston, 1997

Wollheim 1987
R. Wollheim, *Painting as an Art*, London 1987

Index

Barcelona
Museu Picasso

Basle
Fondation Beyeler, Riehen / Basel

Berlin
Staatliche Museen zu Berlin, Nationalgalerie,
Museum Berggruen

Cincinnati, OH
Cincinnati Art Museum

Colmar
Musée d'Unterlinden

East Sussex
The Penrose Collection

Edinburgh
National Galleries of Scotland

Geneva
Jan Krugier and Marie-Anne
Krugier-Poniatowski Collection

Hartford, CT
Wadsworth Atheneum Museum of Art

Lille
Palais des Beaux-Arts

London
The British Museum
Tate

Lyon
Musée des Beaux-Arts

Montreal
The Montreal Museum of Fine Arts /
Musée des Beaux-Arts de Montréal

New York
Solomon R. Guggenheim Museum
Koons Collection
The Metropolitan Museum of Art
The Museum of Modern Art

Paris
Musée National de l'Orangerie
Musée National Picasso
Centre Pompidou, Musée National
d'Art Moderne

Philadelphia, PA
Philadelphia Museum of Art

San Francisco, CA
Museum of Modern Art

Stuttgart
Staatsgalerie

Zurich
Kunsthaus Zürich

Nahmad Collection, Switzerland
Mariann Steegmann Stiftung
Monsieur Claude Ruíz-Picasso
Madame Maya Widmaïer-Picasso
Madame Catherine Hutin-Blay

And all lenders and private collectors
who wish to remain anonymous.

This exhibition has been made possible with
the assistance of the Government Indemnity
Scheme which is provided by DCMS and
administered by MLA.

Lenders

The authors of this publication wish to thank the following colleagues for
their expertise, assistance and support:

Colin B. Bailey, Marie-Laure Bernadac, Jean Sutherland Boggs, Susan Davidson, Ann Dumas,
Carol Eliel, John Golding, Florence Half-Wrobel, Richard Kendall, Elaine Koss, Isabella Kullman,
Philip Lewis, Marilyn McCully, Dana MacFarlane, Joseph J. Rishel, Joanna Sheers, Johanna
Stephenson and Sylvie Vautier.

Authors' Acknowledgements

All works by Pablo Picasso © Succession Picasso / DACS 2009

© akg-images
figs. 7, 10, 11, 12, 19, 29, 43, 68, 71, 72, 75; photo André Held: fig. 46; photo Erich Lessing: figs. 17, 24, 45; photo Nimatallah: cat. 42

© The Art Archive
fig. 67; Musées royaux des Beaux-Arts de Brussels: fig. 49; Musée du Louvre Paris / Gianni Dagli Orti: figs. 36, 51, 74; Musée d'Orsay Paris / Gianni Dagli Orti: figs. 8, 22, 44; British Museum: fig. 6; Museo Nacional del Prado Madrid: fig. 65; Museo Nacional del Prado, Madrid / Alfredo Dagli Orti: fig. 4; The Metropolitan Museum of Art New York / Alfredo Dagli Orti: fig. 13

© Bridgeman Art Library, London
fig. 5; The Wallace Collection, London: fig. 15; Musée Fabre, Montpellier: fig. 53

© Rex Features
p. 2; figs. 79, 80

© Scala, Florence
figs. 16, 21, 39, 62; BPK, Bildagentur für Kunst, Kultur und Geschichte, Berlin/Scala, Florence: cat. 14, fig. 57; New York, The Metropolitan Museum of Art/Art Resource/Scala, Florence: figs. 18, 23; MoMA, NY/Scala, Florence: cats. 3, 12; figs. 25, 27

Barcelona
© Museu Picasso: figs. 3, 14; cats. 1, 2, 27, 44, 45, 46

Basle
© Riehen/Basel, Fondation Beyeler: cats. 15, 73

Budapest
© Ludwig Museum, photo József Rosta: fig. 66

Cincinnati, OH
© Cincinnati Art Museum, OH: cat. 17

Edinburgh
© National Galleries of Scotland: cat. 31; fig. 20

Hartford, CT
© Wadsworth Atheneum Museum of Art, Hartford, CT: cat. 38

London
© British Museum Images: cats. 33, 35, 36, 54, 55, 56, 57, 58, 59, 75, 77 58; © The National Gallery: cats. 5, 16; figs. 26, 30, 38, 69, 70; © Tate: cats. 8, 13, 26, 34, 37, 76

Madrid
© Museo Nacional del Prado: figs. 2, 54, 59

Montreal
© The Montreal Museum of Fine Arts: cat. 70

Switzerland
© Nahmad Collection: cats. 18, 21, 25, 39, 47, 61, 63, 65; fig. 56

New York
© The Metropolitan Museum of Art: cat. 10; © The Solomon R. Guggenheim Foundation: cat. 9

Paris
© CNAC / MNAM, Dist. RMN photo Christian Bahier / Philippe Migeat: cat. 74; photo Béatrice Hatala: cats. 4, 43; photo Adam Rzepka: fig. 35; © RMN, Paris. All rights reserved: cat. 62; figs. 31, 33; photo Jean-Gilles Berizzi: cats. 20, 29, 48, 49, 60, 66; figs. 28, 41, 42, 63, 64; photo Gérard Blot: cats. 24, 28, 30, 78; figs. 31, 32, 50; photo Madeleine Coursaget: figs. 76, 77; photo Béatrice Hatala: cats. 50, 51, 52, 53; photo Christian Jean: fig. 34; photo Thierry Le Mage: figs. 52, 58, 73; photo Hervé Lewandowski: figs. 55, 60; photo René-Gabriel Ojéda: figs. 37, 40, 48; photo Franck Raux: cat. 22; figs. 47, 78

Philadelphia, PA
© Philadelphia Museum of Art. Photo Graydon Wood: cat. 11

Private collection
© Photo courtesy of the owners: cats. 6, 7, 19, 23, 64, 71, 72, 79; photo Orlando Faria: cat. 69; photo courtesy of Libby Howie: cat. 41; © The Penrose Collection: cat. 31

San Francisco, CA
© San Francisco Museum of Modern Art: cat. 40

Seville
© Museo de Bellas Artes: fig. 61

Stuttgart
© Staatsgalerie Stuttgart: cat. 68, fig. 1

Washington, DC
© The Phillips Collection: fig. 9

Zurich
© Kunsthaus Zürich. All rights reserved: cat. 67

Photographic Credits